CW00428874

LUXURY LINERS

THEIR GOLDEN AGE AND THE MUSIC PLAYED ABOARD

ear BOOKS

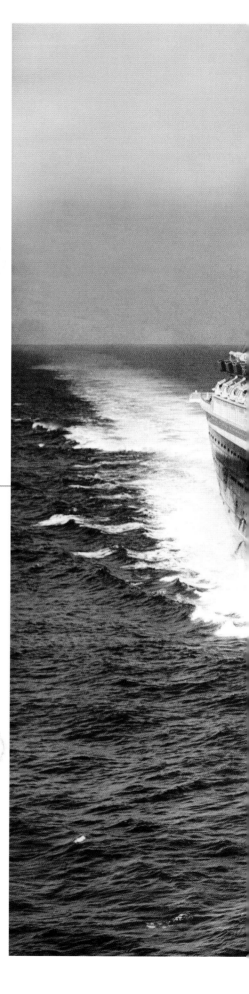

Front cover:
The Cunard White Star liner Queen Mary leaving the dock at Southampton
on her maiden voyage, 27th May 1936.
Umschlagsvorderseite:
Der Cunard White Star Liner Queen Mary verlässt das Dock in Southampton
für seine Jungfernfahrt am 27. Mai 1936.
Copertina davanti:
La Queen Mary, della White Star Line, lascia il 27 maggio 1936 il cantiere di
Southampton per il suo viaggio inaugurale.

Frontispiece:
The new United States liner SS United States, winner of the Blue Riband for 1952.
Frontispiz:
Der neue amerikanische Liner SS United States, Gewinner des Blauen Bands 1952.
Frontespizio:
Il nuovo transatlantico United States, vincitore del Nastro Azzurro nel 1952

Copyright © 2008 by edel entertainment GmbH, Hamburg/Germany
Photographic copyright see page 130
Music copyright see page 128/129

ISBN 978-3-940004-51-2

Editorial direction by Astrid Fischer/edel
Edited and designed by Feierabend Unique Books
Layout and picture processing by Cora Franke
Foreword by Larissa Kröhnert
Music selection by Peter Cadera/edel
Translation by Elmar Schulte (English), Giusi Valent (Italian)

Produced, printed and manufactured by optimal media production GmbH, Röbel/Germany

earBOOKS is a division of edel entertainment GmbH

For more information about earBOOKS please visit www.earbooks.net

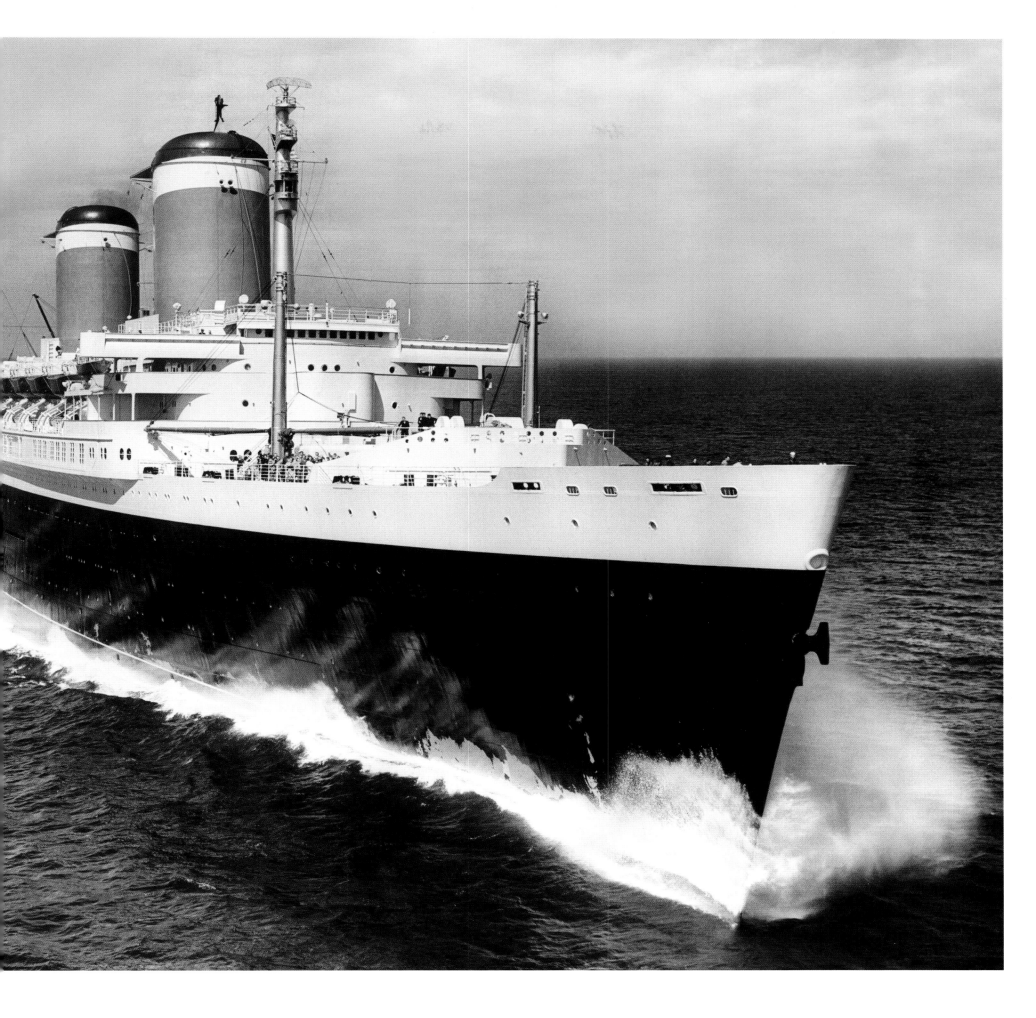

THE GOLDEN AGE OF OCEAN TRAVEL

The golden era of the grand ocean liners, although long gone, has left behind a myth that still surrounds luxury travelling between the continents. For over one century and in times when travelling was still an adventure, the huge liners conveyed large numbers of passengers across the oceans. Their routes went all around the globe, but the fastest and grandest liners served the transatlantic route between Europe and North America. It is their names that we still remember today when we think of this golden era of ocean liners.

In the first years of the 19th century, which were also the early years of the liner trade, sailing boats were still plying the seas. But as the century wore on, they had to compete more and more with steamers. In 1838, the steam-powered Great Western crossed the Atlantic Ocean in the record time of two weeks, much faster than any sailing boat could have done. After that, steamboats began to conquer the oceans: because of their constant speed, it was possible for steamers to keep to fixed schedules – an important step towards liner traffic.

Merely two years later, Cunard, the legendary British shipping company, appeared on the scene. Their steamer **Britannia** was the first to regularly serve the transatlantic route. Because a host of other steamship companies had also been founded, Cunard increasingly faced keen competition. However, this was good for business, and in the second half of the 19th century, steamers eventually replaced sailing boats. One of Cunard's fiercest competitors was the White Star Line, also British-owned. In 1870, it set new standards when it launched the **Oceanic**, all of whose first-class cabins were fitted with electricity and running water. Such luxurious furnishings set the trend and marked an important step in the history of steamline travel.

The golden age of ocean travel had now begun. Suddenly all steamship companies were competing in a booming market. One of the reasons was mass emigration overseas, but another was the high standard in luxurious furnishings that manysteam vessels now

offered: steam-boat passages were beyond competition in this regard and thus very much in demand. This opened new perspectives in the market.

To meet their clientele's exquisite demands, the companies ordered not only very large new ships, but these vessels were also equipped with the latest technology and many luxurious extravagances. The well-off passengers who could afford to board those liners for the unique and exciting experience of a cruise enjoyed themselves in sumptuous suites and elegant dining-halls. Besides those luxuries, the steamliners also provided entertainment that satisfied almost every whim. Resembling first class hotels, these ships offered quick and convenient passages. Consequently, crossing the ocean in a steamboat became the preferred mode of travel.

The Blue Riband, awarded for the fastest transatlantic crossing, was one of the most prestigious awards for ocean liners. In their ambition to receive the Blue Riband, the steamship companies were outperforming one another. When, at the end of the 19th century, the Blue Riband had been won by the **Kaiser Wilhelm der Grosse** and then by a succession of German vessels, Cunard sought to reassert British supremacy in the northern Atlantic. As a consequence, the **Lusitania** and the **Mauretania** were built in 1907. Cunard's plan worked: both ships won the Blue Riband right away, and the **Mauretania**, considered the most magnificent vessel of her time, managed to hold this record for 20 years.

In an attempt to draw level, the White Star Line launched its **Olympic** in 1910, followed by her two ill-fated sister ships: the **Titanic**, of tragic renown for sinking during her maiden voyage, and the **Britannic**, requisitioned for war-service right after she was launched. By their sheer size, these three vessels surpassed

everything Cunard could muster. The German shipping company Hapag also started building three gigantic ocean liners: the **Imperator**, the **Vaterland** and the **Bismarck**. The latter remained the world's largest ship until 1935. However, none of these vessels actually sailed long for Hapag, as all three were captured by the enemy during the First World War.

In the First World War, large ocean liners like the **Mauretania** and the **Olympic** were used as troop carriers and hospital ships, which frequently involved damage and accordingly meant losses for the steamship companies. In the early 1920s, even more heavy losses were occasioned by a new law that restricted immigration into the US – carrying immigrants overseas was one of the most important sources of income for the steamship companies. But the expensive competition between them went on regardless, even in spite of the Great Depression and its consequences. After several decades, progress put the Blue Riband once again into the hands of the Germans, when two vessels, the **Bremen** and the **Europa**, broke the record set by the **Mauretania**, which had stood for twenty years.

The public also remained enthusiastic about ocean liners. In the mid-1930s, a French luxury liner, the **Normandie**, set new standards, not only with its state-of-the-art engines. People were intrigued by her innovative and elegant interiors and her furnishings, designed entirely in the Art Deco style. They made the **Normandie** one of the most magnificent and popular liners of all time.

At the same time, Cunard and White Star merged because of their economic difficulties and created two ships, much admired and of timeless glory: the **Queen Mary**, which won the Blue Riband twice, and the **Queen Elizabeth**. Not long after they were built, the Second World War broke out, and both vessels had to

serve in the navy. A similar destiny was waiting for the **Normandie**, but an accident during refitting prevented it: she capsized and was damaged beyond repair. Many of those much-admired ocean liners were destroyed by mines, torpedoes or during air-raids; none of the big shipping companies escaped such losses. Many things changed after the war. The last Blue Riband was awarded to the **United States** in the early 1950s, and as that award became history, the fame and glamour of steam shipping were also on the wane: its heyday was over. Made redundant by the emerging intercontinental air traffic, most steamers had passed out of service by the late 1960s.

Only very few steamers from this last phase, like the **Norway** or the **Queen Elizabeth 2**, are still sailing the seas today. However, cruise shipping has progressed since then and has now become successful again with new, more magnificent and ever-larger vessels. Aboard these modern ships, and in an atmosphere tinged by nostalgia, passengers can re-live that golden era of steam ocean liners: an era whose charm will never really disappear.

Since the beginning of the era of luxury liners, music ensembles have provided the sophisticated musical entertainment for the upper-class passengers. The track selection of the accompanying CDs offers the listener a genuine impression of the musical entertainment performed on board.
The collection includes vintage swing and tango melodies played by the famous dance orchestras of the 30s and 40s, an entertaining potpourri of couplets and famous melodies from operas and operettas, a mélange of classic and standard compositions presented in sumptuous big band arrangements, and last not least an exquisite medley of smooth, elegant bar music.

DAS GOLDENE ZEITALTER DER OZEANRIESEN

Die Goldene Ära der prächtigen Ocean-Liner, obschon längst vergangen, hat einen Mythos hinterlassen, der sich das üppige Flair des luxuriösen, transkontinentalen Reisens bis heute bewahrt hat.

Über ein Jahrhundert lang, zu Zeiten, in denen das Reisen noch ein Abenteuer war, beförderten die gewaltigen Linienschiffe Unmengen von Passagieren zwischen den Kontinenten. Ihre Wege führten rund um den Globus, doch auf der berühmten Transatlantikroute zwischen Europa und Nordamerika fuhren die schnellsten und mächtigsten Schiffe, deren glanzvolle Namen diese Ära unsterblich machten.

Zu Beginn des 19. Jahrhunderts, als auch die Linienschifffahrt ihre Anfänge fand, waren die Weltmeere noch von Segelschiffen befahren. Doch nach und nach erwuchs ihnen ernsthafte Konkurrenz: 1838 schaffte es die dampfbetriebene **Great Western**, den Atlantik innerhalb einer Rekordzeit von zwei Wochen zu überqueren, was die Leistung der Segelschiffe weit in den Schatten stellte.

Nun begann der Siegeszug der Dampfschifffahrt: Mit ihrer gleichmäßigen Geschwindigkeit waren Dampfschiffe erstmalig in der Lage, feste Fahrpläne einzuhalten – ein entscheidender Schritt für den Linienverkehr.

Bereits zwei Jahre später trat die geschichtsträchtige britische Reederei Cunard auf den Plan. Ihr Schiff **Britannia** befuhr als erster Dampfer regelmäßig die Transatlantikroute. Nun begannen die Reedereien wie Pilze aus dem Boden zu schießen und Cunard bekam ernsthafte Konkurrenz, die den Wettbewerb belebte. So setzten sich in der zweiten Hälfte des 19. Jahrhunderts die Dampfschiffe vollends gegen die Segelschiffe durch.

Einer der wichtigsten Konkurrenten für Cunard war die ebenfalls britische White Star Line. 1870 setzte sie mit der **Oceanic** neue Standards, deren sämtliche Kabinen der Ersten Klasse über Elektrizität und fließend Wasser verfügten. Diese luxuriöse Ausstattung war richtungweisend und ein weiterer wichtiger Schritt in der Geschichte der Liner war getan.

Das Goldene Zeitalter der Ozeanriesen hatte nun begonnen. Unvermittelt befanden sich alle Reedereien in einem Wettbewerb, der florierte wie nie zuvor. Nicht zuletzt war das der verstärkten Auswanderung zu verdanken, doch auch die inzwischen ausnehmend luxuriöse Ausstattung der Schiffe, die mit neuen Maßstäben außer Konkurrenz stand, sorgte für eine hohe Nachfrage und neue Perspektiven des Wettbewerbs.

Um den exquisiten Wünschen der Kunden entgegenzukommen, gaben die Reedereien Schiffe in Auftrag, deren eines größer war als das andere, ausgestattet mit fortschrittlichster Technologie und üppigstem Luxus. Der betuchten Gesellschaft, die sich für viel Geld an Bord begab, um das einmalige Abenteuer einer Schiffsreise zu erleben, wurden prächtige Suiten und Speisesäle geboten. Ein umfangreiches Unterhaltungsangebot ließ keine Wünsche offen. Die schnelle Fahrt auf einem der damaligen Linienschiffe, die erstklassigen Hotels glichen, wurde so zur bevorzugten Art des Reisens.

Eine bei den Ocean-Linern sehr begehrte Auszeichnung war das Blaue Band für die schnellste Atlantiküberquerung. Auf der Jagd danach übertrafen sich die ehrgeizigen Reedereien gegenseitig. Als Ende des 19. Jahrhunderts eine Reihe von Schiffen nach der **Kaiser Wilhelm der Große** das Blaue Band über Jahre in deutscher Hand behielten, beschloss Cunard, die britische Vorherrschaft im Nordatlantik wiederzugewinnen. So wurden 1907 die **Lusitania** und die **Mauretania** gebaut. Der Plan ging auf: Beide erhielten gleich zu Anfang das Blaue Band und die **Mauretania**, die auch als prächtigstes Schiff ihrer Zeit angesehen wurde, verteidigte ihren Rekord für beachtliche 20 Jahre.

White Star ließ im Gegenzug 1910 die **Olympic** vom Stapel, der noch zwei schicksalsträchtige Schwesterschiffe folgen sollten: die **Titanic**, die durch den desaströsen Untergang auf ihrer Jungfernfahrt traurigen Ruhm erlangte, und die **Britannic**, die nach ihrem Stapellauf unverzüglich in Kriegsdienst gestellt wurde.

In ihrer Riesenhaftigkeit schlugen diese drei gigantischen Dampfer die Cunard-Schiffe um Längen.

Die deutsche Reederei Hapag begann ebenfalls mit dem Bau dreier Ozeanriesen, *Imperator*, *Vaterland* und *Bismarck*. Bis 1935 galt die *Bismarck* auch als das größte Schiff der Welt. Keines dieser Schiffe blieb jedoch lange im Dienst der Hapag, da alle drei nach dem Ersten Weltkrieg in feindliche Hände fielen.

Im Ersten Weltkrieg wurden Ozeanriesen wie die *Mauretania* und die *Olympic* als Truppentransporter und Lazarettschiffe eingesetzt, wodurch die Reedereien häufig Schäden und Verluste zu beklagen hatten. Weitere harte Einbußen musste die Linienschifffahrt noch Anfang der 20er Jahre hinnehmen: durch ein Gesetz wurde die Einwanderung nach Amerika, eine der wichtigsten Einnahmequellen der Reedereien, stark eingeschränkt. Doch selbst die folgenreiche Weltwirtschaftskrise konnte den kostspieligen Wettbewerb zwischen den Schiffsgesellschaften nicht aufhalten. Der Fortschritt siegte, die *Bremen* und die *Europa* brachen den zwanzigjährigen Rekord der *Mauretania* und brachten das Blaue Band 1929 so nach Jahrzehnten wieder in deutsche Hände zurück.

Die Begeisterung für die Schifffahrt hielt an. Mitte der 30er Jahre setzte der französische Luxusdampfer *Normandie* nicht nur mit seinem fortschrittlichen Antrieb neue Maßstäbe: Die innovative, elegante Gestaltung des ganz im Stil des Art déco ausgestatteten Liners faszinierte seinerzeit die Menschen und machte ihn zu einem der prächtigsten und beliebtesten Schiffe aller Zeiten.

Zur gleichen Zeit schlossen sich Cunard und White Star aus der wirtschaftlichen Notlage heraus zusammen und erschufen zwei ebenfalls äußerst geschätzte Schiffe von zeitloser Glorie: die *Queen Mary*, die das Blaue Band gleich zweimal erhielt, und die *Queen Elizabeth*.

Bald darauf brach der Zweite Weltkrieg aus und beide wurden in den Kriegsdienst gestellt. Auch die *Normandie* sollte dieses Schicksal ereilen, doch während der Umbauarbeiten kenterte sie in Folge eines Unfalls und wurde unbrauchbar. Viele der so bewunderten Ozeandampfer wurden Opfer von Minen, Torpedos oder Flugangriffen; von diesem verheerenden Krieg blieb keine Reederei verschont.

Nach dem Krieg änderte sich vieles. Anfang der 50er Jahre wurde das letzte Blaue Band an die *United States* verliehen und mit dieser Auszeichnung schwand auch der Ruhm und Glanz der Schifffahrt: die Zeit der Blüte war nun vorüber. In den Hintergrund gedrängt vom aufkommenden interkontinentalen Luftverkehr, blieb den meisten Schiffen bis zum Ende der 60er Jahre nichts anderes übrig, als den Betrieb einzustellen.

Wenige Schiffe aus dieser letzten Phase, wie die *Norway* oder die *Queen Elizabeth 2*, befahren noch heute die Ozeane. Die Schifffahrt hat wieder aufgeholt und feiert erneut große Erfolge mit neuen, immer kolossaleren und prächtigeren Schiffen.

An Bord dieser modernen Luxusliner lebt man heute das Goldene Zeitalter der Ozeandampfer immer wieder von neuem, umweht von einem Hauch Nostalgie: eine Ära, die nie wirklich untergehen wird.

Schon immer sorgten die Schiffskapellen für die abwechslungsreiche und gepflegte Unterhaltung der Passagiere der besseren Klassen. Die Titelauswahl der das Buch begleitenden CDs vermittelt dem Hörer einen authentischen Eindruck des vielfältigen Musikprogramms an Bord: Originale Swing-, Tango- und Evergreensounds berühmter Tanzorchester aus den dreißiger und vierziger Jahren; ein buntes Salonmusik Potpourri aus Couplets und beliebten Opern- und Operettenmelodien; Musikklassiker und Standards im opulenten Big-Band Arrangement und zum Abschluss eine exquisite Mischung leichter und eleganter Barmusik.

ERA COMINCIATA L'EPOCA D'ORO DEI GRANDI TRANSATLANTICI

Pur essendo tramontata da tempo, l'età d'oro dei grandiosi transatlantici ha lasciato dietro di sé un mito che mantiene tutt'ora inalterato il fascino del viaggio transcontinentale di lusso.

Per oltre un secolo, in un'epoca in cui viaggiare era ancora un'avventura, le immense navi passeggeri trasportavano da un continente all'altro migliaia di persone. Incrociavano in tutti i mari del mondo, ma era sulla famosa rotta transatlantica tra Europa e Nordamerica che prestavano servizio le imbarcazioni più rapide e potenti, i cui nomi illustri hanno trasformato quell'era in una leggenda.

All'inizio del XIX secolo, quando cominciò la navigazione di linea, i mari erano solcati ancora da maestosi velieri. A poco a poco questi dovettero fare i conti con una forte concorrenza: nel 1838 il piroscafo **Great Western** riuscì ad attraversare l'Atlantico nel tempo record di due settimane, oscurando di gran lunga le prestazioni delle barche a vela.

Cominciò allora la corsa trionfale della navigazione a vapore. Grazie alla loro velocità costante, i piroscafi furono per la prima volta in grado di rispettare degli orari prestabiliti: un passo decisivo per il traffico di linea.

Solo due anni più tardi entrò in scena la storica compagnia inglese Cunard Line. Il **Britannia**, uscito dai suoi cantieri, fu il primo piroscafo a prestare regolare servizio sulla rotta transatlantica. Da allora le società di armamento si moltiplicarono rapidamente. La Cunard Line si trovò a fronteggiare una nutrita concorrenza: nella seconda metà del XIX secolo i piroscafi avevano ormai soppiantato la navigazione a vela.

Uno dei principali concorrenti della Cunard fu la connazionale White Star Line. Nel 1870 questa compagnia introdusse nuovi standard qualitativi con l'**Oceanic**: tutte le cabine di prima classe erano fornite di elettricità e acqua corrente. Questo equipaggiamento di lusso indicò la direzione per lo sviluppo futuro e segnò un importante progresso nella storia delle grandi navi passeggeri.

Era cominciata l'epoca d'oro dei grandi transatlantici. D'un tratto tutte le compagnie marittime entrarono in concorrenza tra loro. Uno dei principali elementi scatenanti fu l'aumento dell'emigrazione; alla forte richiesta, però, contribuì anche l'allestimento sempre più lussuoso delle navi, che aprì nuovi orizzonti alla competizione.

Per soddisfare i desideri della raffinata clientela, le compagnie ordinavano infatti navi sempre più imponenti, munite delle tecnologie più avanzate ed arredate con il lusso più sfarzoso. Agli agiati passeggeri che spendevano enormi cifre per vivere la straordinaria avventura di un viaggio in nave, venivano offerte suite e sale da pranzo sontuose. A bordo era inoltre prevista una ricca gamma di divertimenti, per soddisfare qualsiasi richiesta. La rapida traversata su una delle navi di linea di allora, paragonabile ad un albergo a cinque stelle, diventò così un modo di viaggiare privilegiato.

Il riconoscimento più ambito era il Nastro Azzurro, assegnato alla nave che effettuava la traversata più veloce dell'Atlantico. Le ambiziose compagnie marittime si superavano a vicenda nell'inseguimento di questo primato. Alla fine del XIX secolo, dopo la **Kaiser Wilhelm der Große**, una serie di navi tedesche detenne per anni il Nastro Azzurro, finché la Cunard Line decise di riaffermare la supremazia britannica nel Nordatlantico. Nel 1907 iniziò la costruzione del **Lusitania** e del **Mauretania**. Il piano riuscì: conseguirono entrambe il Nastro Azzurro e il **Mauretania**, considerata la nave più prestigiosa della sua epoca, difese il record per ben vent'anni.

La White Star Line varò invece nel 1910 l'**Olympic**, seguito da altre due navi sorelle segnate dal destino: il **Titanic**, che diventò tristemente famoso per il disastroso naufragio durante il suo viaggio inaugurale, e il **Britannic**, che appena varato venne adibito ad uso militare. Come dimensioni questi tre giganteschi

piroscafi superavano di gran lunga le navi della Cunard Line. Anche la compagnia marittima Hapag mise in cantiere tre transatlantici: **Imperator**, **Vaterland** e **Bismarck** (la più grande nave del mondo fino al 1935). Nessuna di queste imbarcazioni prestò a lungo servizio presso la casa madre: durante la Prima guerra mondiale caddero tutte e tre in mano nemica.

Nel corso dei combattimenti, transatlantici come il **Mauretania** e l'**Olympic** furono impiegati per il trasporto delle truppe e come navi ospedale, per cui le compagnie marittime registrarono numerosi danni e perdite. I duri colpi per la navigazione non erano finiti: all'inizio degli anni Venti una severa legge limitò infatti la migrazione in America, che era una delle principali fonti di reddito degli armatori.

Ma nemmeno la crisi economica, con tutte le conseguenze che comportò, poté arrestare la dispendiosa corsa verso il trionfo del piacere. Così nel 1929 il progresso riportò dopo decenni il Nastro Azzurro in mano tedesca, quando la **Bremen** e l'**Europa** superarono il record ventennale del **Mauretania**.
L'entusiasmo per la navigazione proseguì. A metà degli anni Trenta, il lussuoso piroscafo francese **Normandie** stabilì i nuovi parametri con la sua tecnologia all'avanguardia e l'arredo elegante e innovativo, tutto in stile art déco, che affascinò i contemporanei e ne fece una delle imbarcazioni più belle e amate di tutti i tempi.

Nel frattempo le due società Cunard e White Star Line si fusero per questioni economiche e crearono due navi di grande pregio e gloria perenne: la **Queen Mary**, subito decorata due volte con il Nastro Azzurro, e la **Queen Elizabeth**. Poco dopo scoppiò la Seconda guerra mondiale e furono entrambe utilizzate per scopi militari. Anche il **Normandie** avrebbe seguito lo stesso destino, ma durante i lavori di riconversione la nave si rovesciò a seguito di un incidente e non fu più utilizzabile. Molte navi tanto ammirate furono preda di mine, cannonate, siluri o attacchi aerei; nessuna compagnia scampò alla devastazione della guerra.
Dopo la fine del conflitto, molte cose cambiarono. All'inizio degli anni Cinquanta l'ultimo Nastro Azzurro fu assegnato alla **United States** e con questo premio scemò anche la gloria e lo sfarzo della navigazione marittima: l'epoca di maggior splendore era ormai passata. Spinte sullo sfondo dall'affermarsi del traffico aereo intercontinentale, a molte navi non restò che concludere il proprio esercizio alla fine degli anni Sessanta.

Solo rare imbarcazioni di quest'ultima fase, come la **Norway** o la **Queen Elizabeth 2**, solcano i mari ancora ai giorni nostri. Viceversa la navigazione ha riguadagnato terreno e riscuote di nuovo grande successo con navi moderne sempre più colossali e fastose. A bordo si celebra oggi una nuova età dell'oro dei transatlantici, avvolta da un velo di nostalgia: un'era destinata a non tramontare piú.

Un tempo le orchestre di bordo provvedevano ad intrattenere in modo vario e raffinato i passeggeri delle classi più alte. La scelta dei brani contenuti nei CD allegati al libro permette di farsi un'idea realistica del ricco programma eseguito durante la navigazione: ritmi swing, tanghi e i più grandi successi delle famose orchestre da ballo degli anni Trenta e Quaranta in versione originale; un pot-pourri delle canzoni in voga e delle melodie più amate di opere e operette; motivi classici e standard jazz in opulenti arrangiamenti da big band, e per finire un'accurata selezione di elegante musica da nightclub.

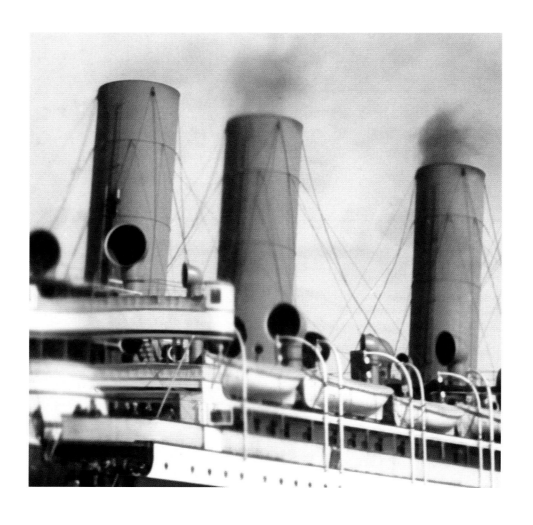

TRANSATLANTIC LINER
THE BEGINNING OF AN ERA

✦ ✦ ✦ ✦

TRANSATLANTIK-LINER
DER BEGINN EINER EPOCHE

✦ ✦ ✦ ✦

I TRANSATLANTICI
L'INIZIO DI UN'EPOCA

The Kaiser Wilhelm der Große, which was on transatlantic duty for the Norddeutscher Lloyd since 1897.

Die Kaiser Wilhelm der Große, die 1897 für den Norddeutschen Lloyd den transatlantischen Dienst antrat.

La Kaiser Wilhelm der Große, che nel 1897 svolse servizio transatlantico per la Norddeutscher Lloyd.

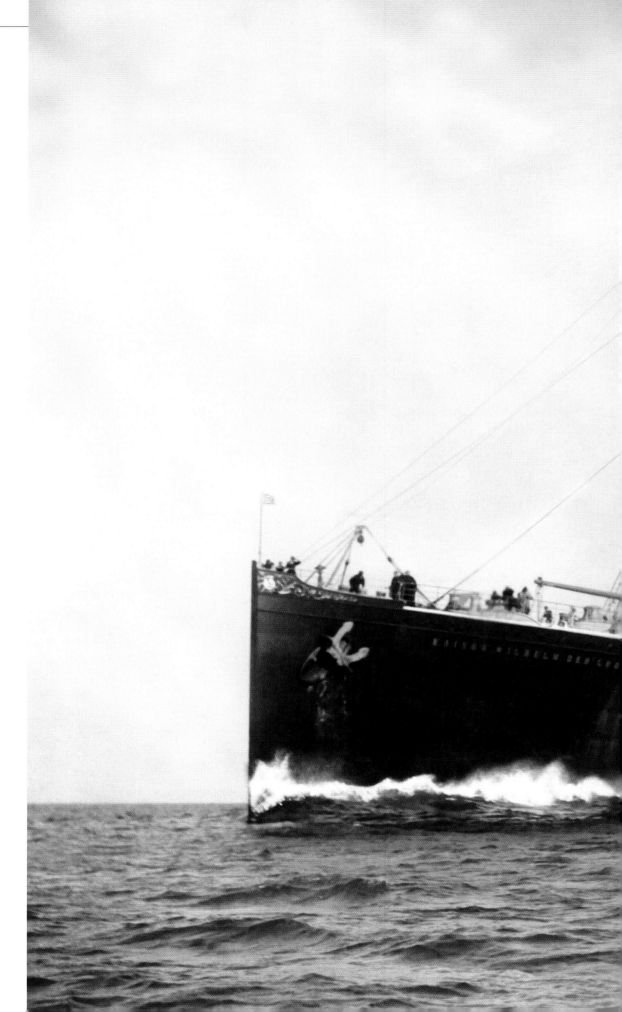

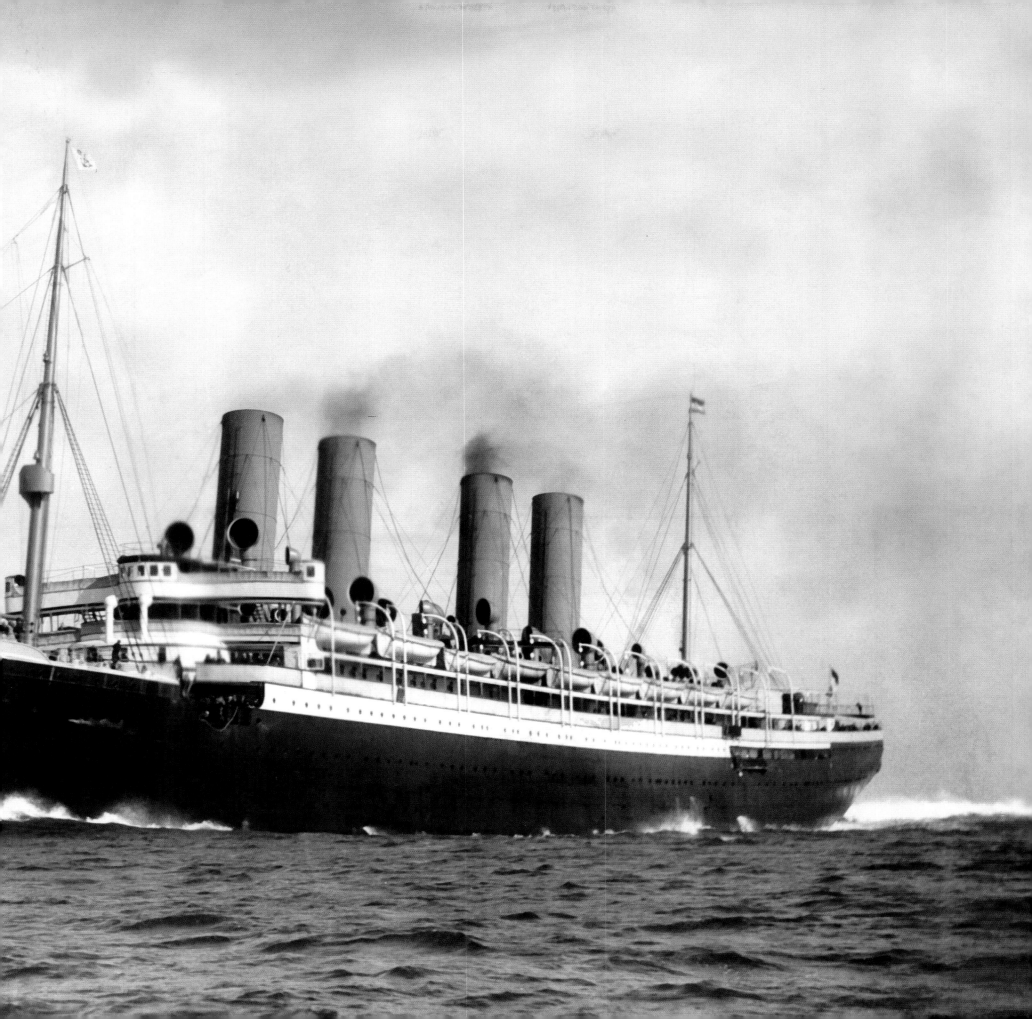

Poster of the Cunard liners Mauretania, Berengaria and Aquitania.

Poster von Cunard mit der Mauretania, Berengaria und Aquitania.

Manifesto della Cunard Line, con il Mauretania, il Berengaria e l'Aquitania.

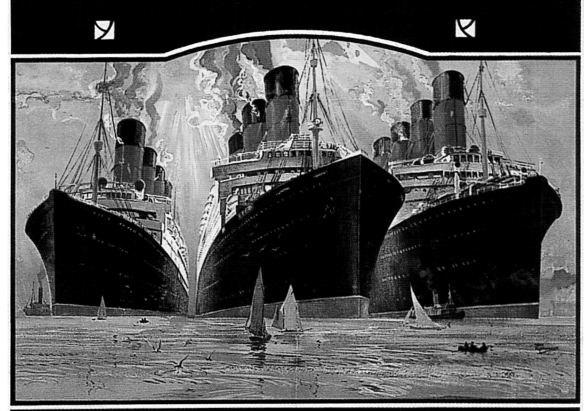

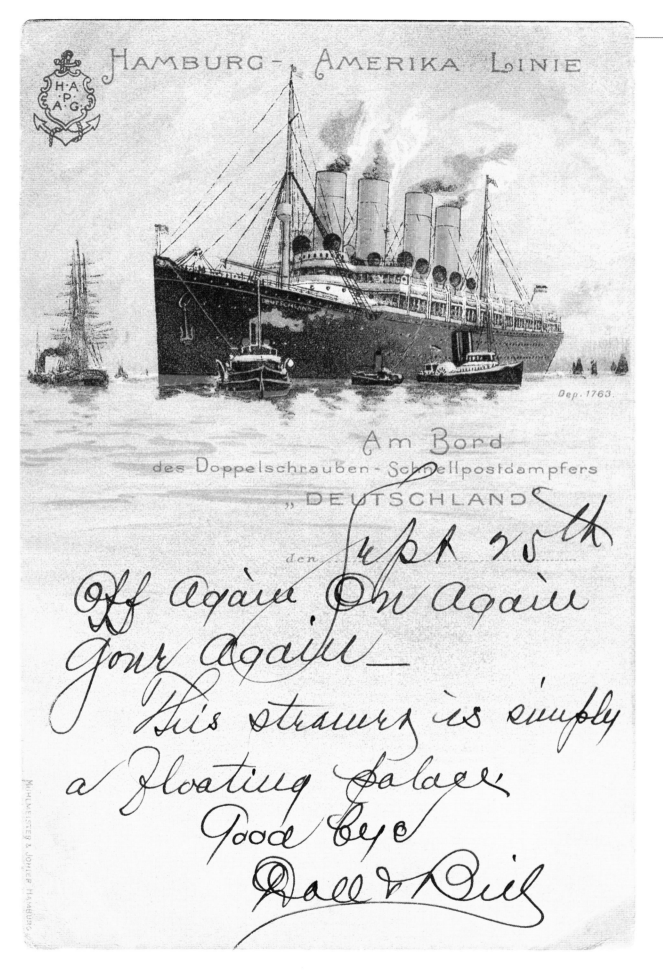

HAMBURG - AMERIKA LINIE

Am Bord
des Doppelschrauben-Schnellpostdampfers
„DEUTSCHLAND"

den Sept 25th

Off Again, On Again
Gone Again —
This steamer is simply
a Floating Palace
Good bye
Dall & Dill

Postcard of the Deutschland.

Postkarte der Deutschland.

Una cartolina della Deutschland.

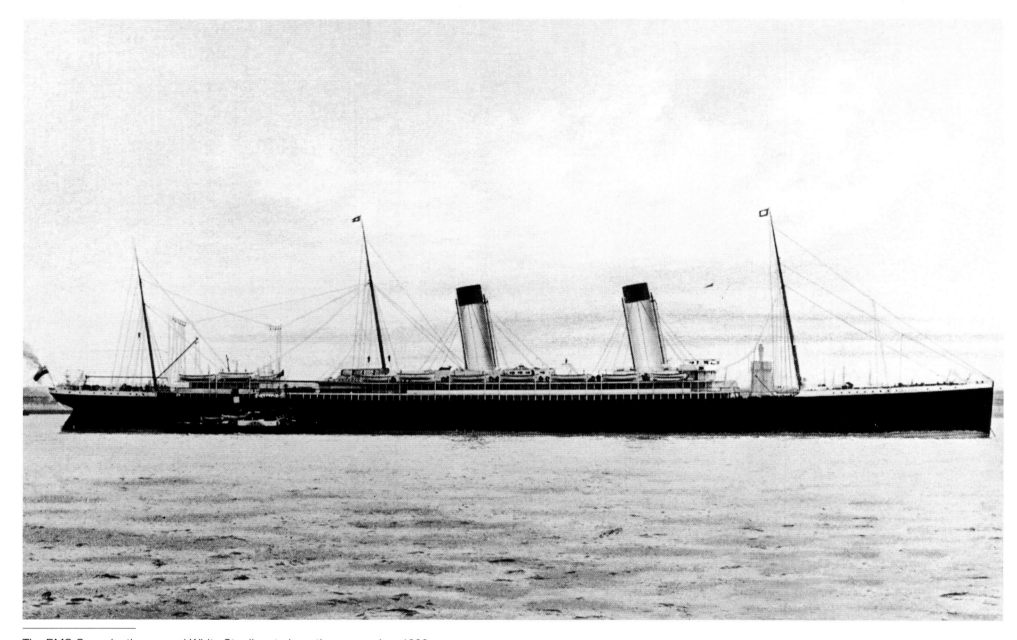

The RMS Oceanic, the second White Star liner to bear the name, circa 1908.
She was launched in 1899 and ran aground in Shetland in 1914.

Die RMS Oceanic, die als zweiter White-Star-Liner diesen Namen trug, um 1908.
Sie wurde 1899 vom Stapel gelassen und lief 1914 vor Shetland auf Grund.

R.M.S. Oceanic, il secondo transatlantico della White Star Line con questo
nome (1908): varato nel 1899, si arenò nel 1914 al largo delle isole Shetland.

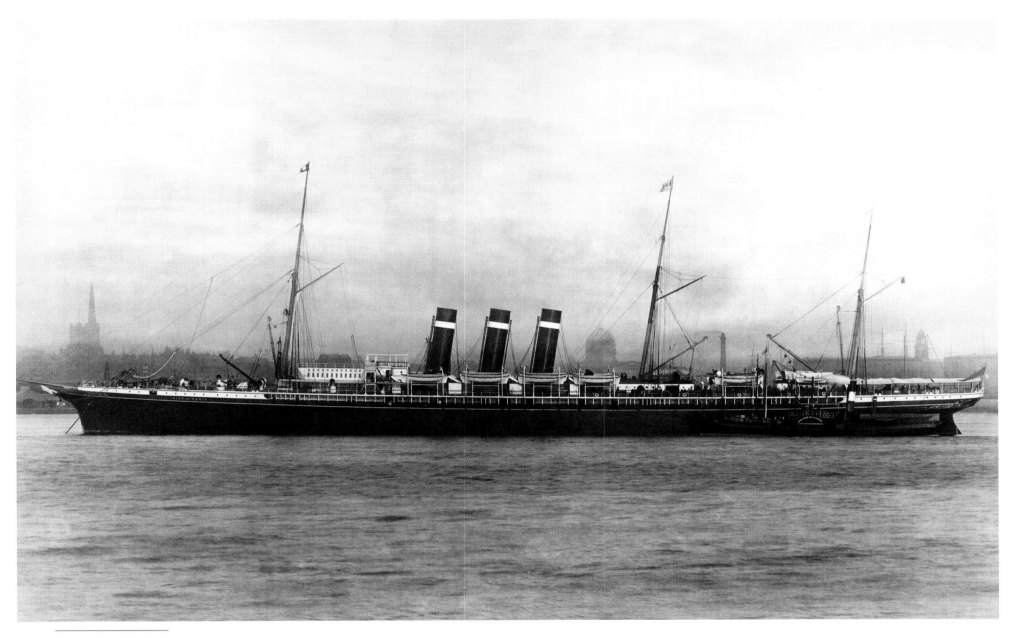

The Inman Liner SS City of Paris at one of the ports on the
Liverpool-Queenstown-New York service, 1890.

Der Inman Liner SS City of Paris in einem Hafen auf der Route
Liverpool-Queenstown-New York, 1890.

Il transatlantico della Inman Line S.S. City of Paris, attraccato
in un porto sulla rotta Liverpool-Queenstown-New York (1890).

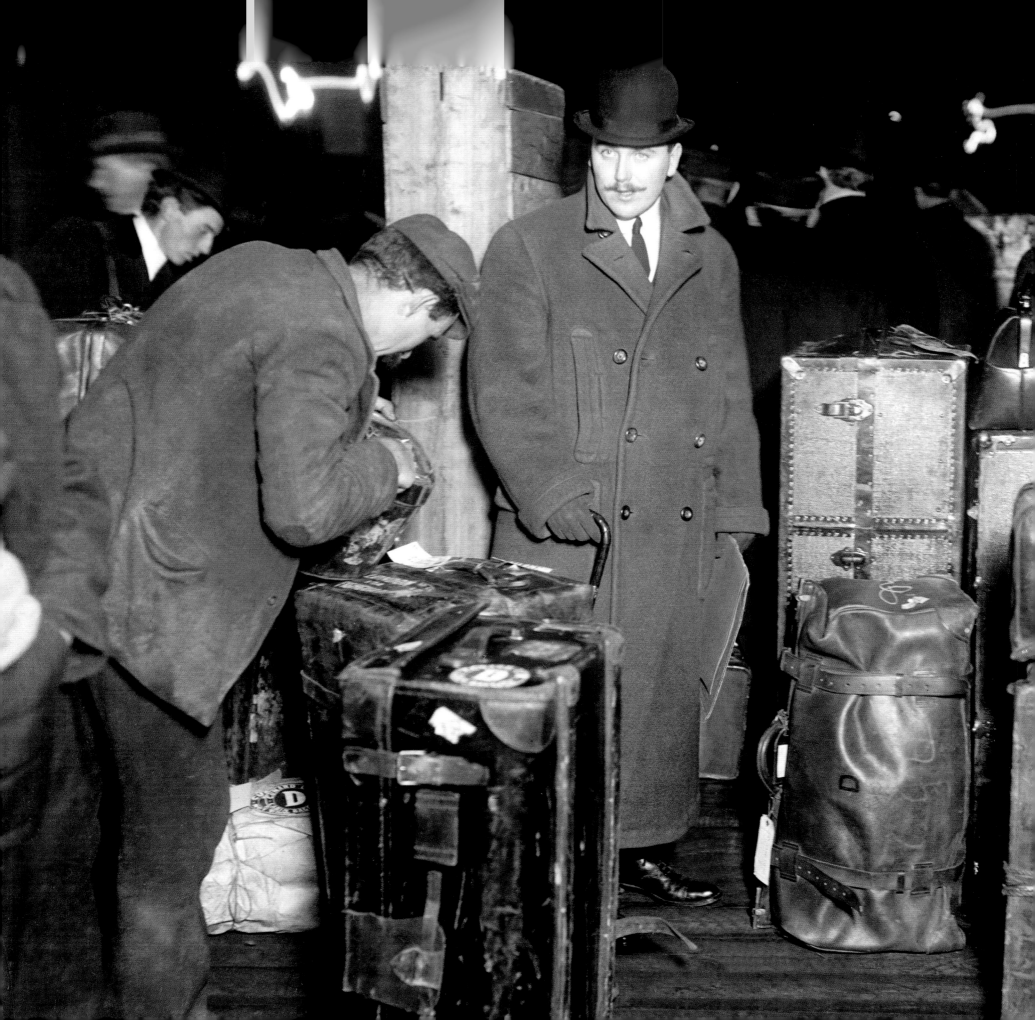

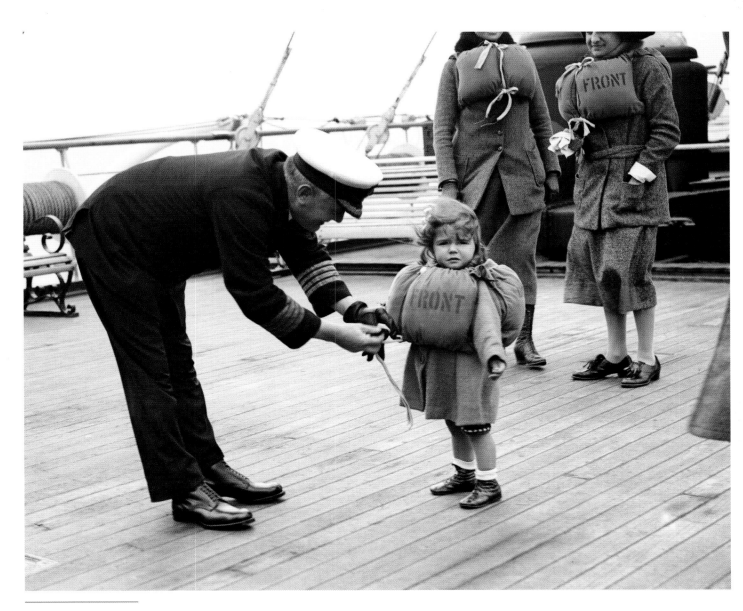

A young passenger aboard the Mauretania gets her lifejacket adjusted, 1922.

Eine junge Reisende bekommt an Bord der Mauretania eine Schwimmweste angepasst, 1922.

Una giovane ospite del Mauretania riceve un giubbotto di salvataggio (1922).

Even airmen like to travel by ship: famous aviator Joseph Eduard Drexel amidst his luggage.

Auch Flieger sind gern auf dem Wasser unterwegs: Der bekannte Pilot Joseph Eduard Drexel mit seinem Gepäck.

Anche gli aviatori amano viaggiare per mare: nella foto, il pilota della Prima guerra mondiale Joseph Eduard Drexel con il suo bagaglio.

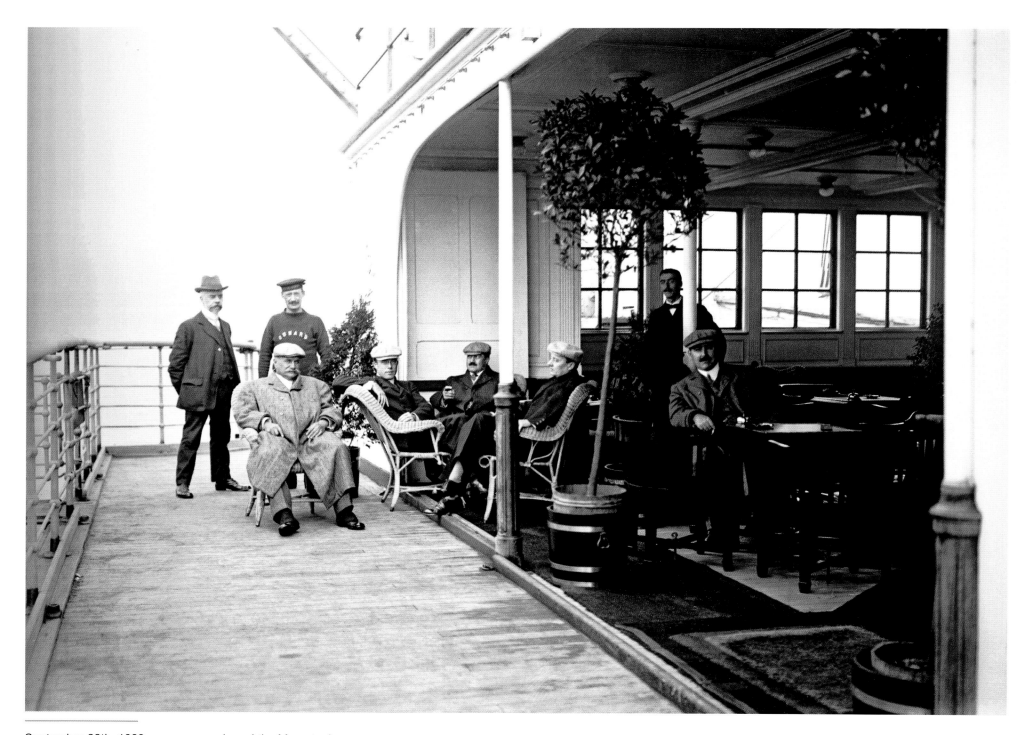

September 20th, 1909: passengers aboard the Mauretania are having some drinks before going ashore in Fishguard.

September 1909: Passagiere nehmen in der Bar an Bord der Mauretania noch eine Erfrischung zum Abschied, bevor sie in Fishguard von Bord gehen.

Settembre 1909: i passeggeri si ristorano nel bar a bordo del Mauretania prima di sbarcare a Fishguard.

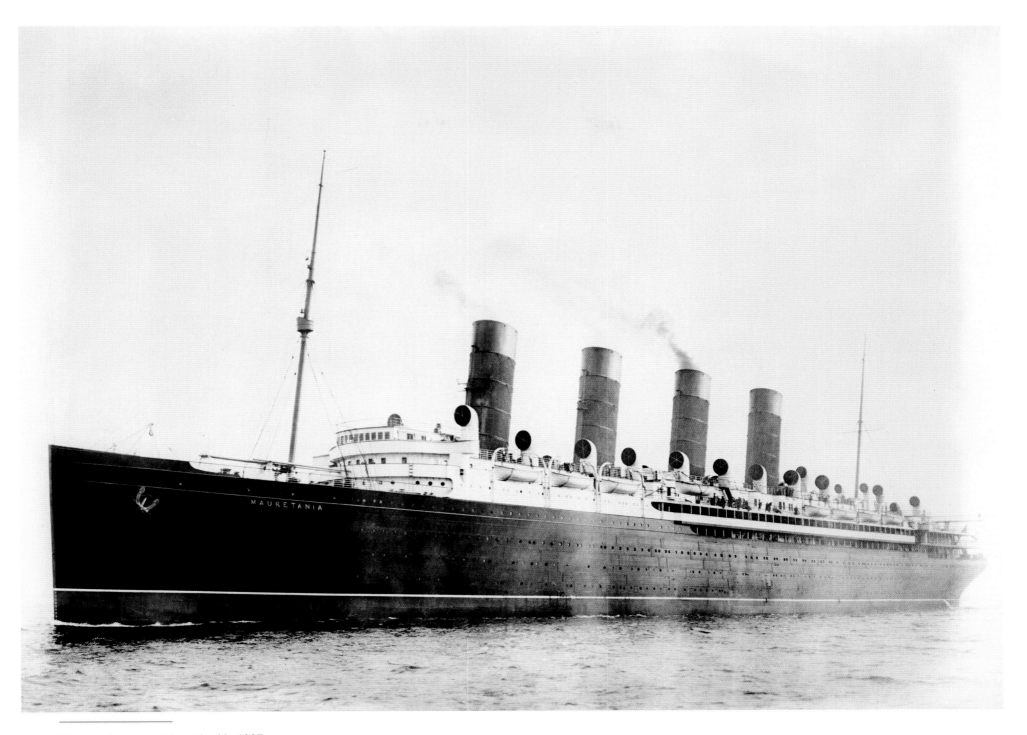

The liner Mauretania launched in 1907.

Die Mauretania von 1907.

Il Mauretania nel 1907.

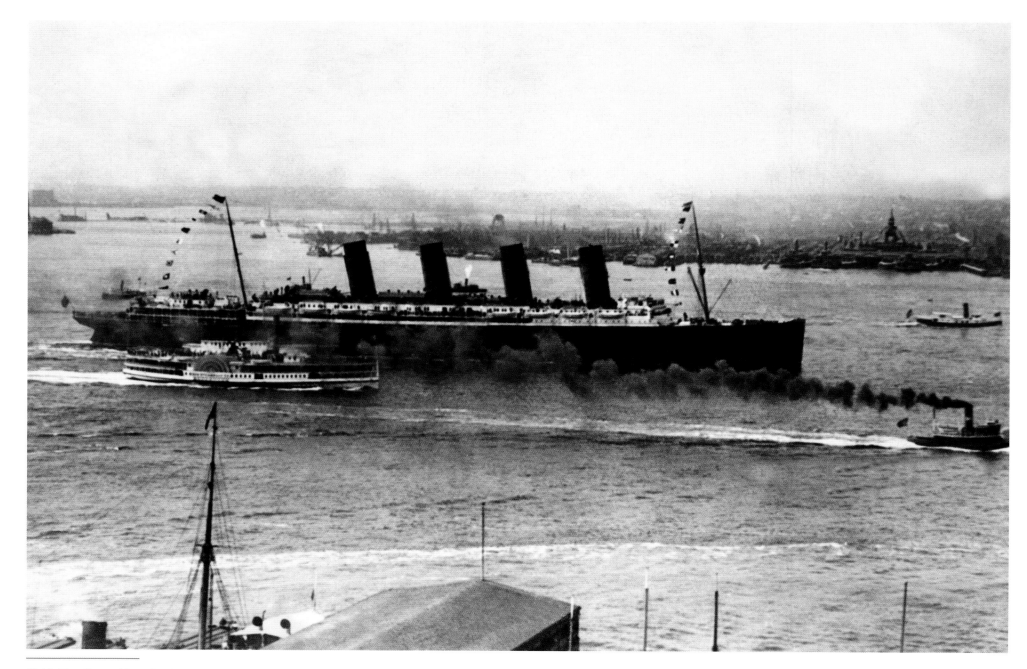

1912: The Cunard liner Lusitania, one of only 14 four-stackers ever built steaming into New York harbour. She was torpedoed by a German submarine off the coast of Ireland in 1915 and sunk with the loss of 1,198 lives.

Die Lusitania der Cunard Line im Jahre 1912, eines von nur 14 Vier-Schornstein-Schiffen, die je erbaut wurden, läuft aus dem Hafen von New York aus. Als sie 1915 nach einem Torpedoangriff von deutscher Seite sank, riss sie 1.198 Menschen mit in den Tod.

Il Lusitania, una delle solo quattordici navi a quattro fumaioli mai costruite, salpa dal porto di New York nel 1912. Il suo affondamento, nel 1915, causò la morte di 1.198 persone.

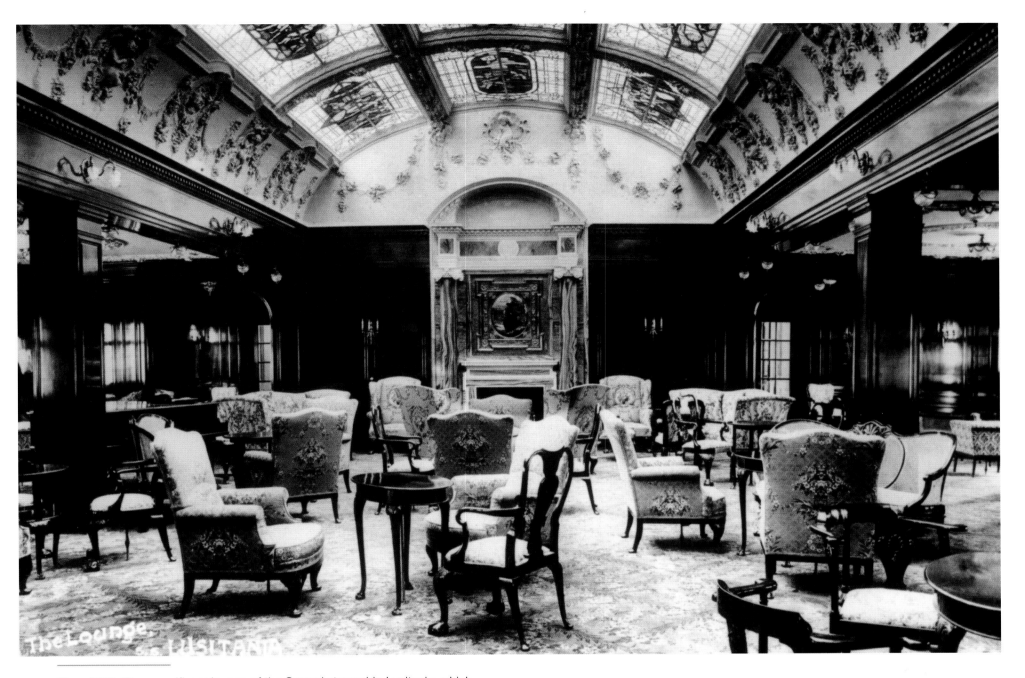

Circa 1910: The magnificent lounge of the Cunard steamship Lusitania, which was torpedoed by a German submarine during World War I.

Die prächtige Lounge des Cunard-Schiffs Lusitania um 1910. Das Schiff wurde im Ersten Weltkrieg von einem deutschen U-Boot torpediert.

Il sontuoso lounge del Lusitania (1910 ca.); il transatlantico della Cunard Line fu silurato da un sommergibile tedesco durante la Prima guerra mondiale.

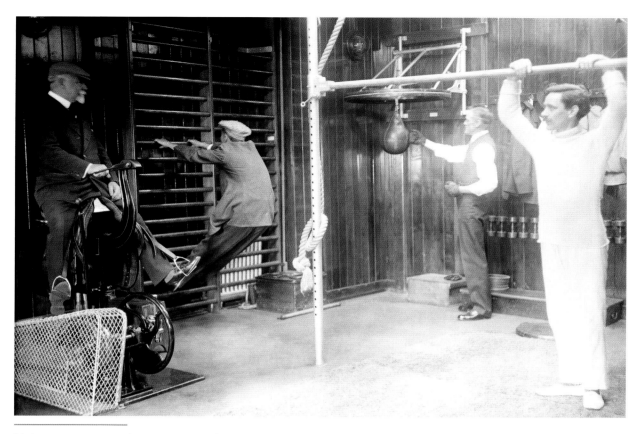

Male passengers work out at a gym aboard the Franconia.

Passagiere im Sportstudio an Bord der Franconia.

Alcuni passeggeri in una palestra a bordo del Franconia.

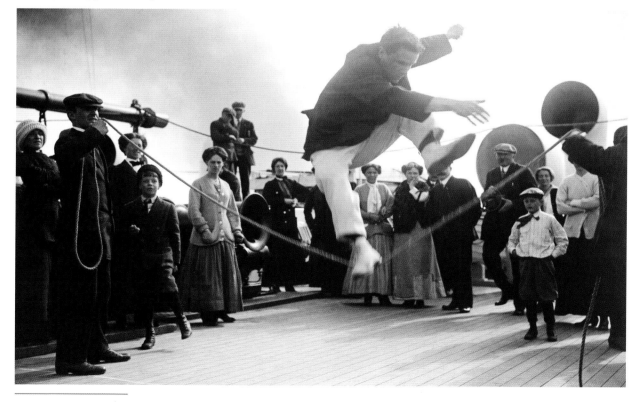

A skipping game on Deck. June 1912.

Seilhüpfen an Deck, Juni 1912.

Sul ponte si gioca a saltare la corda (giugno 1912).

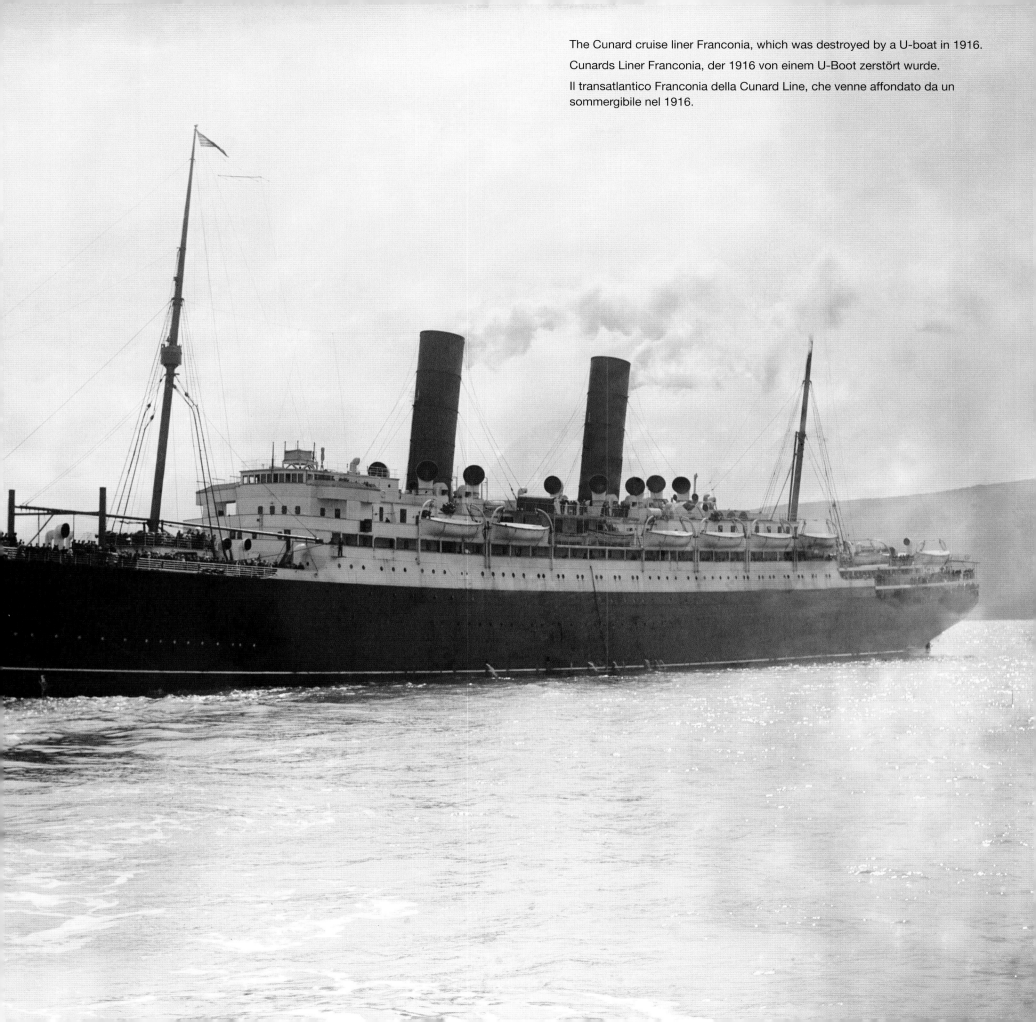

The Cunard cruise liner Franconia, which was destroyed by a U-boat in 1916.

Cunards Liner Franconia, der 1916 von einem U-Boot zerstört wurde.

Il transatlantico Franconia della Cunard Line, che venne affondato da un sommergibile nel 1916.

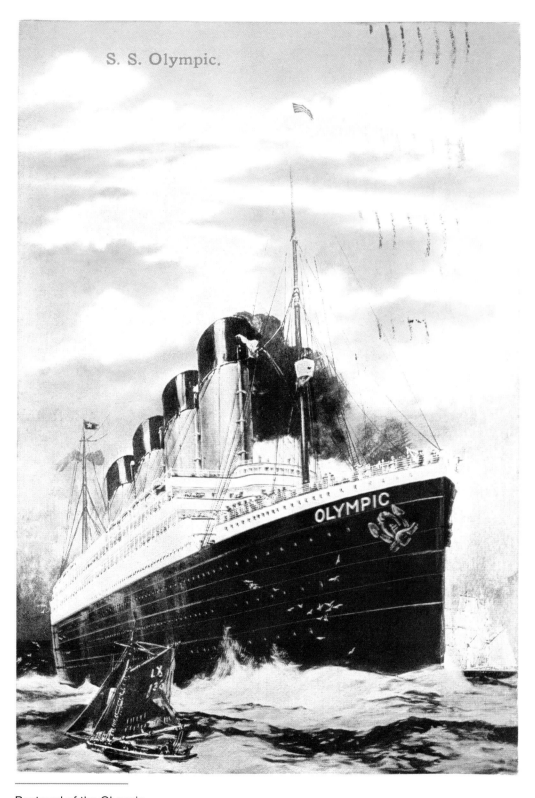

S. S. Olympic.

OLYMPIC

Postcard of the Olympic.

Postkarte der Olympic.

Cartolina dell'Olympic.

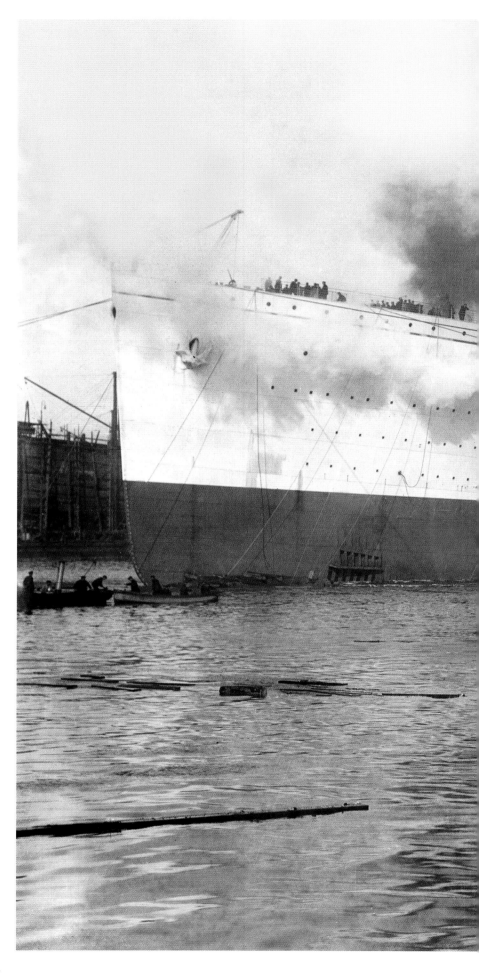

The Olympic, first of White Star's 'Big Three', who survived her sister ships Titanic and Britannic for many years, after her launch in Belfast on October 20th, 1910.

Die Olympic, die erste der ‚Big Three' von White Star, überlebte ihre Schwesterschiffe Titanic und Britannic viele Jahre. Hier nach dem Stapellauf in Belfast am 20. Oktober 1910.

L'Olympic, il primo dei tre colossi della White Star Line, sopravvisse di molti anni alle navi sorelle Titanic e Britannic.
Qui, dopo il varo a Belfast il 20 ottobre 1910.

S.S. "TITANIC."
LENGTH, 882 FEET; BEAM, 92 FEET; TONNAGE, 46,192.

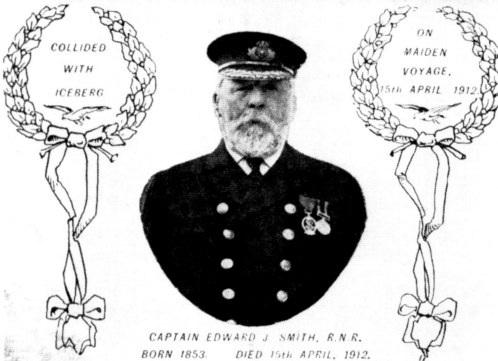

COLLIDED WITH ICEBERG

ON MAIDEN VOYAGE, 15th APRIL, 1912.

CAPTAIN EDWARD J. SMITH, R.N.R.
BORN 1853. DIED 15th APRIL, 1912.

NEARER MY GOD TO THEE!

Nearer, my God, to Thee, Nearer to Thee.

E'en though it be a cross that raiseth me;

Still all my song shall be, Nearer, my God, to Thee, Nearer to Thee.

Though like the wanderer,
 The sun gone down,
Darkness comes over me,
 My rest a stone;
Yet in my dreams I'd be
Nearer, my God, to Thee,
 Nearer to Thee.

There let my way appear
 Steps unto Heav'n,
All that Thou sendest me
 In mercy given,
Angels to beckon me
Nearer, my God, to Thee,
 Nearer to Thee.

Then, with my waking thoughts
 Bright with Thy praise,
Out of my stony griefs
 Beth-el I'll raise;
So by my woes to be
Nearer, my God, to Thee,
 Nearer to Thee.

Hymn played by Bandsmen of the S.S. "TITANIC" as she sank to
her doom, 15th April, 1912.

Postcard of the Titanic

Postkarte der Titanic.

Cartolina del Titanic.

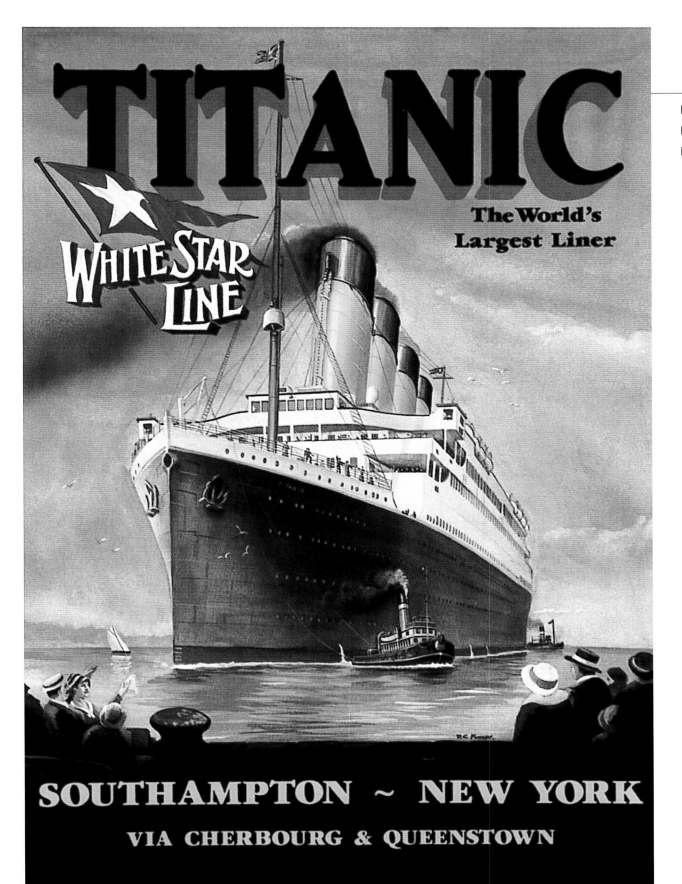

Poster of the White Star liner Titanic.
Poster der Titanic von White Star.
Manifesto del Titanic, White Star Line.

The Titanic's first trial run. She sank in a catastrophic disaster on her maiden voyage 1912.

Erste Probefahrt der Titanic, die 1912 auf ihrer Jungfernfahrt in einer katastrophalen Havarie unterging.

Il viaggio di prova del Titanic; la nave affondò tragicamente durante la sua prima traversata nel 1912.

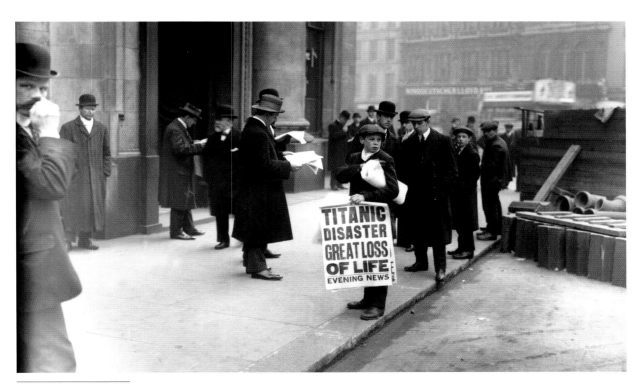

April 16th 1912: One day after the foundering of the Titanic the news spread like wildfire.

Die Nachricht über den Untergang der Titanic breitet sich am Tag danach wie ein Lauffeuer aus.

16 aprile 1912: un giorno dopo il naufragio del Titanic, la notizia si diffonde con grandissima rapidità.

The four Pascoe brothers, who survived the sinking of the the White Star liner Titanic, 1912.

Die vier Pascoe Brüder hatten den Untergang der Titanic überlebt, 1912.

I quattro fratelli Pascoe, sopravvissuti al naufragio (1912).

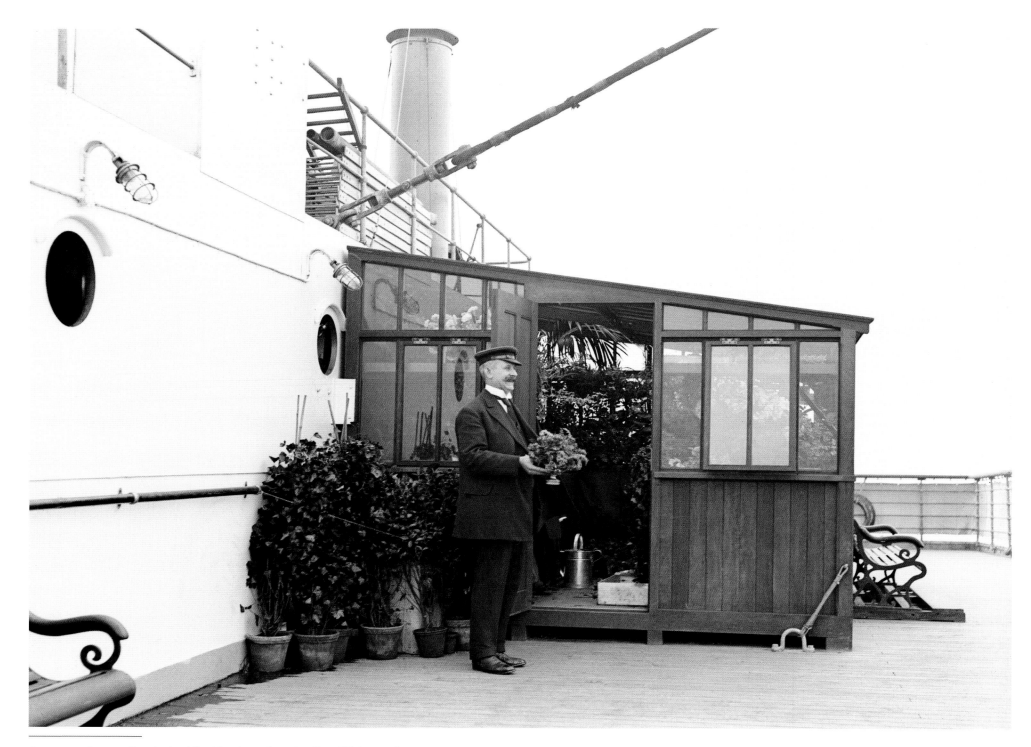

A conservatory on the deck of the Hamburg America liner SS Imperator, later operated by Cunard as the Berengaria, 1916.

Gewächshaus an Deck des Hapag-Liners SS Imperator (1916), der später von Cunard unter dem Namen Berengaria betrieben wurde.

La serra sul ponte dell'Imperator della Hapag SS (1916); il transatlantico in seguito passerà alla Cunard Line con il nome di Berengaria.

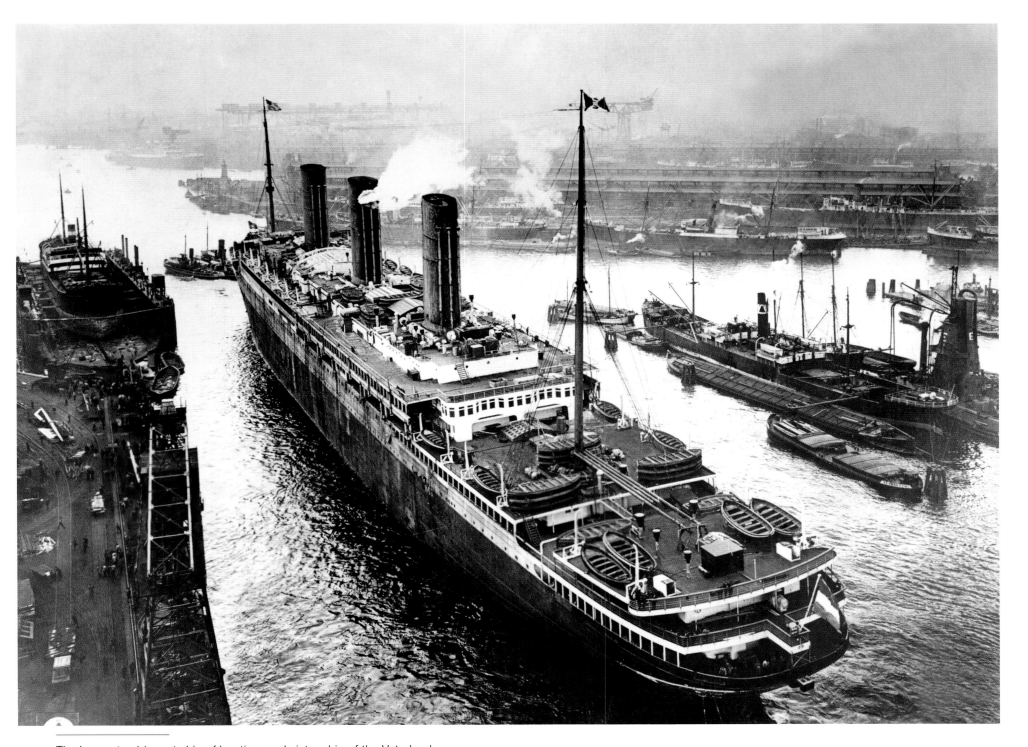

The Imperator, biggest ship of her time and sister ship of the Vaterland and the Bismarck.

Die Imperator, damals zusammen mit den Schwesterschiffen Vaterland und Bismarck das größte Schiff der Welt.

L'Imperator, all'epoca la più grande imbarcazione del mondo insieme alle navi sorelle Vaterland e Bismarck.

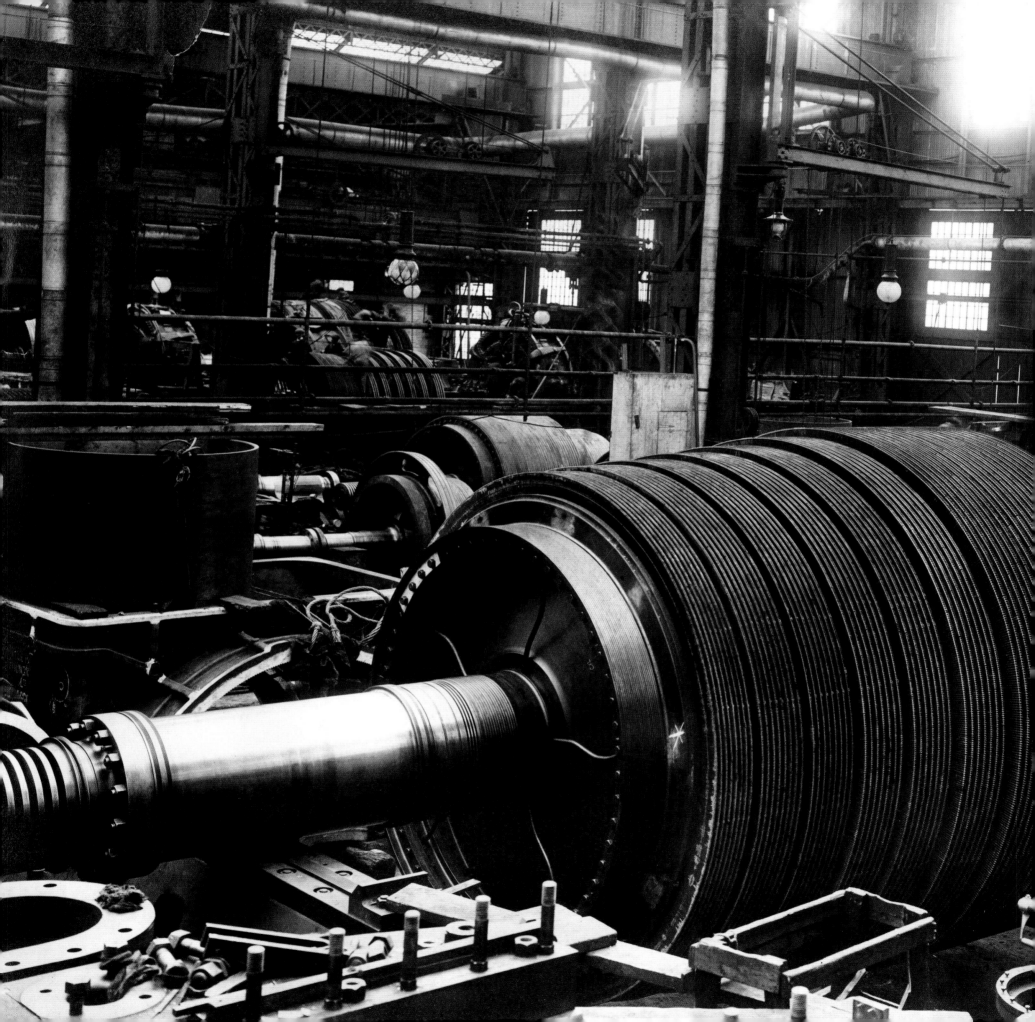

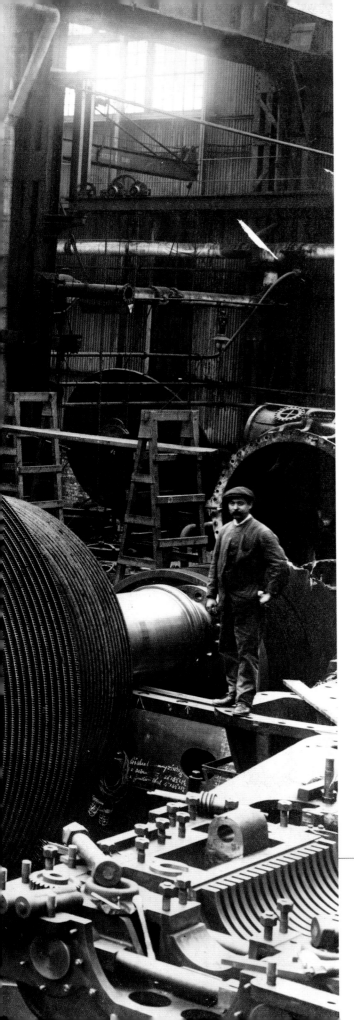

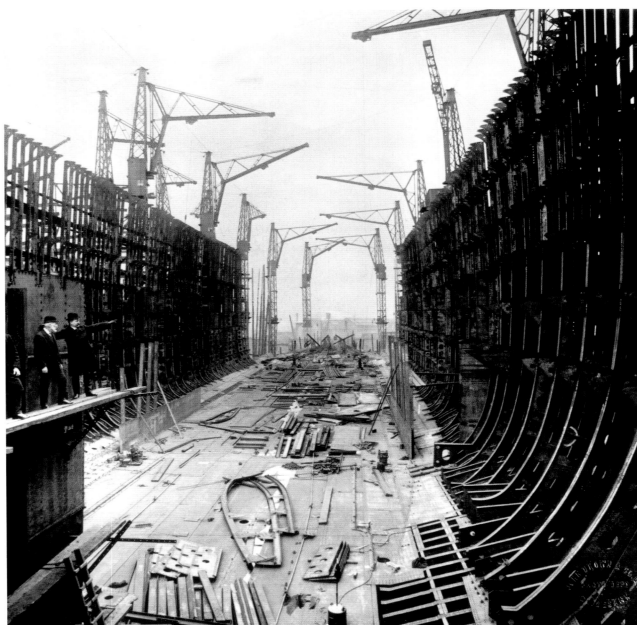

The Aquitania took three years to build and was launched in 1914.

Der Bau der Aquitania dauerte drei Jahre; 1914 wurde sie vom Stapel gelassen.

La costruzione della nave durò tre anni; il varo fu effettuato nel 1914.

The rotor for one of the giant steam turbines which will drive the Cunard liner Aquitania, currently under construction on Clydebank, 1912.

Das Schaufelrad für eine der gewaltigen Dampfturbinen, die den Cunard-Liner Aquitania antreiben werden. Hier noch im Bau in Clydebank, 1912.

La pala di una delle enormi turbine che saranno montate sul transatlantico Aquitania, della Cunard, ancora in construzione a Cladebank (1912).

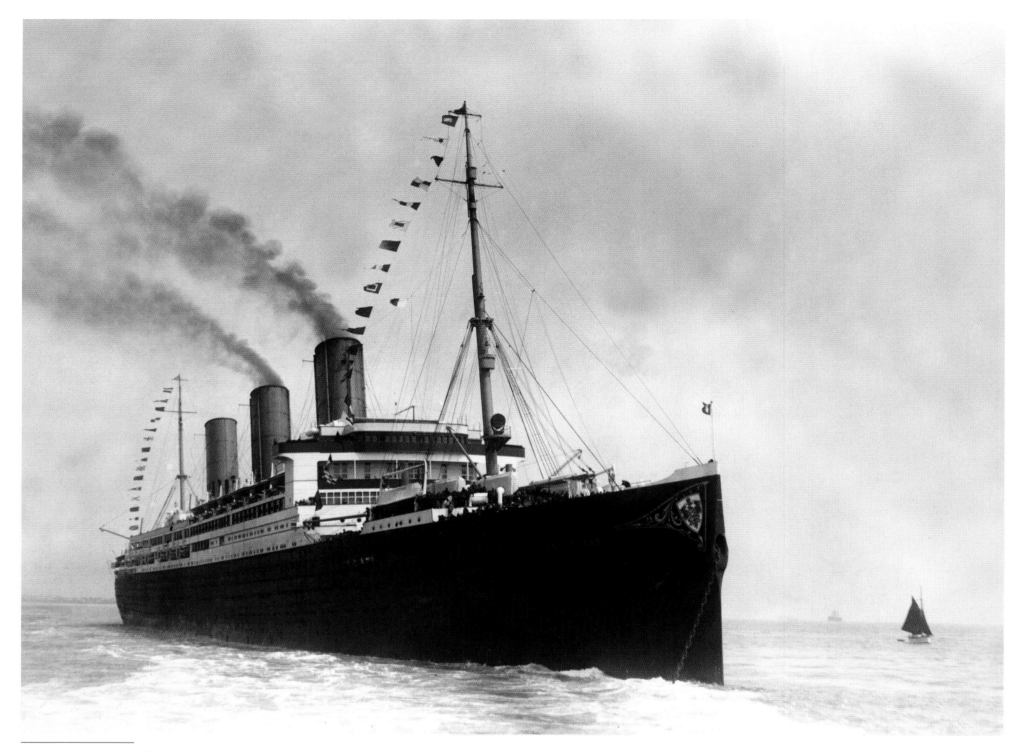

The Hamburg-America liner Vaterland leaving Southampton on her maiden voyage from Cuxhaven in Germany to New York. That same year, she was requisitioned by the US Navy and renamed Leviathan, 1914.

Die Vaterland der Hapag verlässt 1914 Southampton auf ihrer Jungfernfahrt von Cuxhaven nach New York. Noch im selben Jahr wurde sie von der US Army beschlagnahmt und in Leviathan umbenannt.

Il transatlantico Vaterland della Hapag lascia Southampton nel 1914, per la sua prima traversata da Cuxhaven a New York. Quello stesso anno sarà confiscato dall'esercito americano e ribattezzato Leviathan.

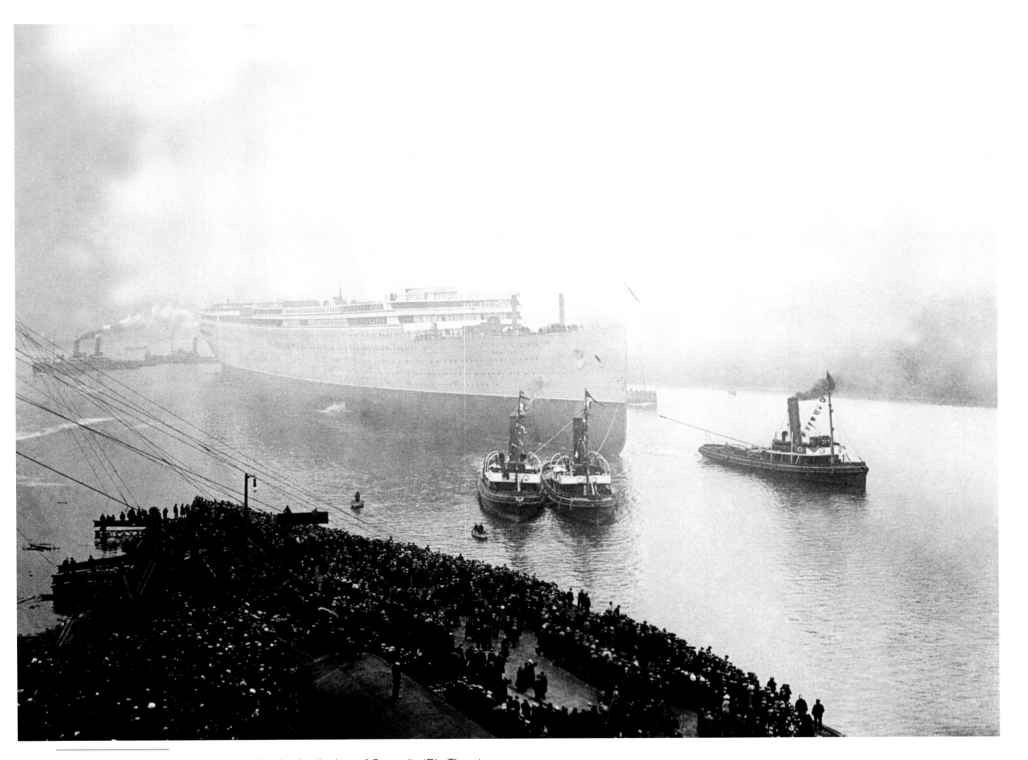

1914: The launch of the massive liner Aquitania, the last of Cunard's 'Big Three'.

1914: Stapellauf der majestätischen Aquitania, der letzten von Cunards ,Big Three'.

1914: il varo del maestoso Aquitania, l'ultimo dei tre colossi della Cunard Line.

The Britannic, last ship of White Star's 'Big Three'. She was put into military service from the beginning, 1914.

Die Britannic, das letzte Schiff des White Star-Trios, wurde von Anfang an in Kriegsdienst gestellt: Hier auf der Fahrt zum Umbau als Lazarettschiff, 1914.

La più giovane delle tre navi sorelle della White Star Line, il Britannic, venne subito adibita ad uso miliare. Qui è in viaggio per essere riconvertito in nave ospedale (1914).

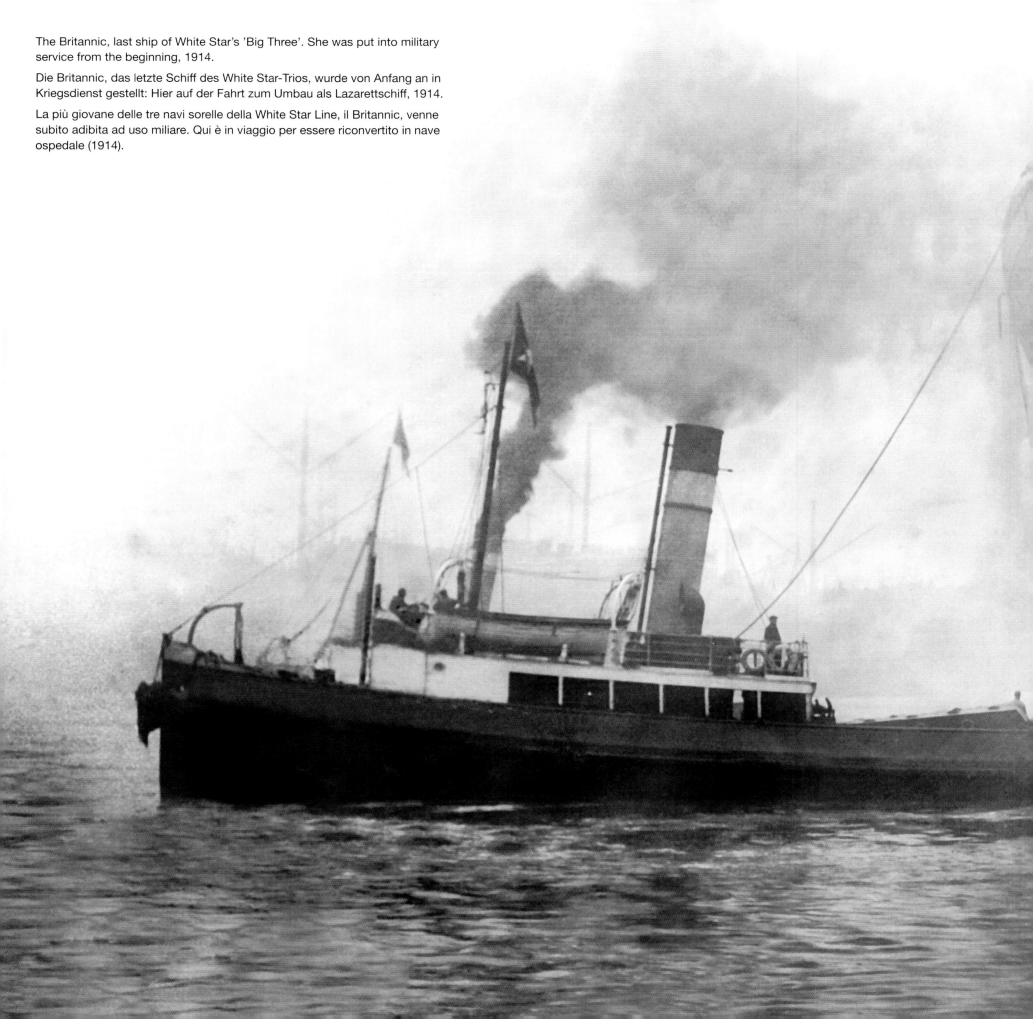

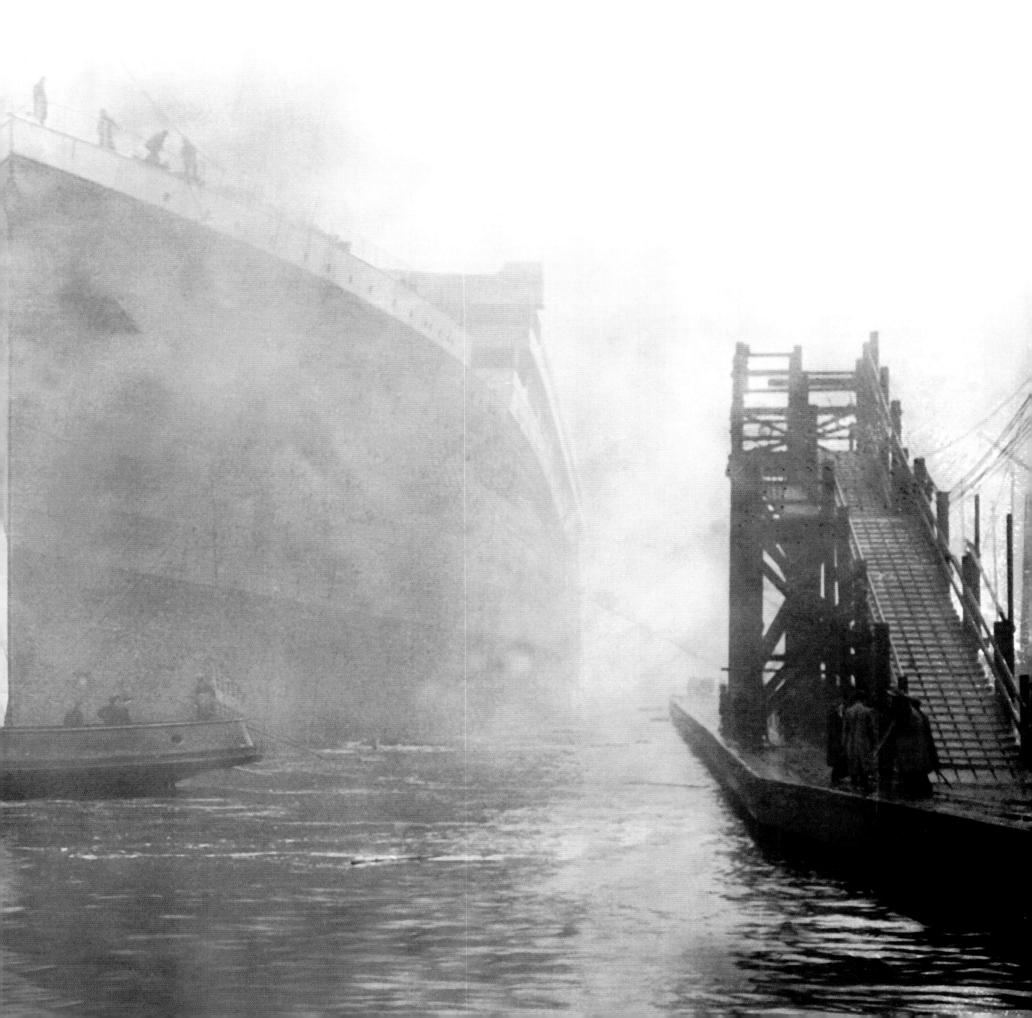

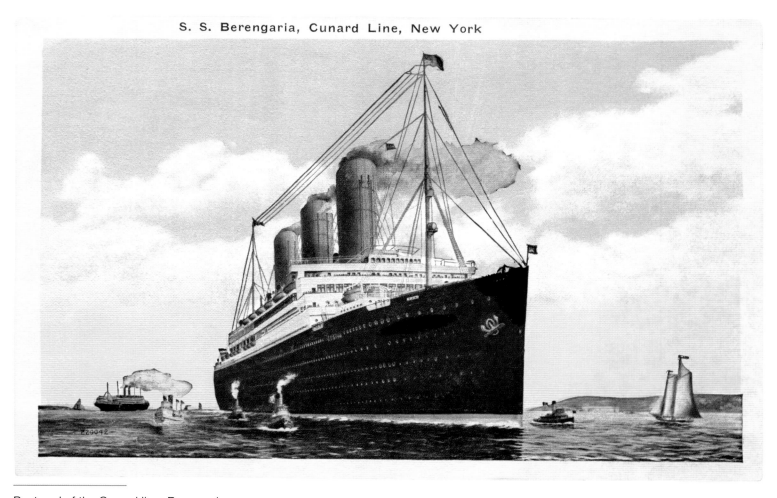

S. S. Berengaria, Cunard Line, New York

Postcard of the Cunard liner Berengaria.

Postkarte der Berengaria von Cunard.

Cartolina del Berengaria, della Cunard Line.

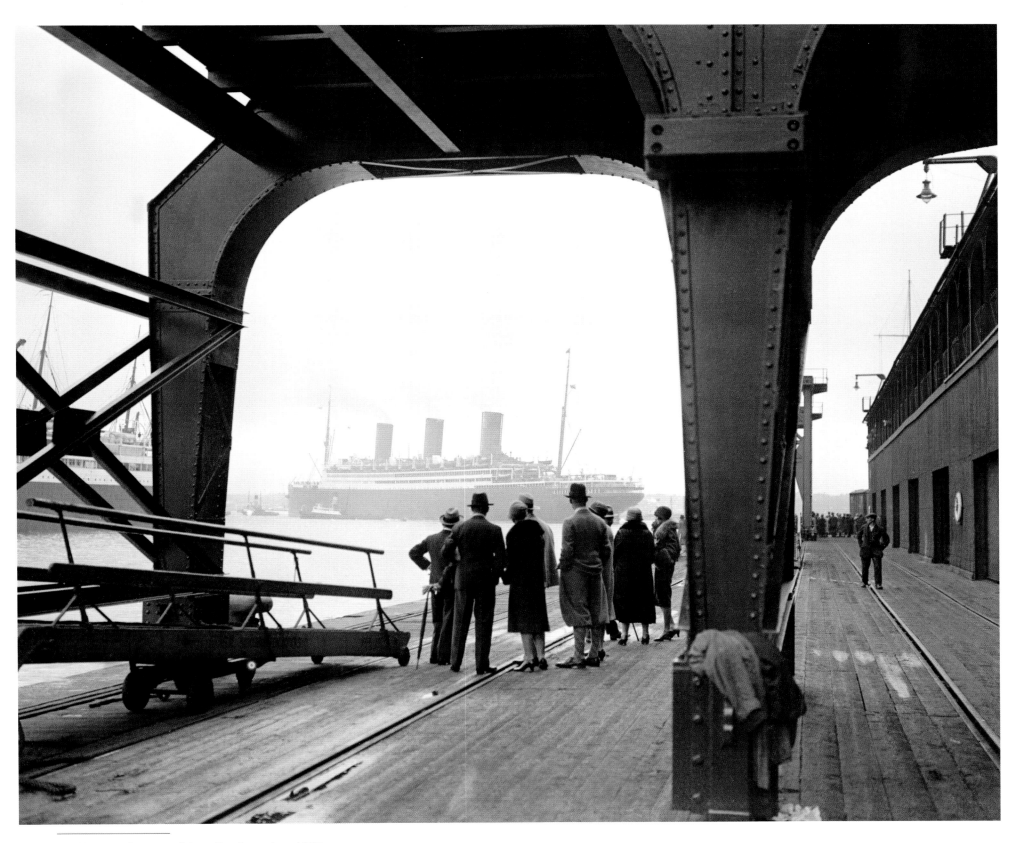

The Berengaria sets sail from Southampton, 1926.

Die Berengaria sticht 1926 vor Southampton in See.

Nel 1926 il Berengaria davanti a Southampton.

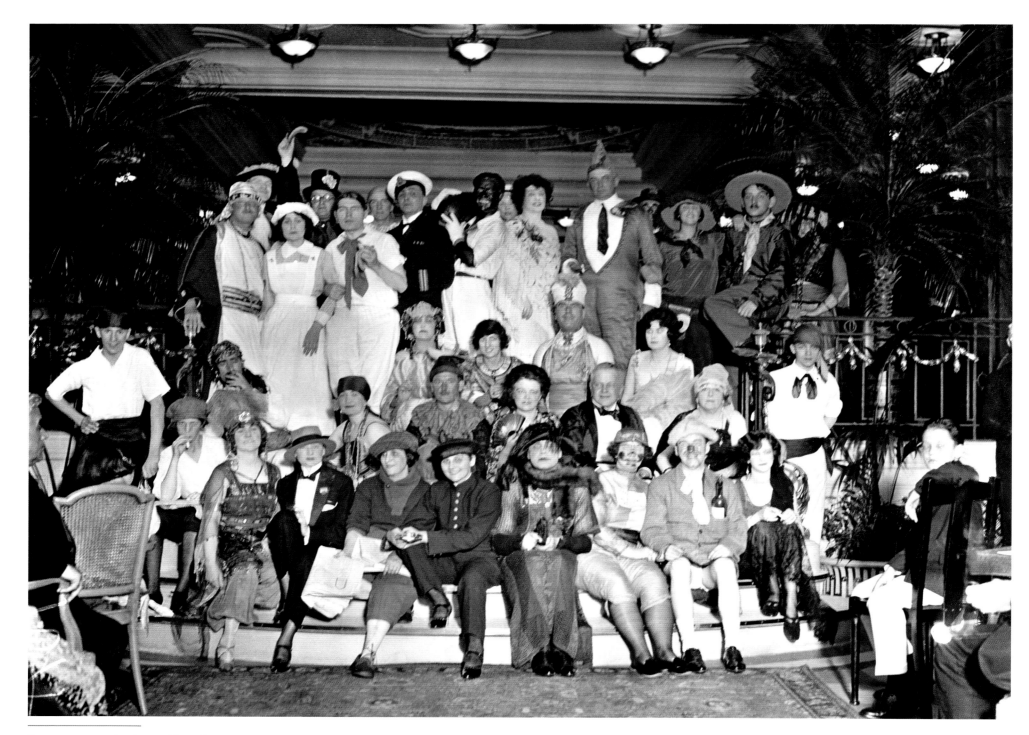

Passengers on the Cunard liner Berengaria display their various costumes
at a fancy dress party, 1923.

Passagiere der Berengaria präsentieren ihre vielfältigen Kostüme auf einem
Maskenball, 1923.

I passeggeri del Berengaria sfoggiano i loro variopinti costumi a un ballo in
maschera (1923).

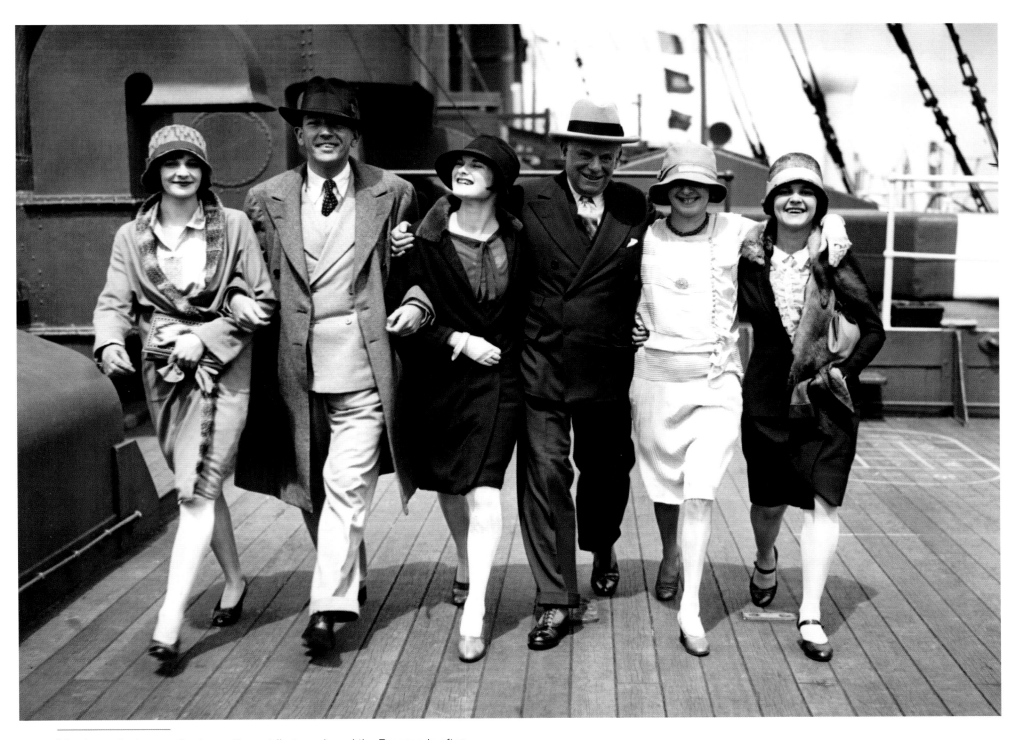

Members of a troupe of actors with contributors aboard the Berengaria after
a successful New York tour, July 1928.

Mitglieder einer Schauspieltruppe und Kollegen an Bord der Berengaria nach
einer erfolgreichen New York-Tournee im Juli 1928.

I membri di una compagnia teatrale e alcuni colleghi a bordo del Berengaria
dopo una fortunata tournée a New York, nel luglio del 1928.

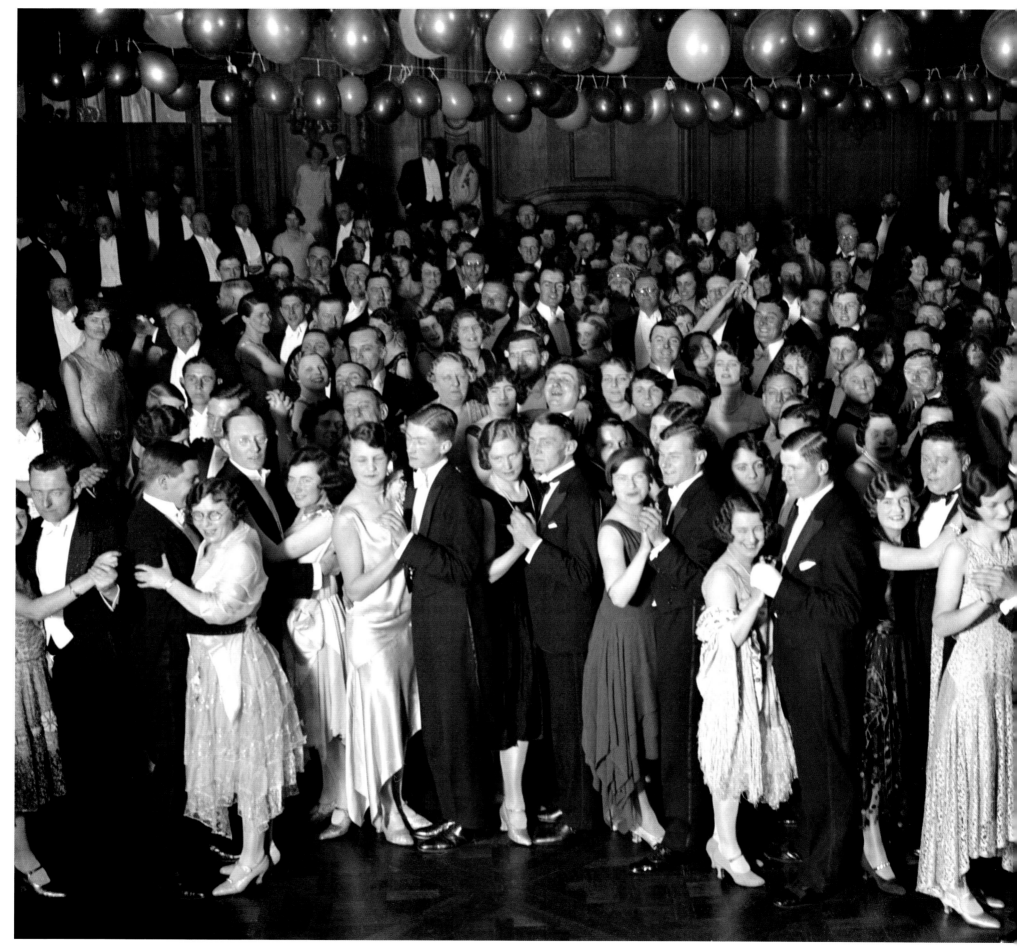

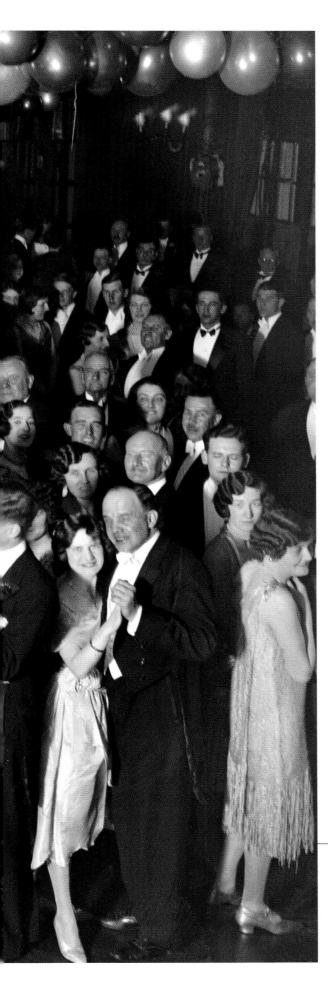

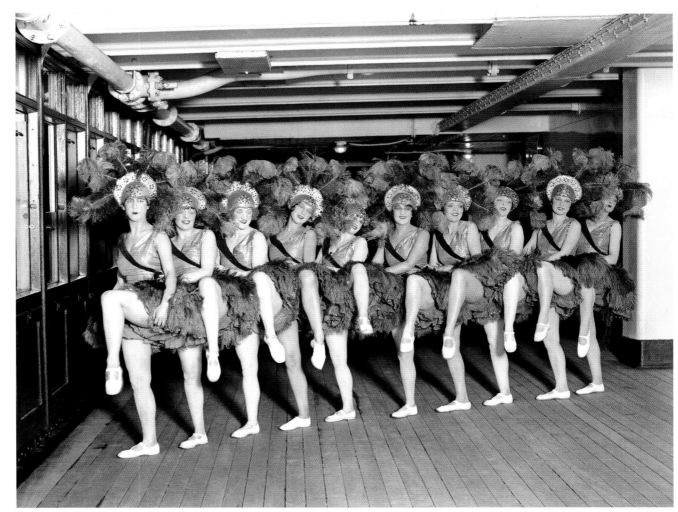

Members of a dancing chorus in the context of a charity performance aboard the Berengaria.

Mitglieder einer Tanztruppe im Rahmen einer Wohltätigkeitsveranstaltung an Bord der Berengaria.

Membri di una compagnia di danzatori in occasione di uno spettacolo di beneficenza sul Berengaria.

Guests dancing in the ballroom aboard Cunard liner Berengaria at Southampton Docks. They are attending a dance and cabaret to raise funds for charity, 1929.

Wohltätigkeitsveranstaltung mit Tanz und Kabarett im Ballsaal der Berengaria, die in Southampton vor Anker liegt, 1929.

Ballo durante uno spettacolo di beneficenza con musica e cabaret nel salone del Berengaria, ancorato a Southampton (1929).

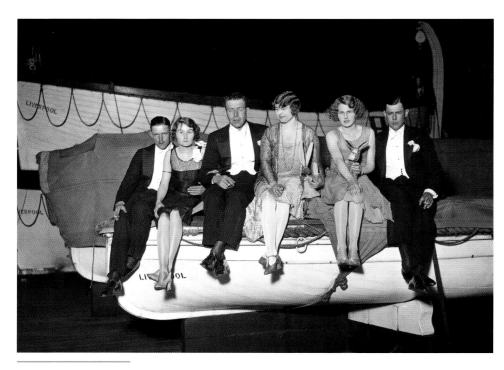

April 1929: Guests sitting on a lifeboat during a dance aboard Cunard liner Berengaria, docked at Southampton. The function is to raise funds for Southampton Children's Hospital.

Gäste pausieren während eines Balls auf der Berengaria in Southampton in einem Rettungsboot, April 1929. Der Ball wurde zu Gunsten des Kinderkrankenhauses Southampton organisiert.

Alcuni passeggeri sono seduti in una scialuppa di salvataggio durante il ballo organizzato sul Berengaria nell'aprile del 1929 per raccogliere fondi a favore dell'Ospedale per bambini di Southampton.

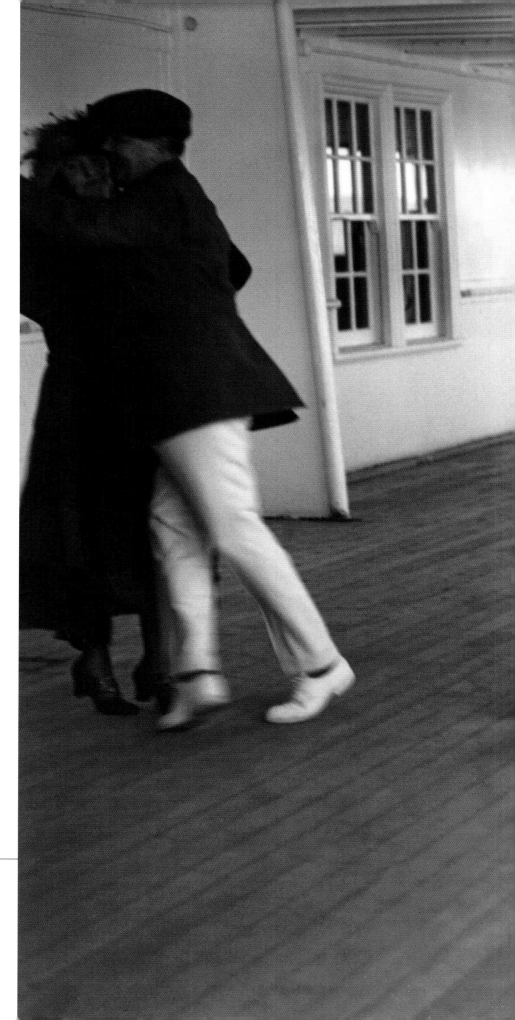

Passengers dancing on the promenade around the deck of the Cunard liner Aquitania upon her arrival at dock.

Passagiere beim Tanz auf dem Promenadendeck des Cunard-Liners Aquitania anlässlich ihrer Ankunft im Hafen.

I passeggeri ballano sul ponte di passeggiata del transatlantico della Cunard Aquitania, al suo arrivo in porto.

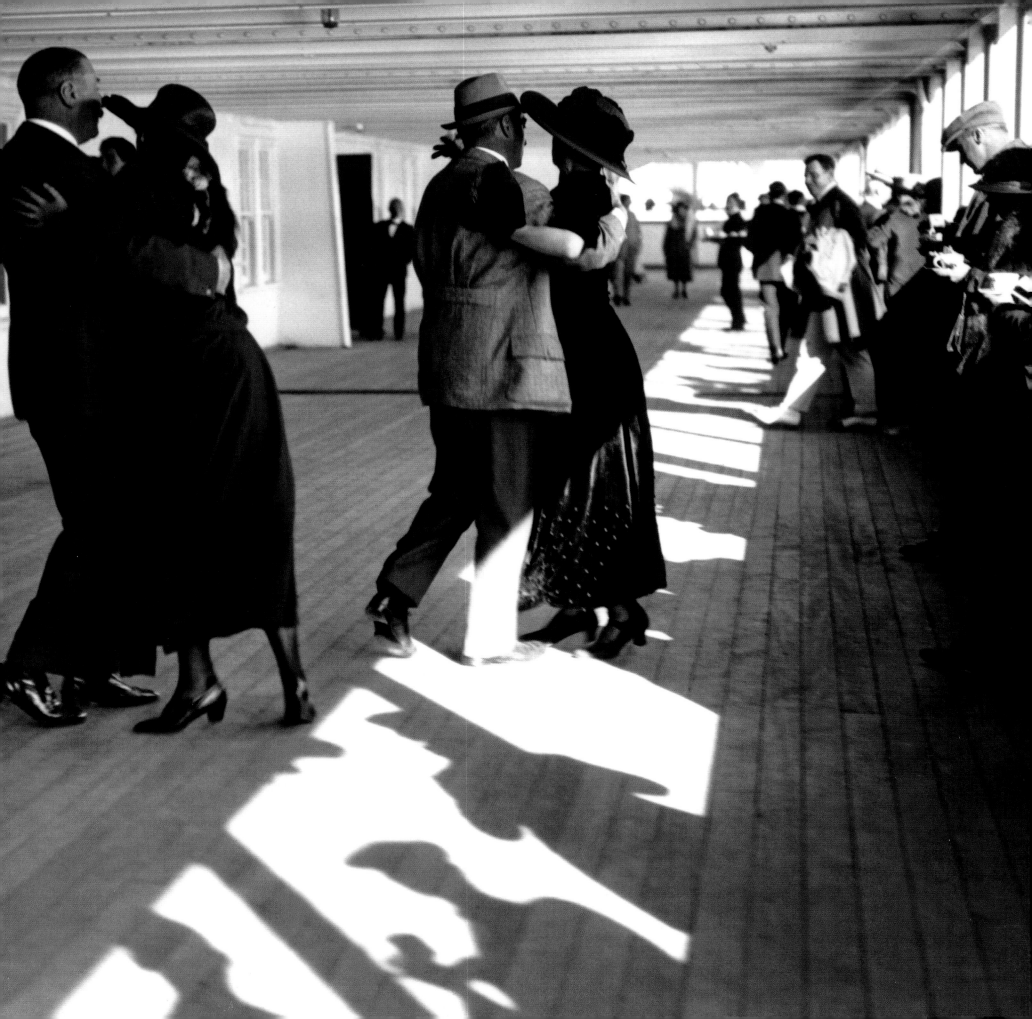

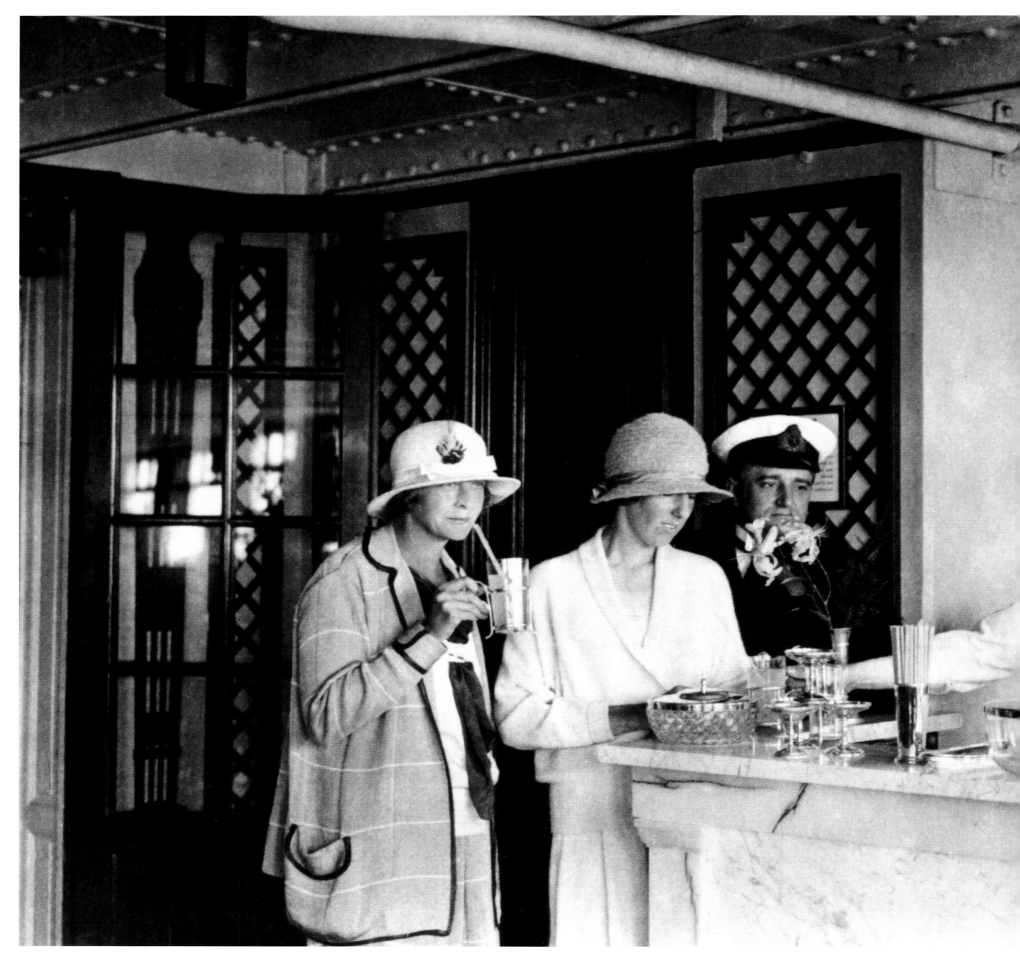

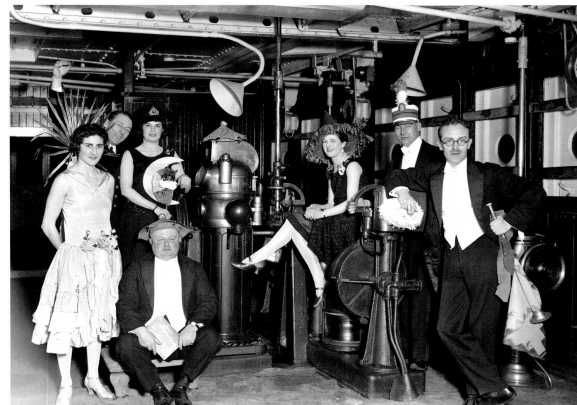

Partygoers visit the bridge of the Cunard liner Aquitania during a masked ball in Southampton, 1927.

Partygänger besuchen die Brücke der Aquitania während eines Maskenballs in Southampton, 1927.

Gli invitati a un ballo in maschera visitano il ponte dell Aquitania a Southampton (1927).

A barman serves drinks at the soda fountain on board the Cunard liner Aquitania, 1923.

Ein Barkeeper serviert an der Eisbar der Aquitania Erfrischungen, 1923.

Un barista al banco gelati serve delle bibite a bordo dell'Aquitania (1923).

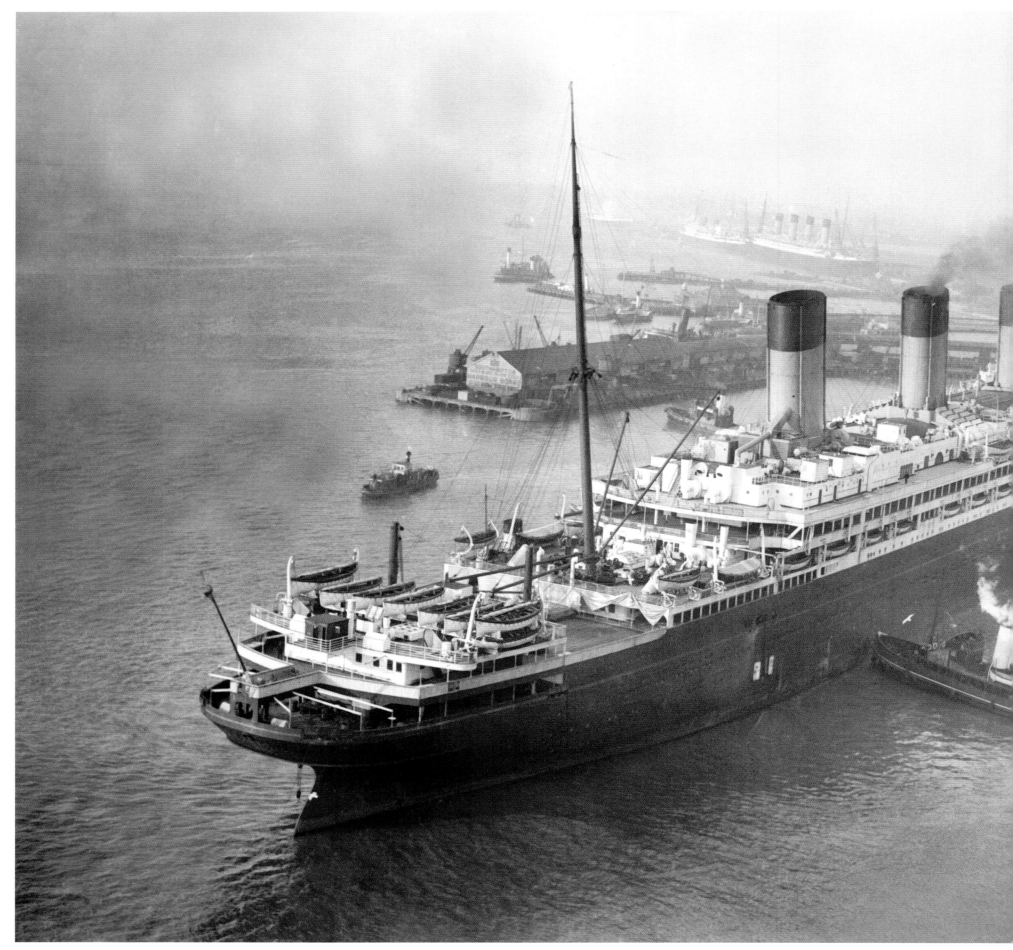

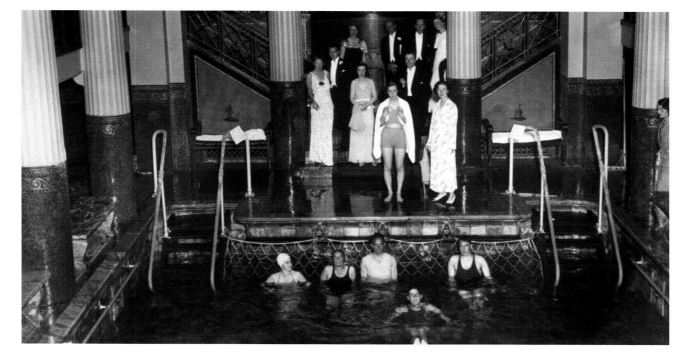

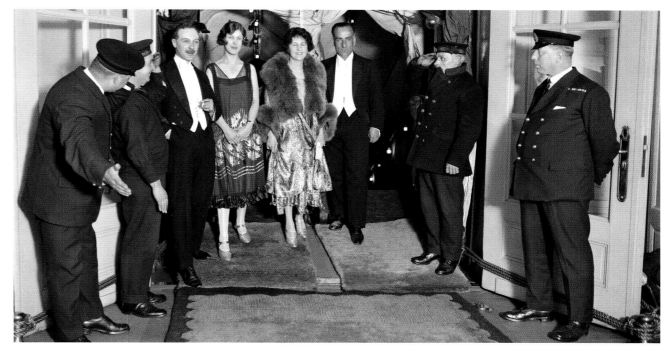

High society people come aboard the Majestic in Southampton Port, April 1926.

Feine Gesellschaft an Bord der Majestic im Hafen von Southampton, April 1926.

Eleganti ospiti salgono a bordo del Majestic nel porto di Southampton (aprile 1926).

January 16th 1933: White Star liner Majestic being manoeuvred into dry dock in Southampton for her annual overhaul.

16. Januar 1933: Der White Star Liner Majestic wird in Southampton für seine jährliche Überholung ins Trockendock manövriert.

16 gennaio 1933: il transatlantico della White Star Line Majestic viene portato nel bacino di carenaggio di Southampton per la revisione annuale.

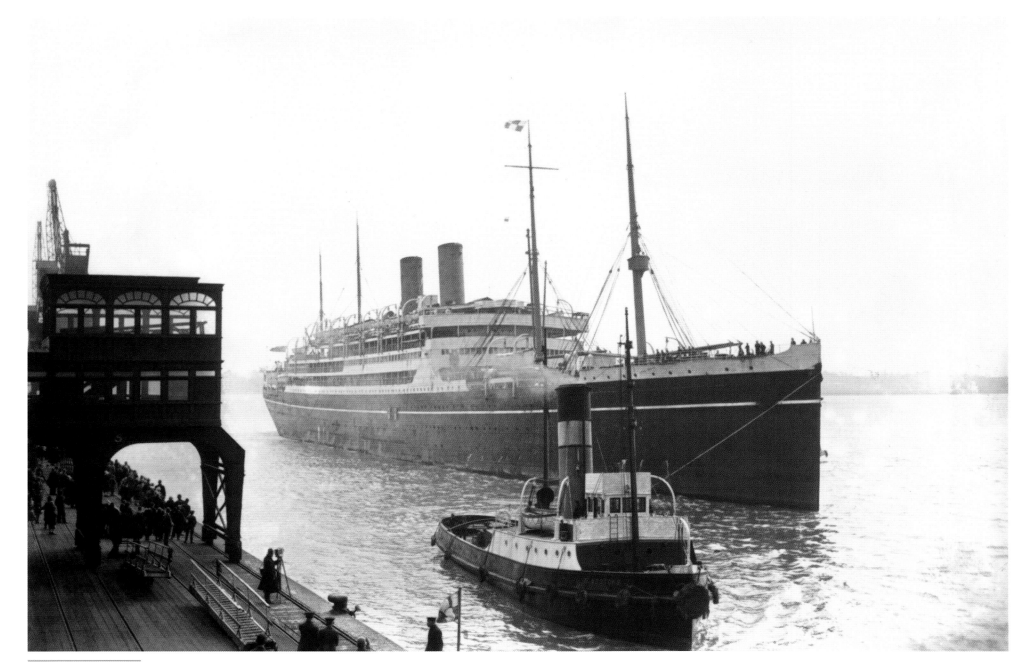

The Canadian Pacific liner Empress of Scotland (captured Hamburg America liner Kaiserin Auguste Victoria) returns to Southampton at the end of a round-the-world cruise, 1926.

Der Canadian Pacific Liner Empress of Scotland fuhr vorher als Kaiserin Auguste Victoria für die Hapag und war als persönliches Triumphschiff des Kaisers geplant. Hier kehrt das Schiff nach einer Weltumrundung nach Southampton zurück, 1926.

Il transatlantico della Canadian Pacific Line Empress of Scotland un tempo faceva parte della flotta Hapag con il nome di Kaiserin Auguste Victoria ed era stato progettato come nave personale dell'imperatore. Qui rientra a Southampton al termine di un giro del mondo (1926).

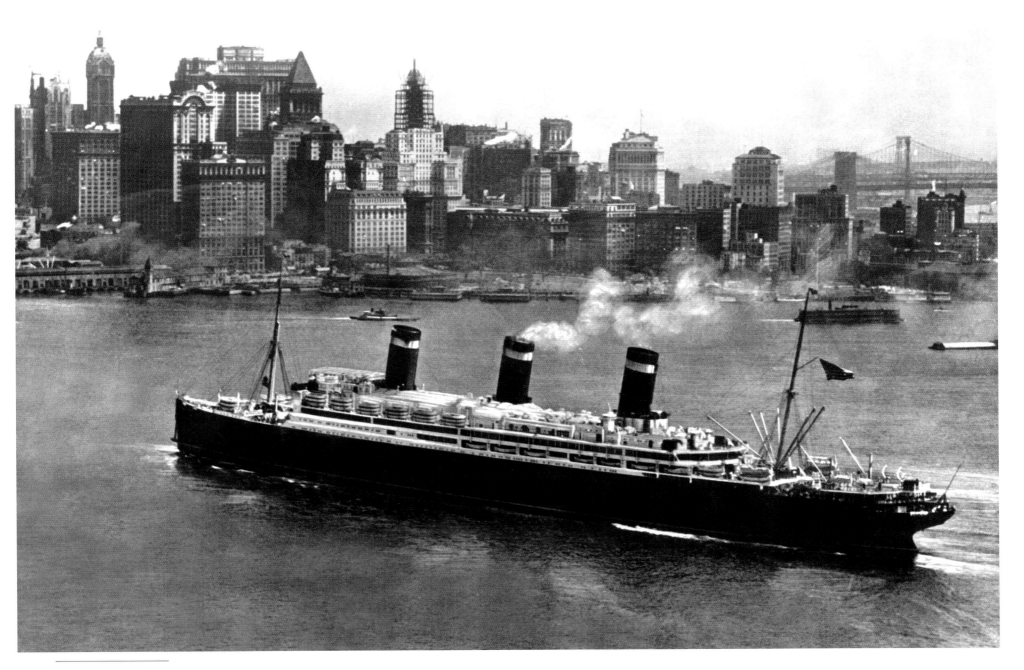

The USS Leviathan, a former vessel of the Hamburg-American Line steams into New York Harbour. Originally named Vaterland, she was seized by the US Government in New York during World War I and renamed, 1925.

Die USS Leviathan, ein ehemaliges Schiff der Hapag, läuft in den Hafen von New York ein. Ursprünglich trug sie den Namen Vaterland, wurde jedoch während des Ersten Weltkrieges von der US-Regierung beschlagnahmt und umgetauft, 1925.

L'USS Leviathan, in precedenza della compagnia Hapag, arriva nel porto di New York. Il suo nome originario era Vaterland, ma durante la Prima guerra mondiale fu requisito dal governo americano e ribattezzato (1925).

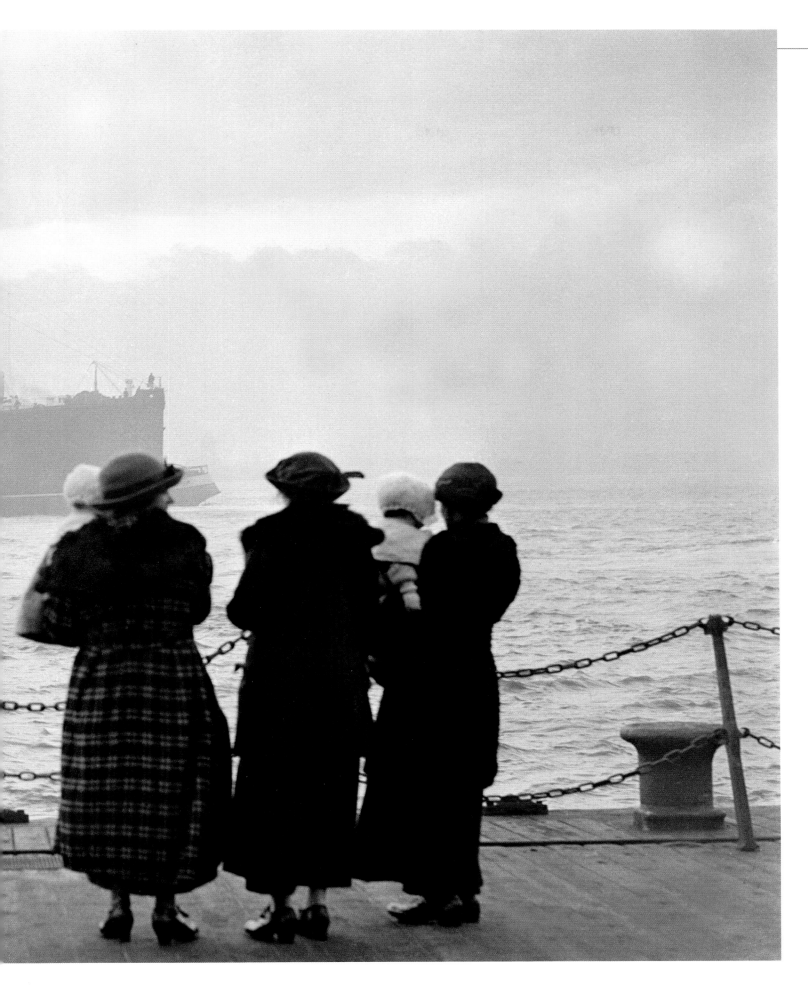

Three ladies watch the second Cunard liner to be named Laconia leaving Liverpool on a transatlantic voyage to New York, 1922.

Drei Frauen beobachten den zweiten Cunard-Liner Laconia, der gerade Liverpool verlässt und die Transatlantikfahrt nach New York antritt, 1922.

Tre donne osservano il secondo transatlantico della Cunard Line, il Laconia, che nel 1922 lascia il porto di Liverpool inziando la traversata per New York.

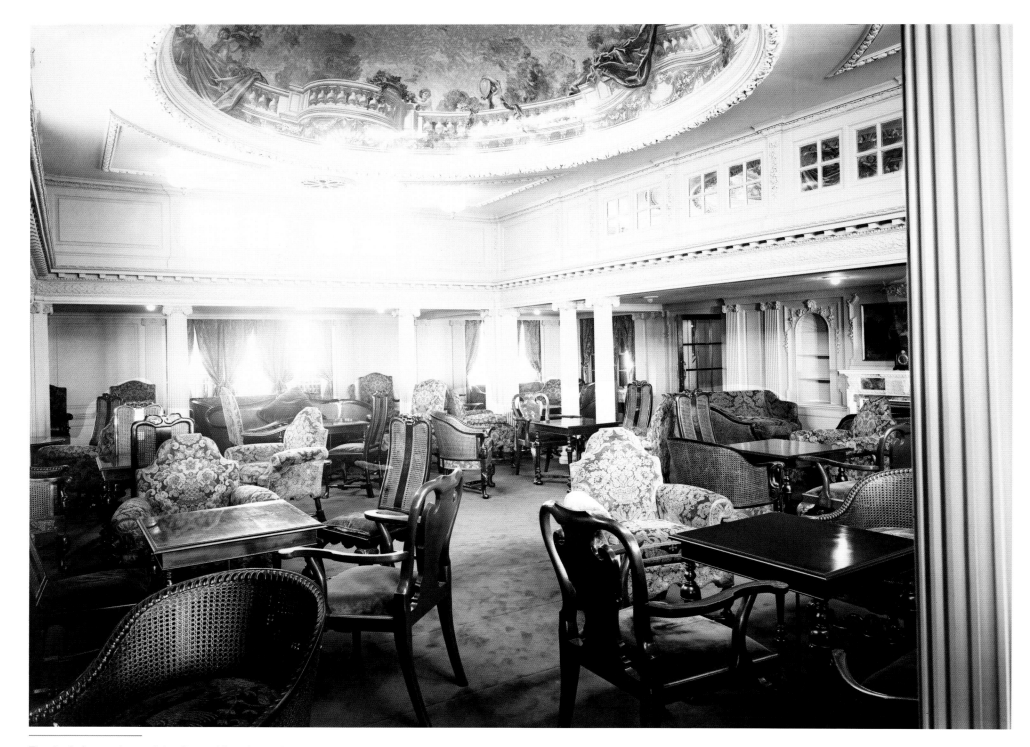

The 2nd class saloon of the Cunard liner Laconia, with a painted ceiling and pillared colonnade, 1921.

Der mit Säulen und Deckenbemalung geschmückte Salon der Zweiten Klasse an Bord der Laconia, 1921.

Il salone di seconda classe del Laconia, con colonne e soffitti decorati (1921).

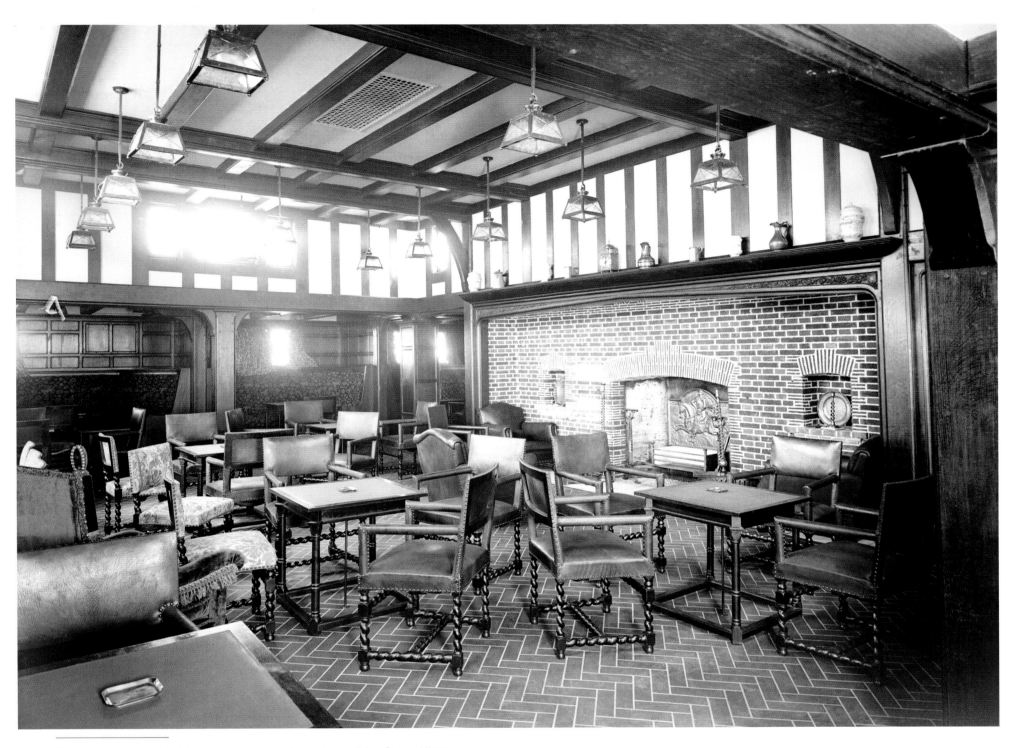

The luxurious wood-finished 1st class smoking saloon of the Cunard liner
Laconia, 1921.

Der luxuriöse holzvertäfelte Rauchsalon der Ersten Klasse an Bord der
Laconia, 1921.

La lussuosa sala fumatori del Laconia rivestita in legno nella prima classe (1921).

Cunard Liner Caronia, which was launched in 1905, in Alexandria Port, March 1921.

Cunards Kreuzfahrtschiff Caronia, das 1905 vom Stapel gelassen wurde.
Hier im Hafen von Alexandria, im März 1921.

La Caronia, nave da crociera della Cunard Line varata nel 1905, nel porto
di Alessandria d´Egitto (marzo 1921).

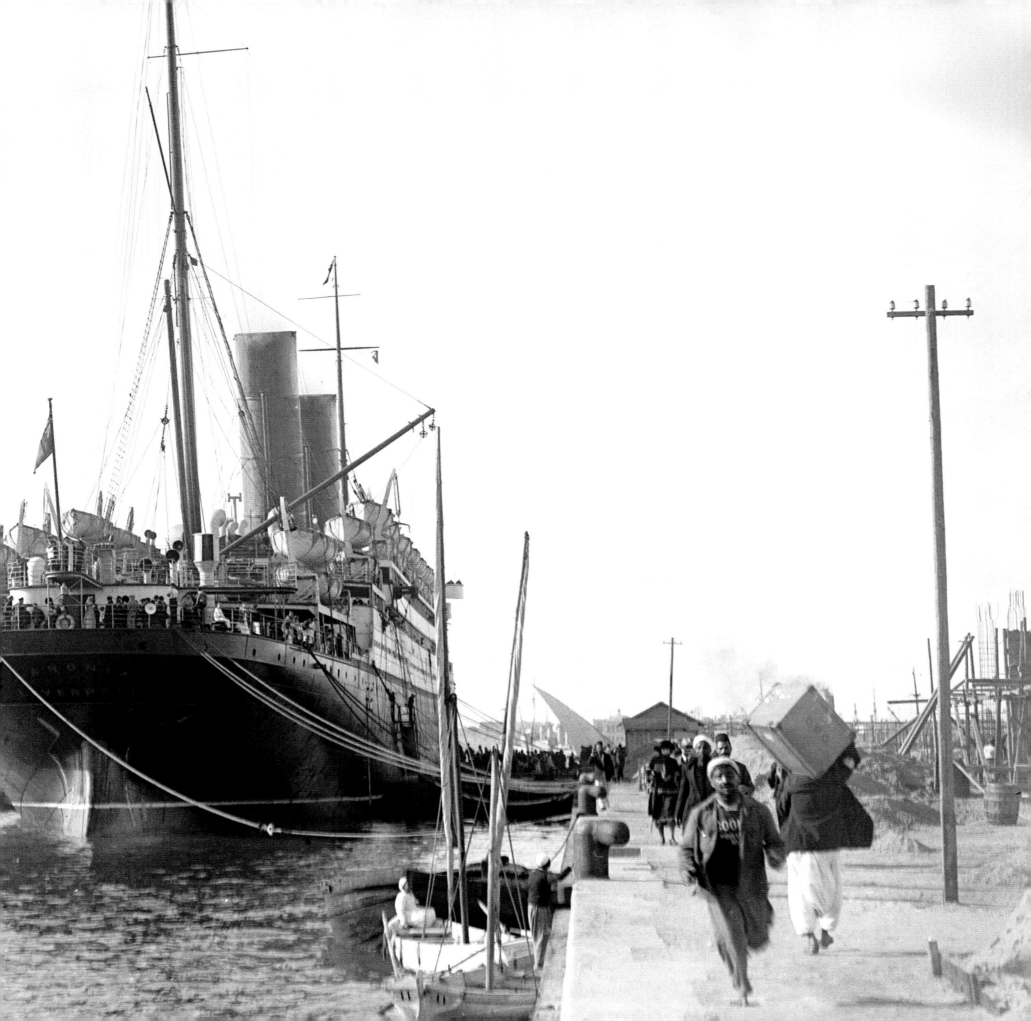

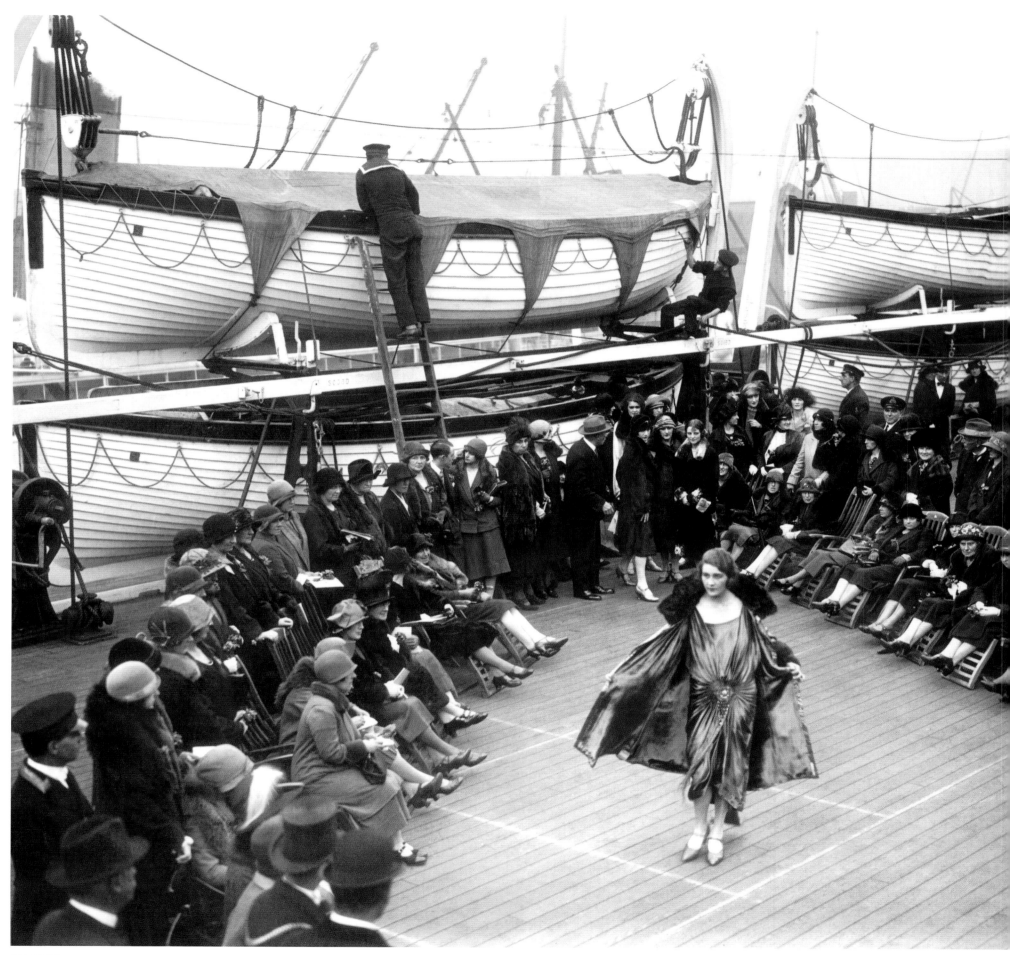

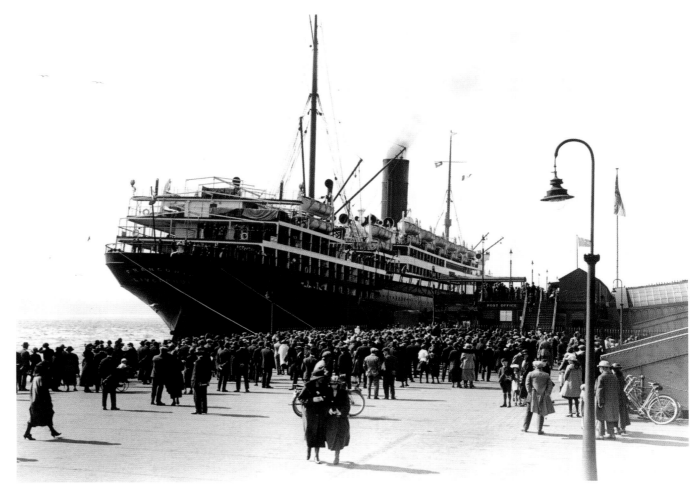

The Franconia in Liverpool Port, 1923.

Die Franconia im Hafen von Liverpool, 1923.

Il Franconia nel porto di Liverpool (1923).

A catwalk parade held aboard the Cunard liner Franconia
during Liverpool's Civic Week, 1925.

Modenschau an Bord des Cunard-Liners Franconia im
Rahmen der Civic Week in Liverpool, 1925.

Sfilata di moda a bordo del transatlantico Franconia della Cunard
in occasione della Civic Week a Liverpool (1925).

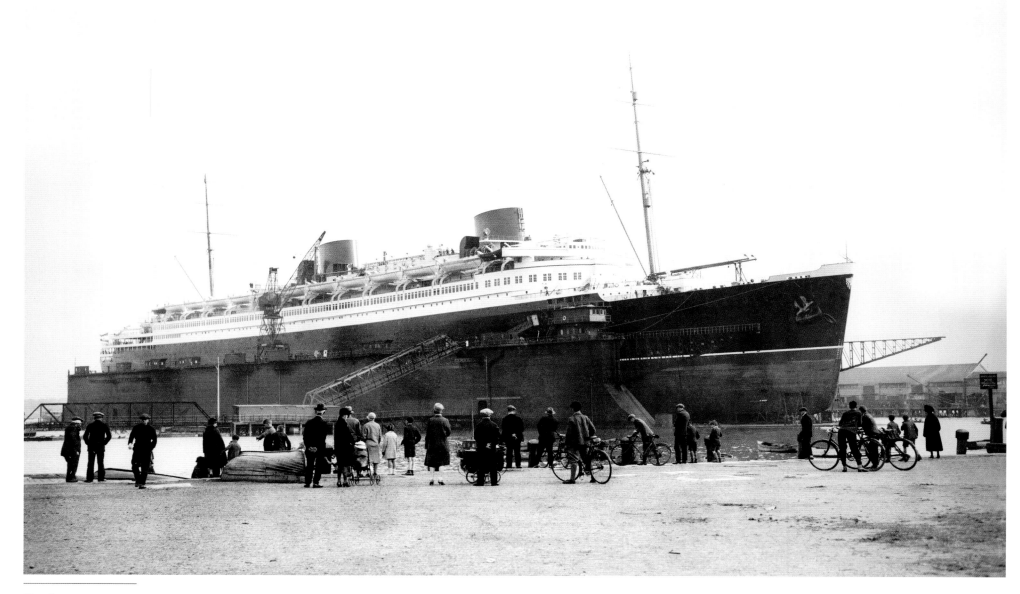

The German ocean liner Bremen in dock, 1929. In 1935, a group of anti-Nazi protesters stormed aboard the Bremen in New York Harbour, tore down its Swastika and threw it into the Hudson River.

Der deutsche Ocean-Liner Bremen im Dock, 1929. 1935 stürmten einige Anti-Nazi-Protestler im New Yorker Hafen die Decks der Bremen, rissen das Hakenkreuz herunter und warfen es in den Hudson River.

Il transatlantico tedesco Bremen (1929). Nel 1935 alcuni manifestanti anti-nazisti invasero i ponti della nave ancorata nel porto di New York, strapparono la croce uncinata e la gettarono nel fiume Hudson.

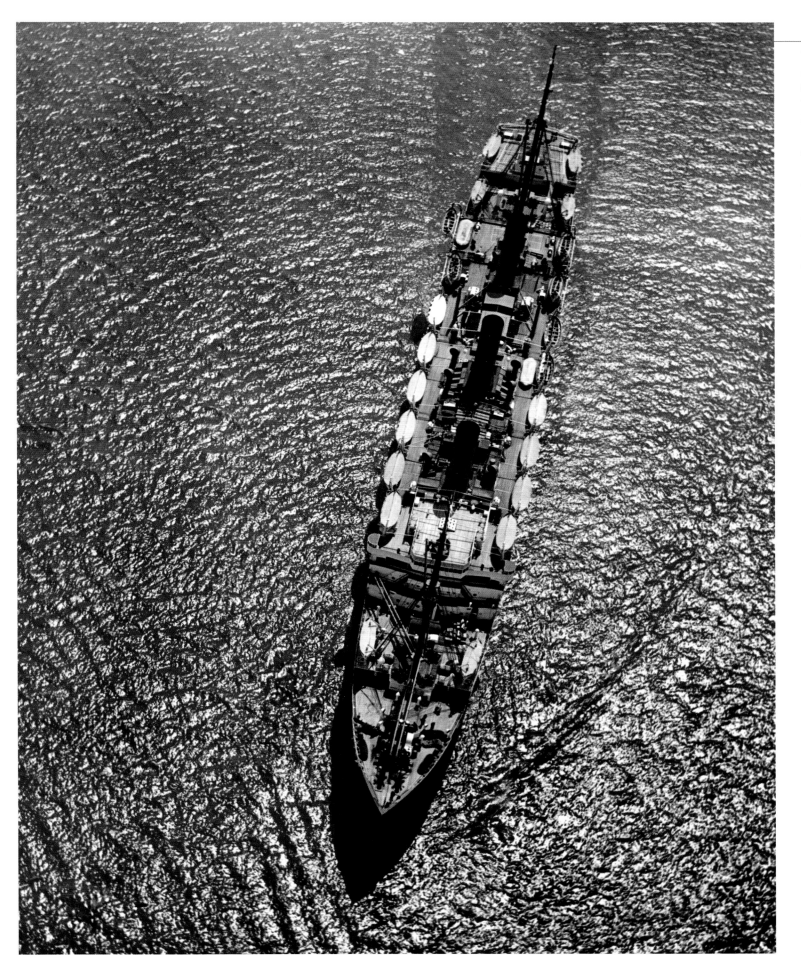

The Canadian Pacific ocean liner Empress of Australia off shore at Southampton. She was built as the Hamburg America liner Tirpitz, planned 1928.

Die Empress of Australia der Canadian Pacific Line vor Southampton. Erbaut wurde sie ursprünglich für die Hapag als Tirpitz, geplant 1928.

La Empress of Australia della Canadian Pacific Line davanti a Southampton. In origine era stata progettata per la compagnia Hapag, con il nome di Tirpitz (1928).

SWIMMING LUXURY HOTELS

OPULENCE ON THE SEVEN SEAS

✦ ✦ ✦ ✦

SCHWIMMENDE GRAND HOTELS

OPULENZ AUF DEN WELTMEEREN

✦ ✦ ✦ ✦

GRANDI ALBERGHI GALLEGGIANTI

LUSSO SUGLI OCEANI

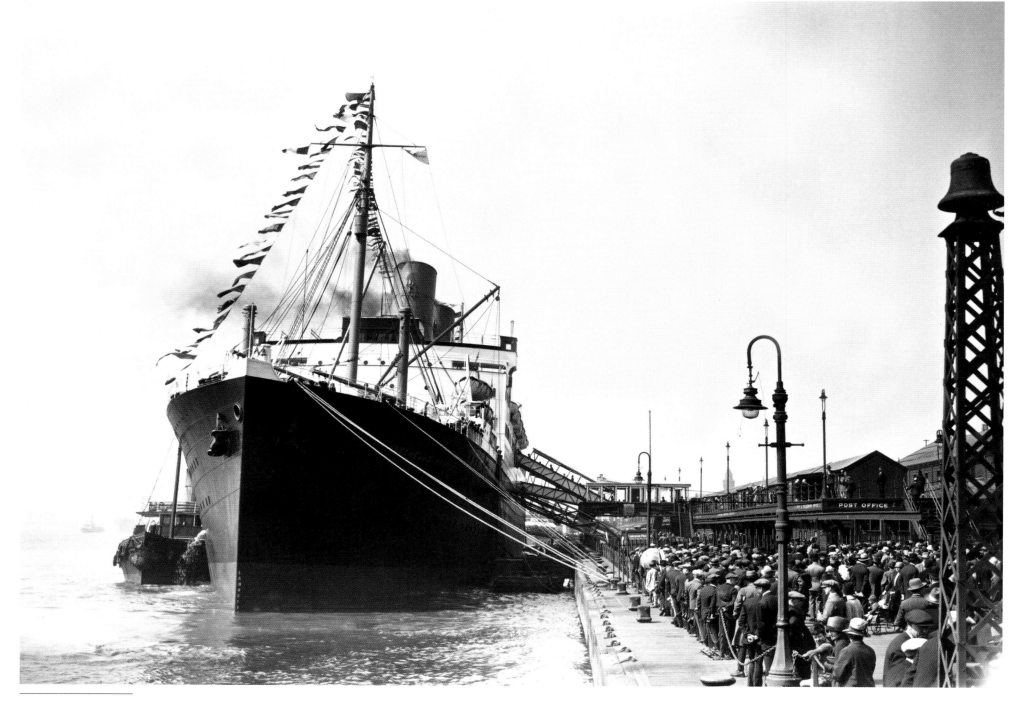

January 16th 1933: White Star liner Majestic being manoeuvred into dry dock
in Southampton for her annual overhaul.

16. Januar 1933: Die Majestic der White Star Line wird für ihre jährliche Überholung
in Southampton ins Trockendock befördert.

16 gennaio 1933: il Majestic della White Star Line viene portato nel bacino di
carenaggio di Southampton per la revisione annuale.

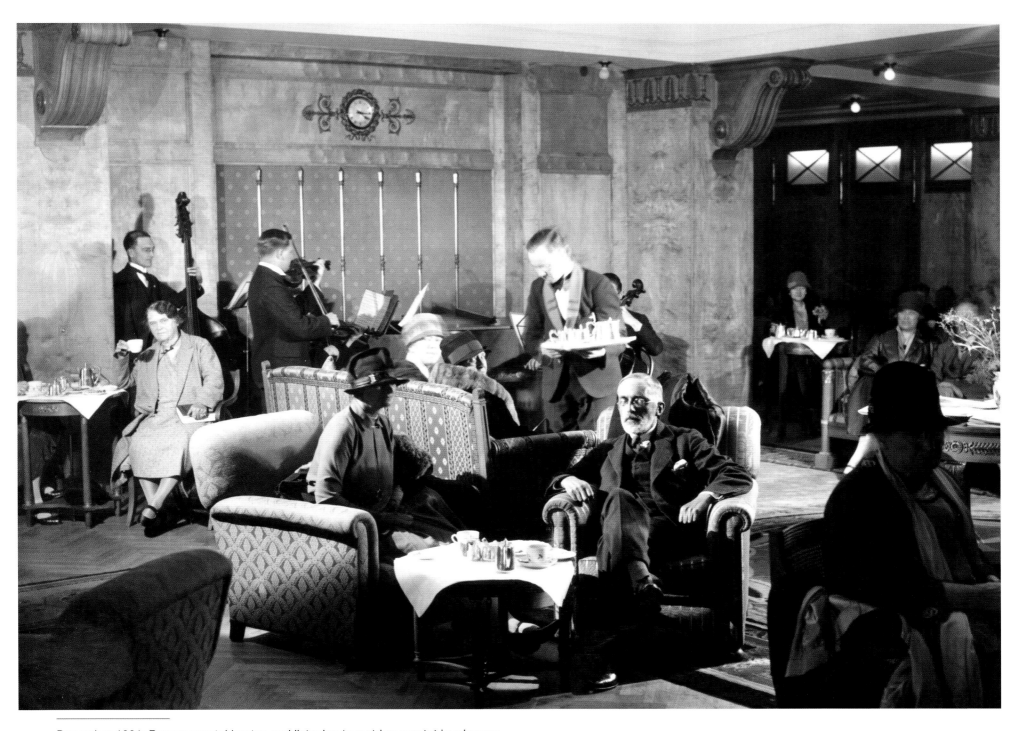

December 1931: Passengers taking tea and listening to a string quartet in a lounge of the Canadian Pacific liner Duchess of Bedford during a transatlantic voyage.

Passagiere an Bord des Canadian Pacific Liners Duchess of Bedford lauschen beim Tee im Salon den Klängen eines Streichquartetts, Dezember 1931.

I passeggeri ascoltano la musica di un quartetto d'archi all'ora del tè nel salone principale del transatlantico Duchess of Bedford della Canadian Pacific Line (dicembre 1931).

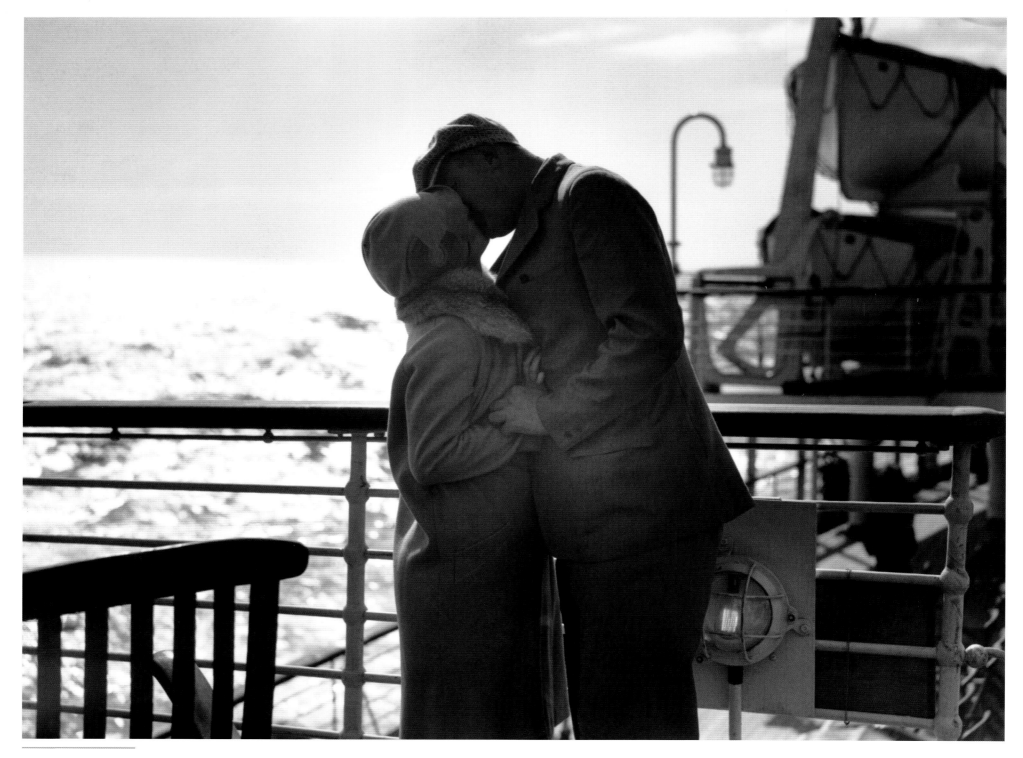

December 1931: A couple enjoying a romantic moment out on the deck
of the Duchess of Bedford during a transatlantic voyage.

Ein Liebespaar genießt im Dezember 1931 einen romantischen Augenblick
auf dem Außendeck der Duchess of Bedford.

Il romantico panorama avvolge una coppia sul ponte esterno della Duchess
of Bedford (dicembre 1931).

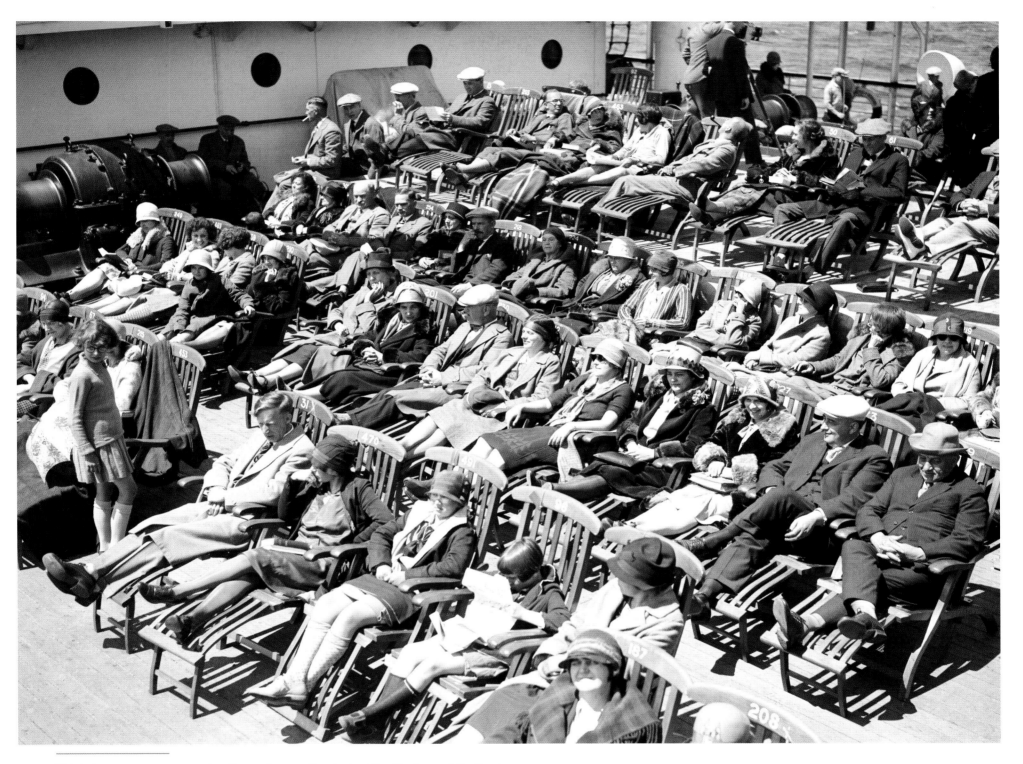

Third class passengers sunning themselves on the deck of the Duchess of Bedford during a transatlantic voyage.

Passagiere der Dritten Klasse sonnen sich an Deck der Duchess of Bedford während einer Transatlantikfahrt.

I passeggeri della terza classe prendono il sole sul ponte della Duchess of Bedford durante la traversata.

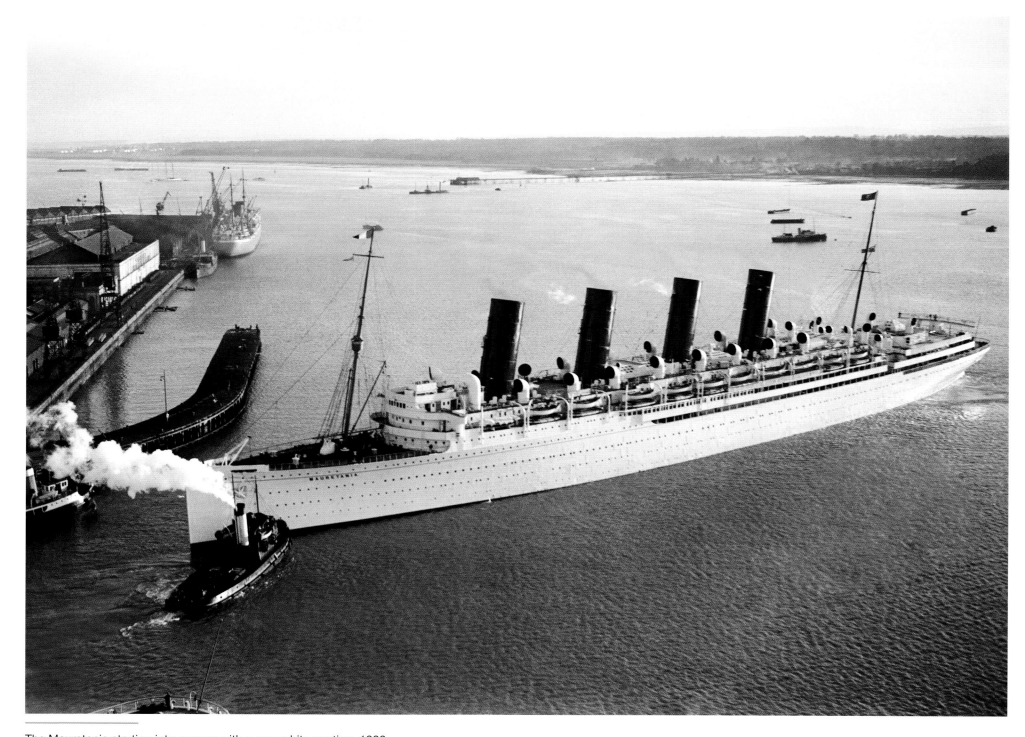

The Mauretania starting into season with a new white coating, 1933.

Die Mauretania startet mit ihrem neuen weißen Anstrich in die Saison, 1933.

Il Mauretania inizia la stagione con la sua nuova verniciatura bianca (1933).

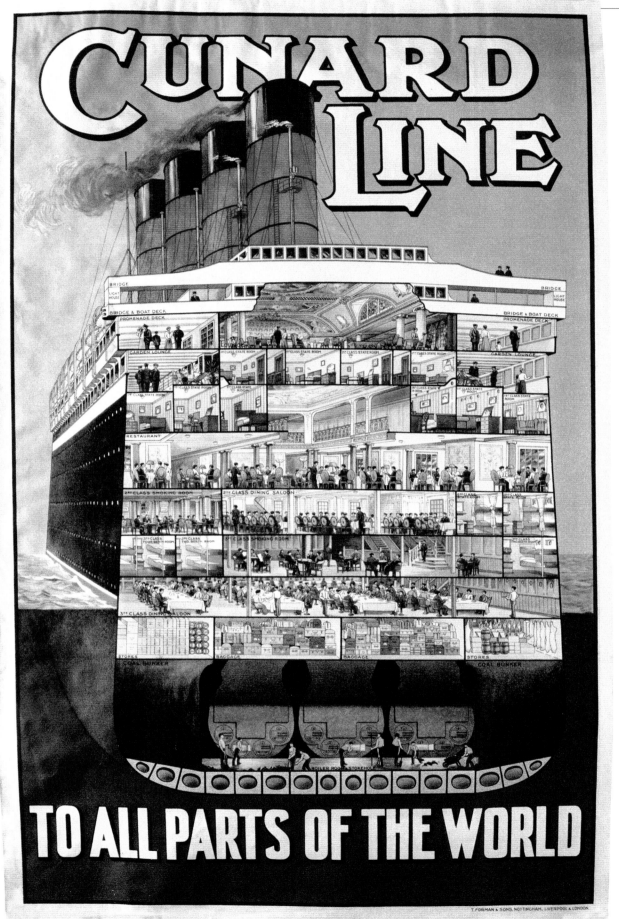

Poster advertising the Cunard Line.

Werbeplakat von Cunard.

Manifesto della Cunard.

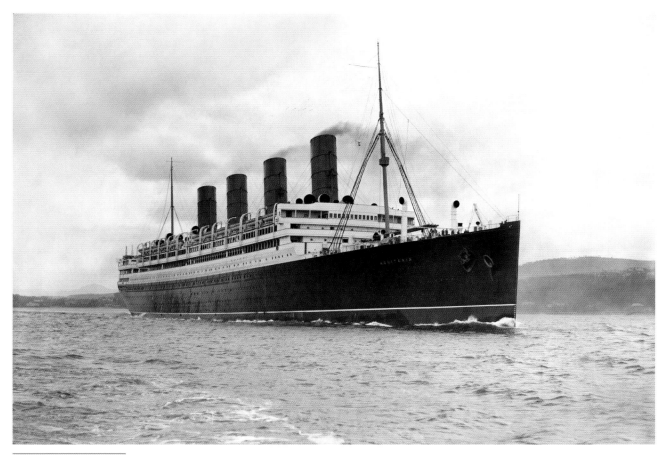

June 11th 1932: The giant liner SS Aquitania at sea.

11. Juni 1932: Der Ozeanriese SS Aquitania auf See.

11 giugno 1932: il transatlantico SS Aquitania durante la navigazione.

Admiral of the Fleet Sir Roger John Brownlow Keyes, 1st Baron Keyes, and Lady Keyes at a table with the ship's captain Captain Gibbons on board the Aquitania during a voyage from America to England, 1934.

Flottenadmiral Sir Roger John Brownlow Keyes, Erster Baron von Keyes und Lady Keyes sitzen an Bord der Aquitania zu Tisch mit dem Schiffskapitän Captain Gibbons, 1934.

L'ammiraglio della flotta sir Roger John Brownlow Keyes, primo barone di Keyes, e lady Keyes siedono al tavolo del capitano Gibbons a bordo dell'Aquitania (1934).

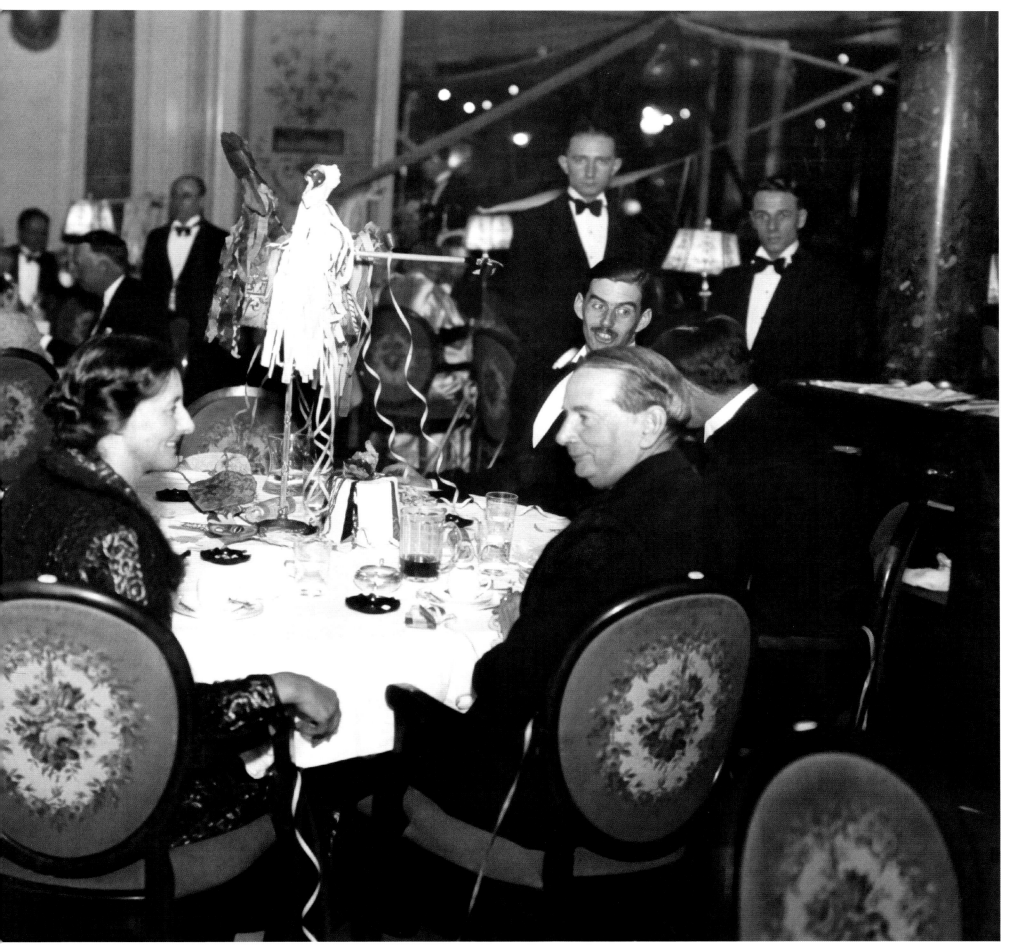

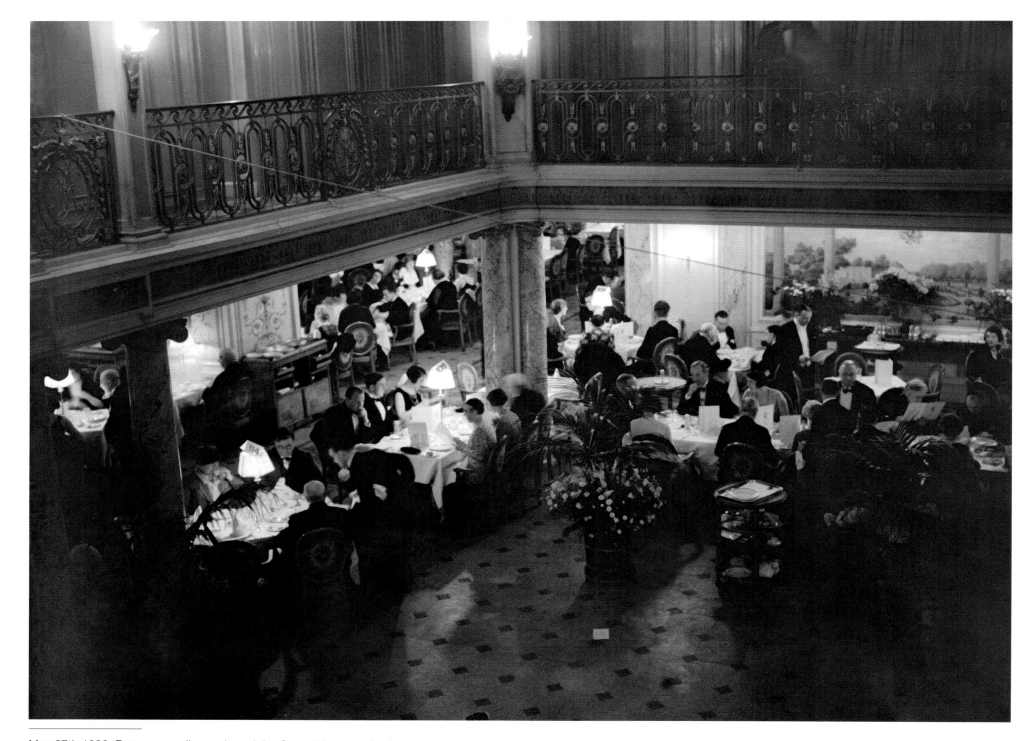

May 27th 1932: Passengers dine on board the Cunard liner Aquitania.

27. Mai 1932: Passagiere beim Diner an Bord der Aquitania.

27 maggio 1932: i passeggeri pranzano a bordo dell'Aquitania.

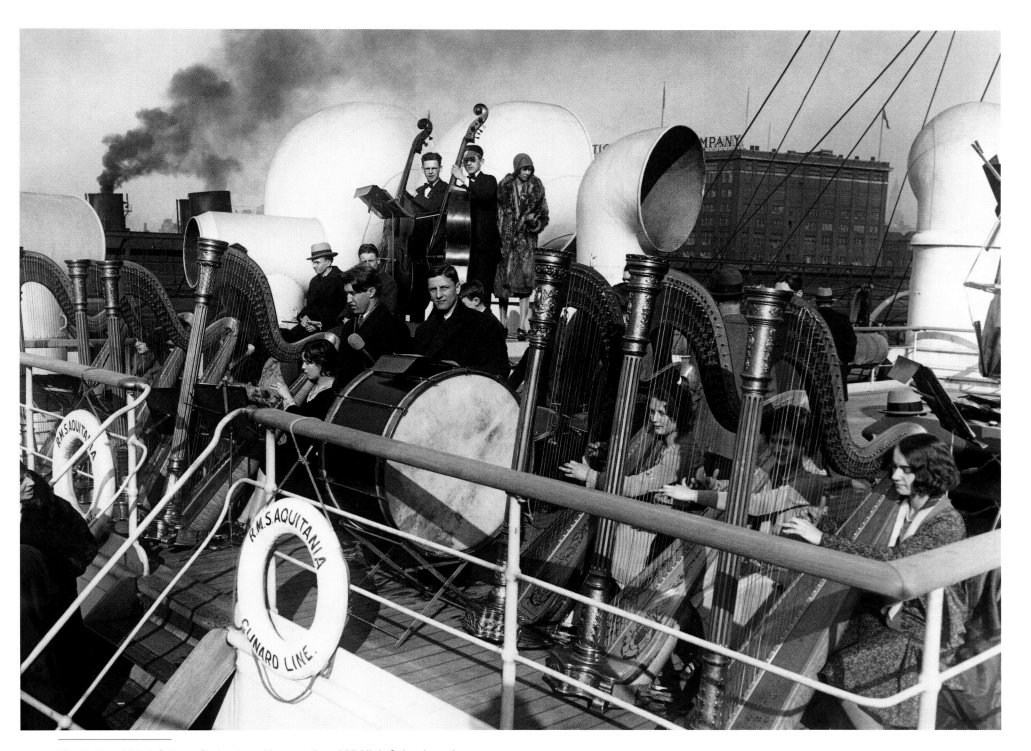

The National High School Orchestra with more than 300 High School musicians coming from North America, is playing on bord of the Aquitania in the harbour of New York, in the foreground a row of harpists, 1935.

Das National High School Orchestra mit über 300 High School Musikern aus ganz Nordamerika spielt an Bord der Aquitania im Hafen von New York, 1935.

L'orchestra della National High School, composta da più di trecento musicisti provenienti da tutto il Nordamerica, suona a bordo dell'Aquitania nel porto di New York (1935).

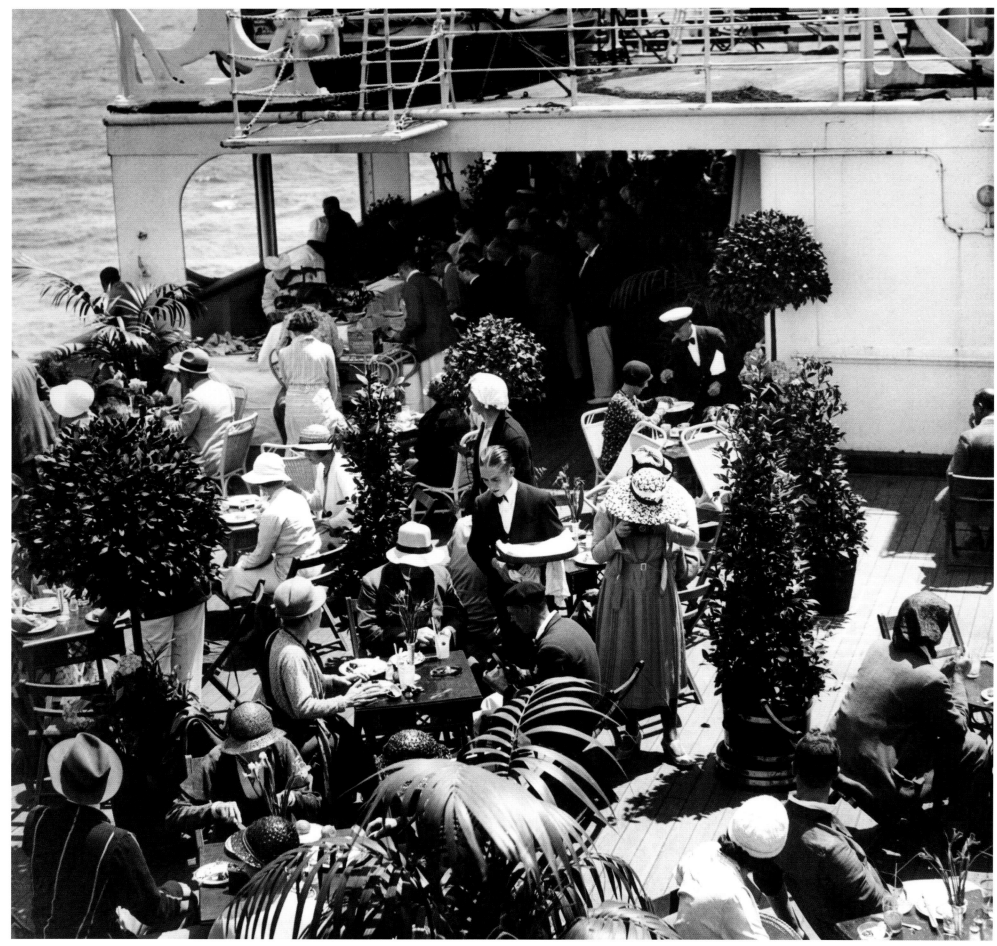

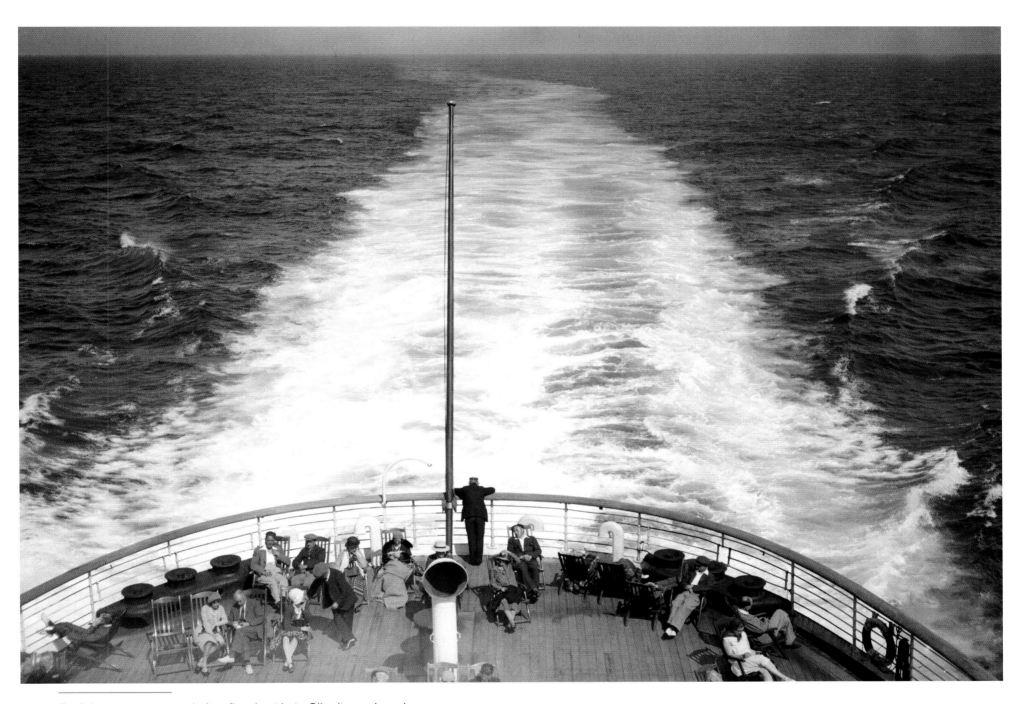

English passengers conclude a five day trip to Gibraltar on board the Cunard liner Aquitania, 1932.

Englische Passagiere bei einem fünftägigen Ausflug nach Gibraltar an Bord der Aquitania, 1932.

Alcuni passeggeri inglesi durante un'escursione di cinque giorni a Gibilterra a bordo dell'Aquitania (1932).

The second Canadian Pacific liner to be named Empress of Britain on her maiden voyage from Southampton to Quebec. She was torpedoed by a German U-boat in October 1940, with the loss of 49 lives.

Das zweite Schiff, das von der Canadian Pacific Line den Namen Empress of Britain erhielt, auf der Jungfernfahrt von Southampton nach Quebec. 1940 wurde es von einem deutschen U-Boot torpediert und riss 49 Menschen mit in den Tod.

La seconda nave, battezzata dalla Canadian Pacific Line Empress of Britain, nel suo viaggio inaugurale da Southampton a Quebec. Nel 1940 venne silurata da un sommergibile tedesco; il suo affondamento provocò la morte di 49 persone.

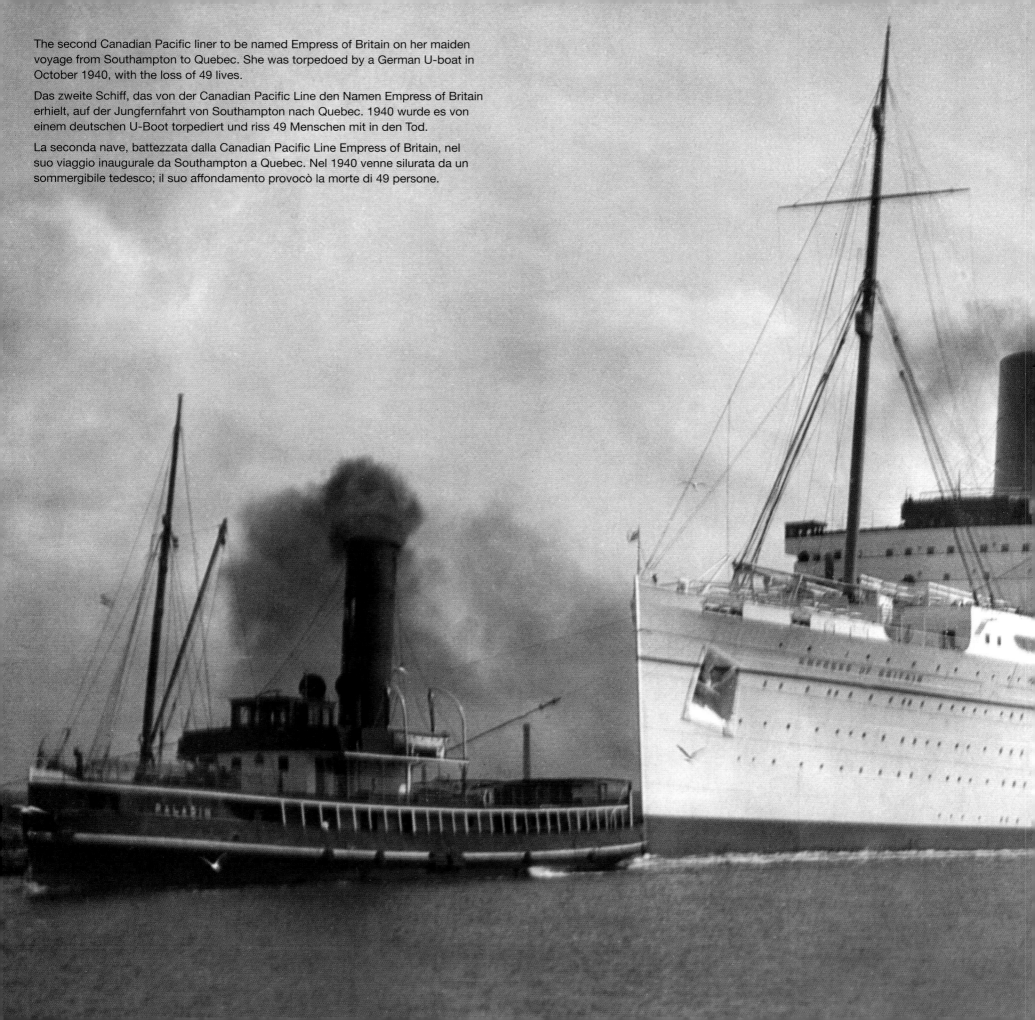

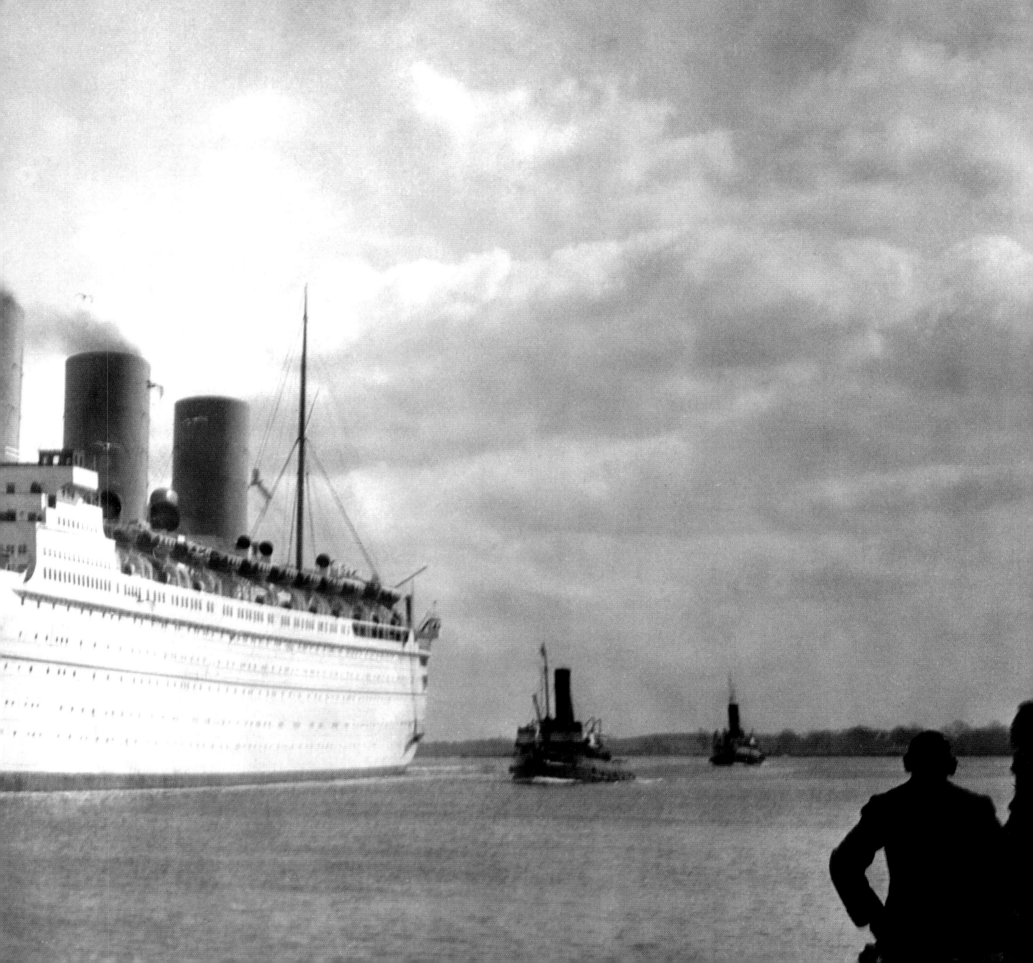

December 14th 1938: Two young passengers aboard the Canadian Pacific liner Empress of Britain getting a preview of what's on the menu.

14. Dezember 1938: Zwei junge Passagiere bekommen an Bord der Empress of Britain eine Vorschau auf das Tagesmenü.

14 dicembre 1938: presentazione del menu a due giovani passeggeri a bordo della Empress of Britain.

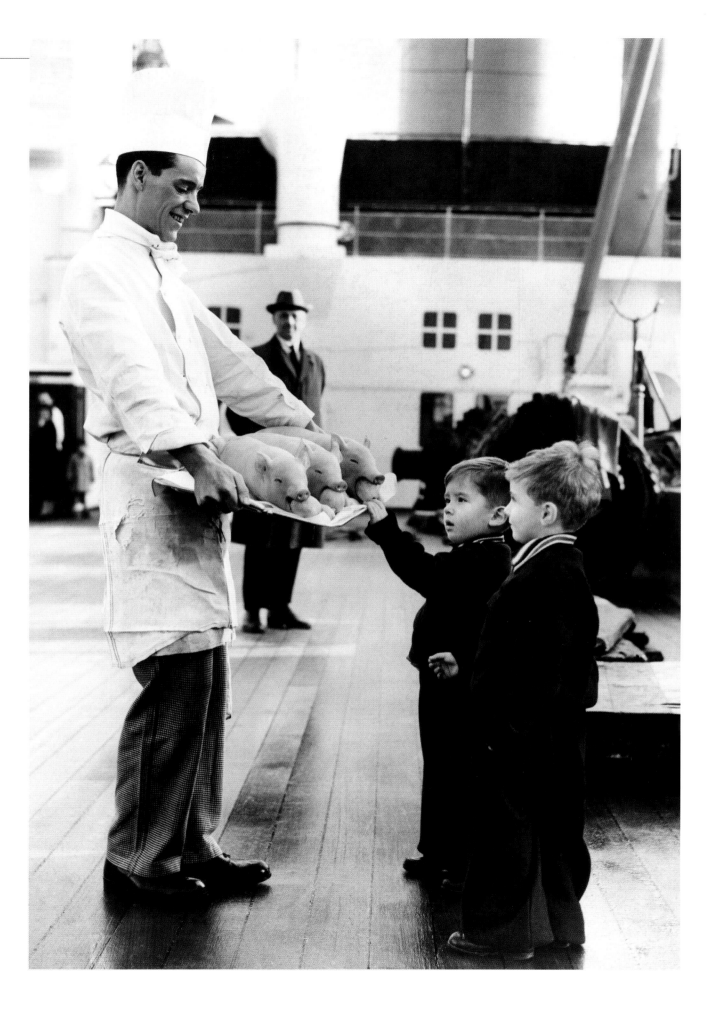

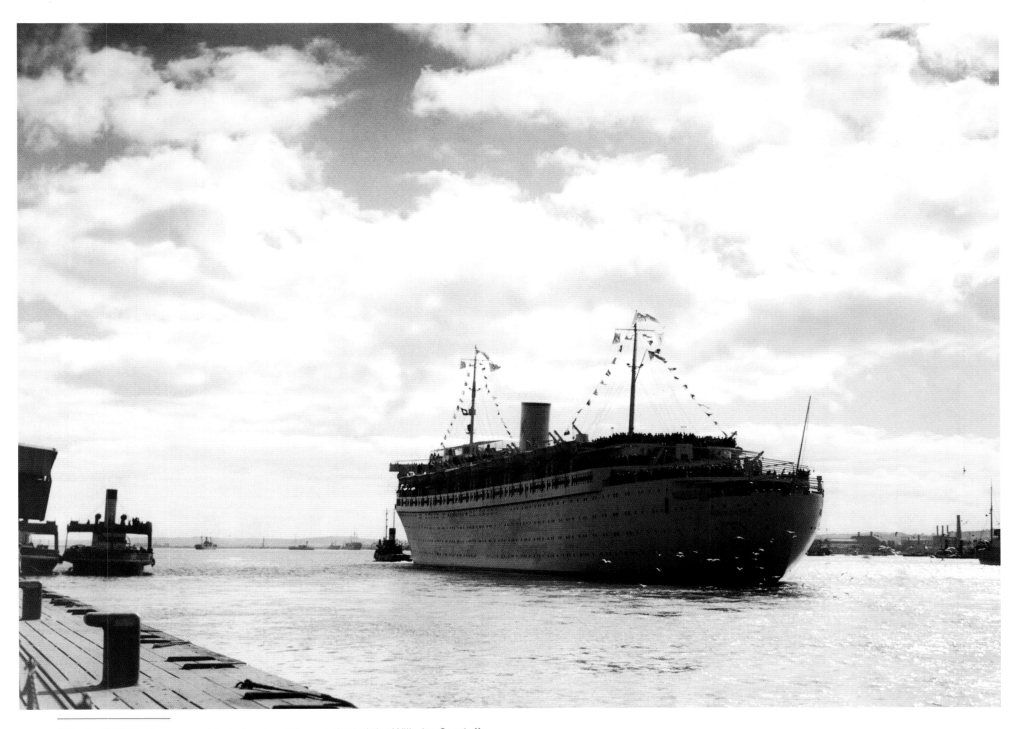

10th April 1938: German residents leaving Tilbury onboard the Wilhelm Gustloff.

10. April 1938: Deutsche Staatsangehörige verlassen Tilbury an Bord der Wilhelm Gustloff.

10 aprile 1938: cittadini tedeschi lasciano Tilbury a bordo della Wilhelm Gustloff.

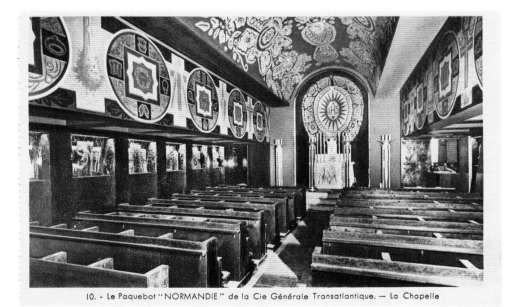

10. - Le Paquebot "NORMANDIE" de la Cie Générale Transatlantique. — La Chapelle

Postcard of the chapel on board of the Normandie.

Postkarte der Kapelle an Bord der Normandie.

Cartolina della cappella del Normandie.

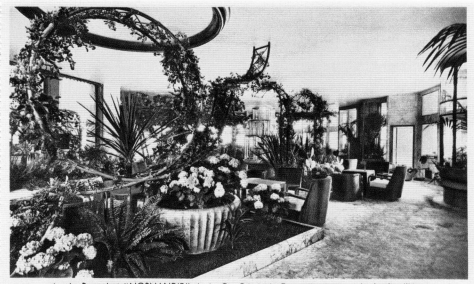

4. - Le Paquebot "NORMANDIE" de la Cie Générale Transatlantique. — Le Jardin d'Hiver

Postcard of the 'Jardin d'Hiver' on board of the Normandie.

Postkarte des 'Jardin d'Hiver' an Bord der Normandie.

Cartolina del 'Jardin d'hiver' a bordo del transatlantico francese.

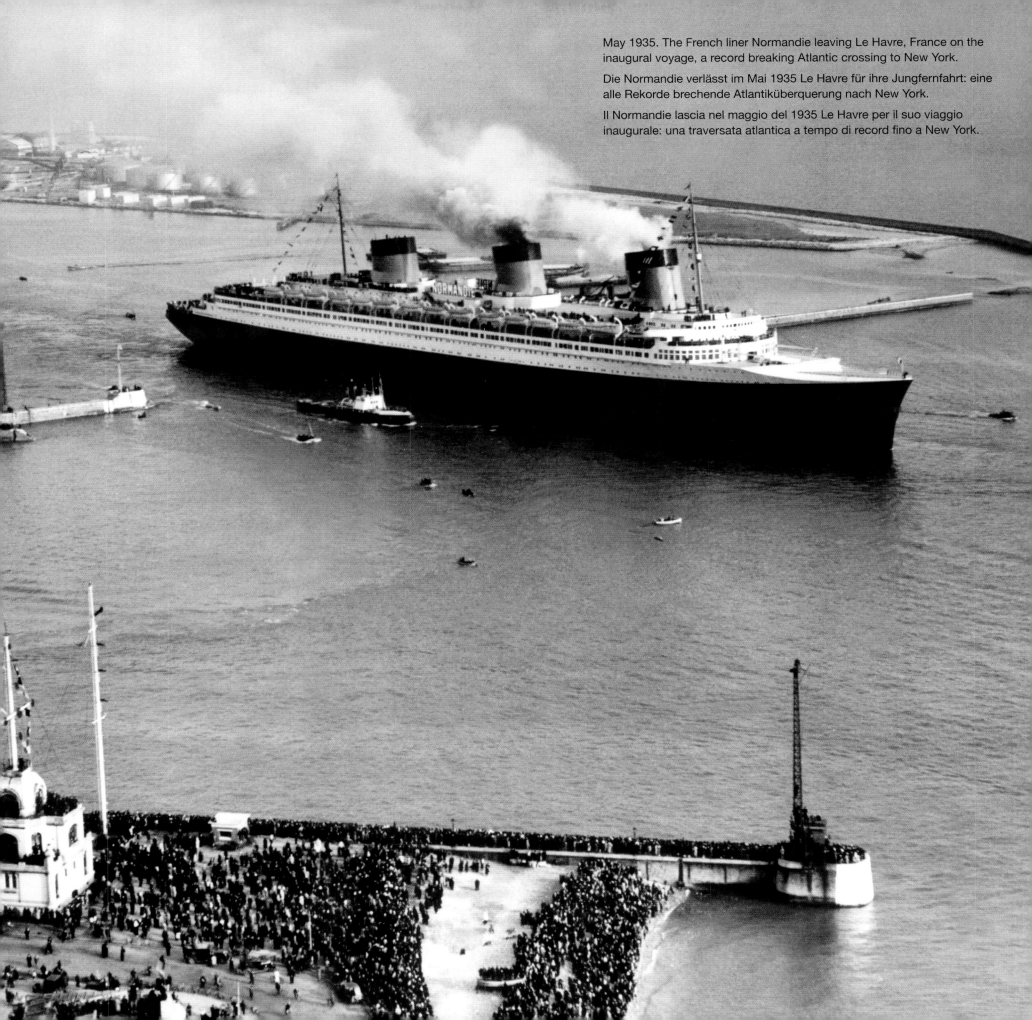

May 1935. The French liner Normandie leaving Le Havre, France on the inaugural voyage, a record breaking Atlantic crossing to New York.

Die Normandie verlässt im Mai 1935 Le Havre für ihre Jungfernfahrt: eine alle Rekorde brechende Atlantiküberquerung nach New York.

Il Normandie lascia nel maggio del 1935 Le Havre per il suo viaggio inaugurale: una traversata atlantica a tempo di record fino a New York.

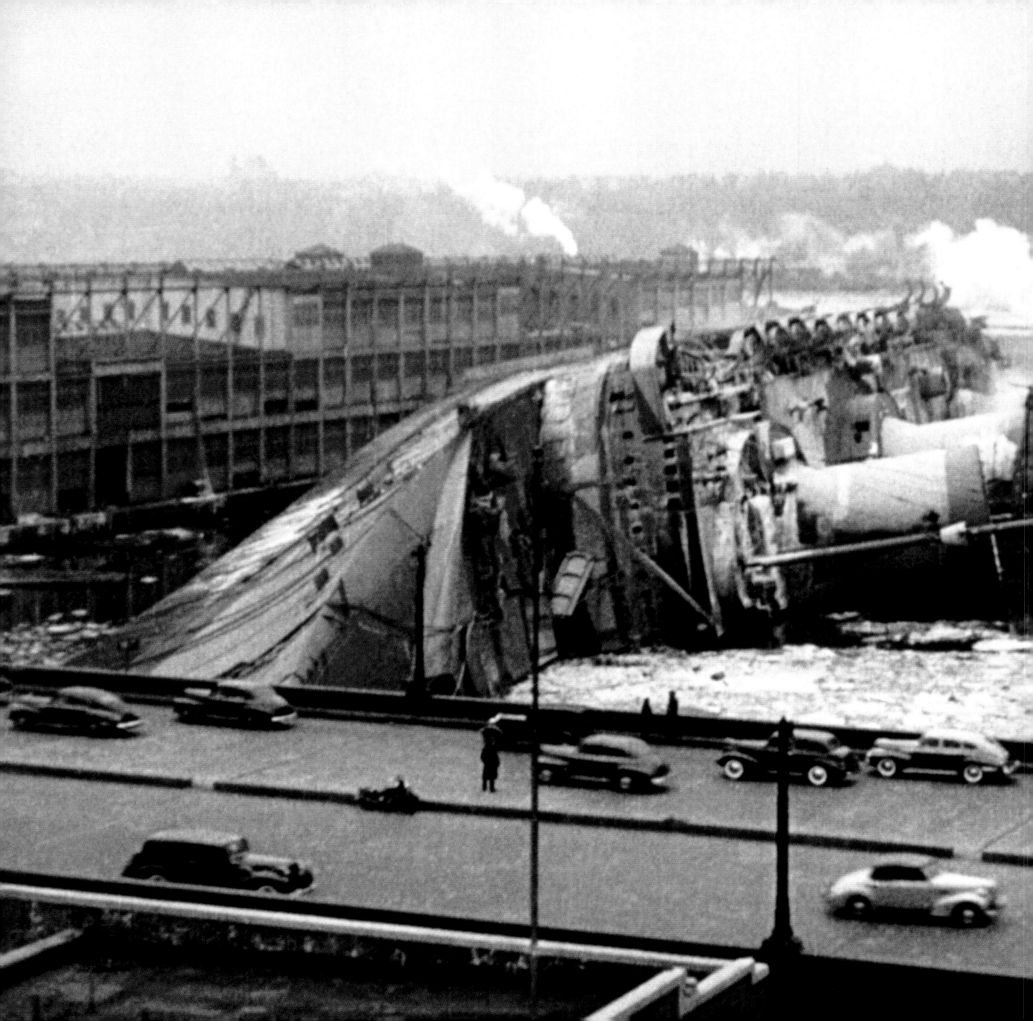

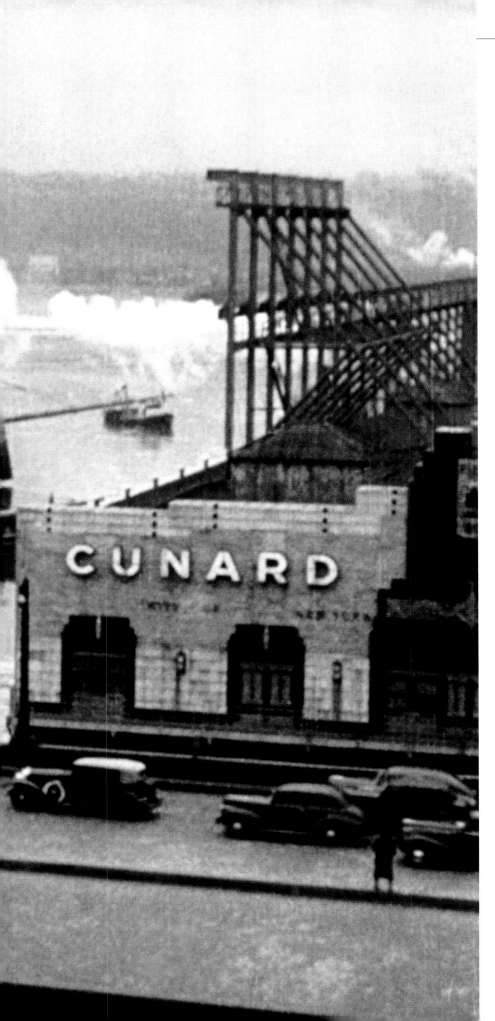

View of the capsized French ocean liner Normandie, laying on its side in port after it caught fire and began to sink, New York City.

Blick auf den gekenterten französischen Ocean-Liner Normandie, der seitlich im Hafen von New York City liegt, nachdem er Feuer fing und zu sinken begann, 1942.

Vista del transatlantico francese Normandie nel porto die New York: si inabisserà poco dopo a causa di un incendio (1942).

An opulent bedroom on board the Normandie.

Ein üppig ausgestattetes Schlafzimmer an Bord der Normandie.

Una sontuosa camera da letto a bordo del Normandie.

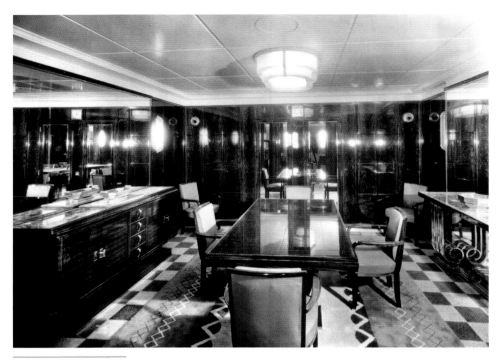

The elegant dining-room of the 'Caen-Suite'.

Das elegante Speisezimmer der Caen-Suite.

L'elegante sala da pranzo della suite Caen.

Through a colonnade to the living room next door.

Zwischen Säulen gelangt man ins Wohnzimmer nebenan.

Passando tra le colonne si arriva in salotto.

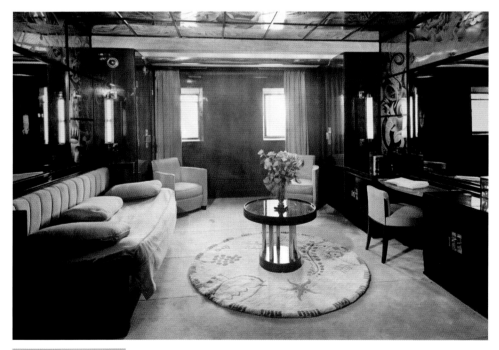

A stylish cabin on the promenade deck.

Eine stilvolle Kabine auf dem Promenadendeck.

Una cabina di lusso sul ponte di passeggiata.

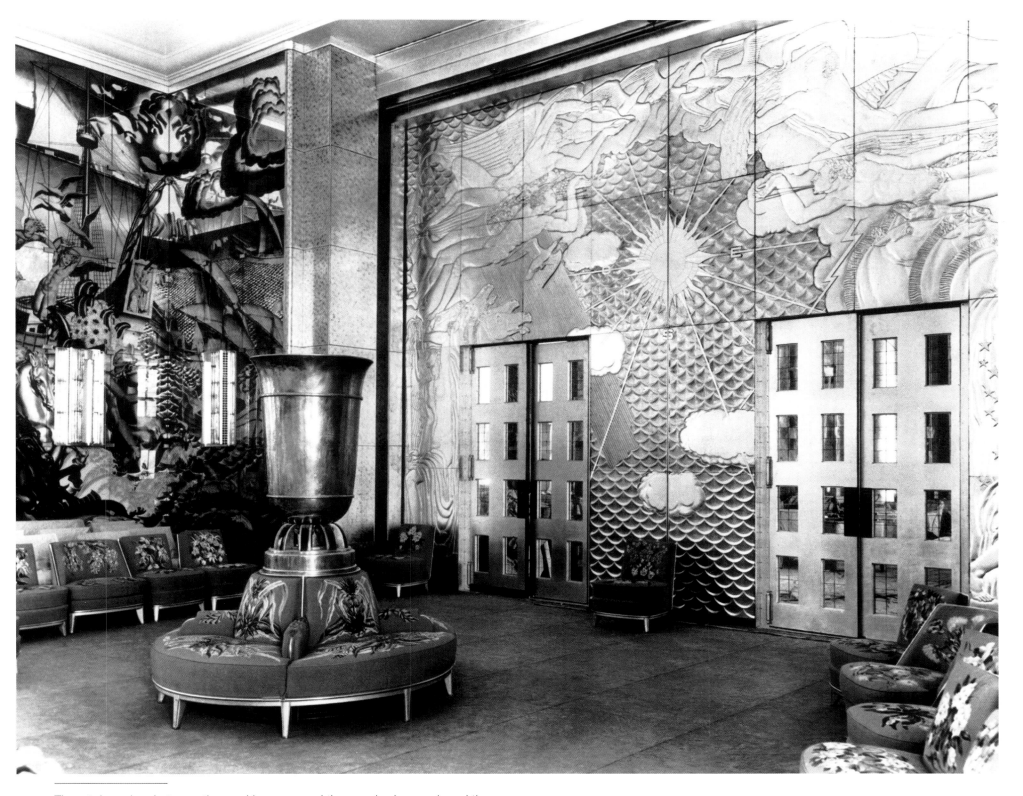

The art deco door between the smoking room and the grand saloon on board the
Normandie, 1935.

Die prunkvolle Art-déco-Tür zwischen Raucherzimmer und Großem Salon an Bord der
Normandie, 1935.

La fastosa porta art déco tra la sala fumatori e il salone, a bordo del Normandie (1935).

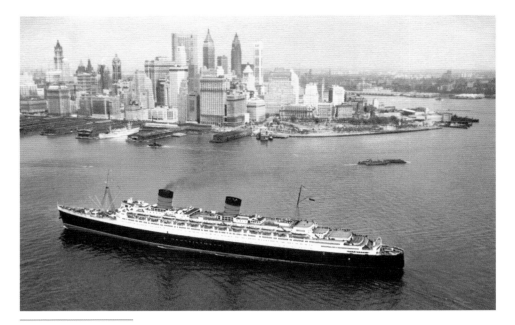

Postcard of the Queen Elizabeth.

Postkarte der Queen Elizabeth.

Cartolina della Queen Elizabeth.

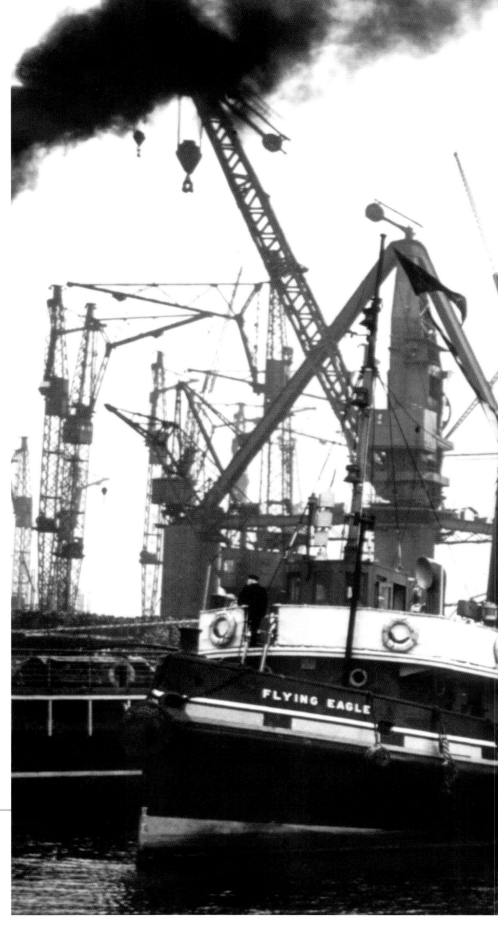

After her launch the Queen Elizabeth is getting towed to a dock, 1938.

Die Queen Elizabeth wird im Jahr 1938, bereits kurz nach ihrem Stapellauf, zum Dock geschleppt.

Nel 1938 la Queen Elizabeth viene trainata nel bacino appena dopo il varo.

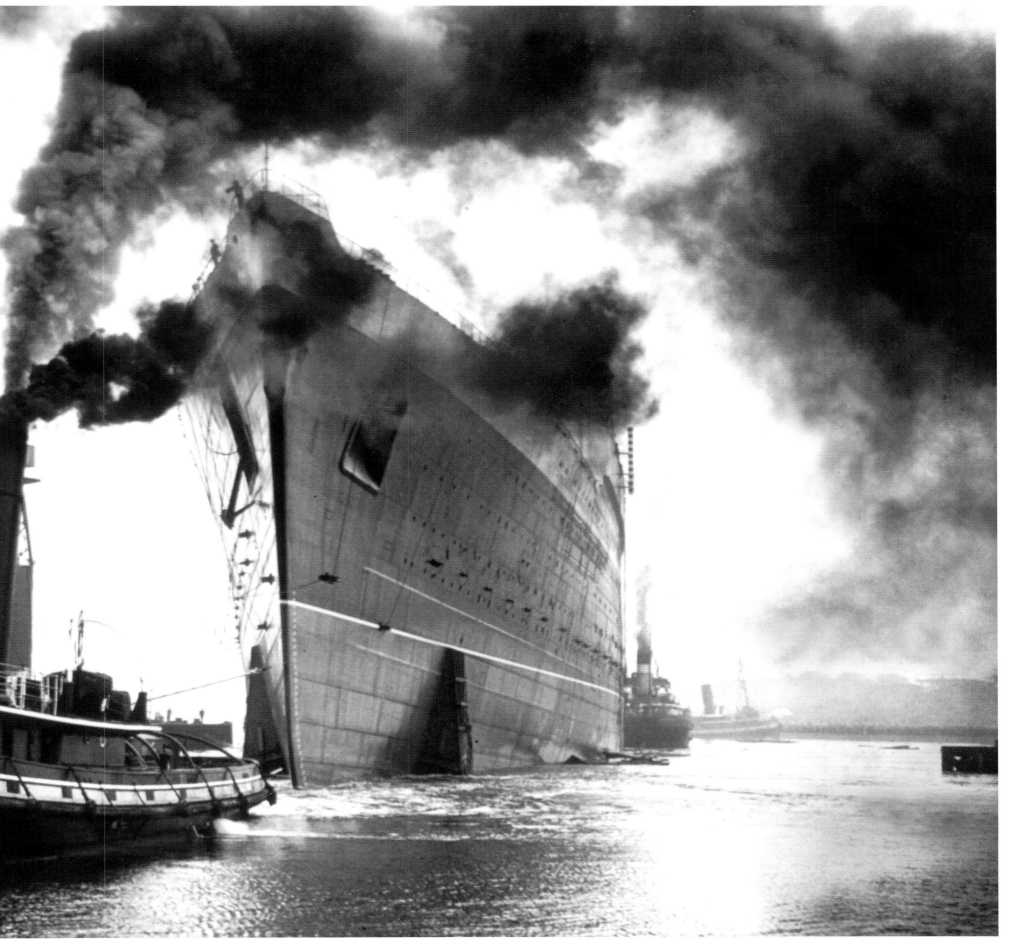

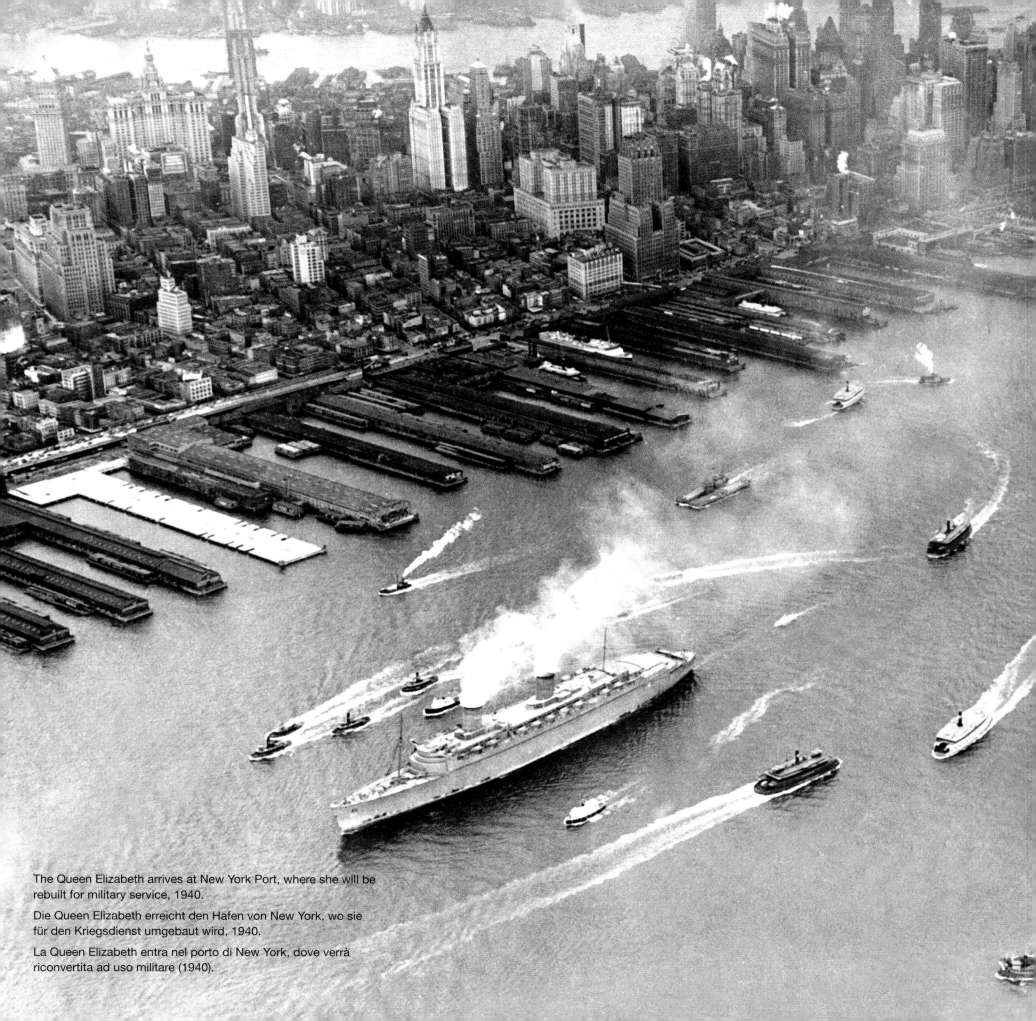

The Queen Elizabeth arrives at New York Port, where she will be rebuilt for military service, 1940.

Die Queen Elizabeth erreicht den Hafen von New York, wo sie für den Kriegsdienst umgebaut wird, 1940.

La Queen Elizabeth entra nel porto di New York, dove verrà riconvertita ad uso militare (1940).

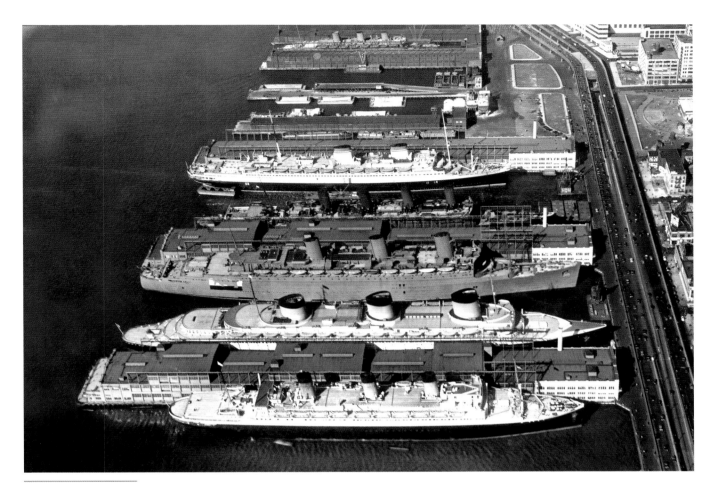

Several ocean liners anchor in New York Port.

Ozeanriesen im Hafen von New York.

Alcuni transatlantici ancorati nel porto di New York.

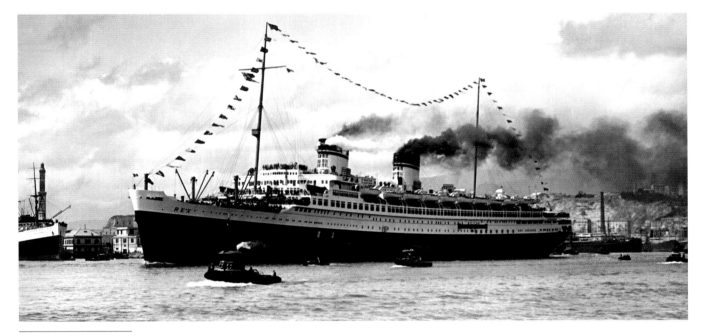

The brand new 51,062 ton Italia Flotte Riunite vessel Rex in 1932, the world's fastest liner between 1933 and 1935.

Das nagelneue 51.062-Tonnen-Schiff Rex der Italia Flotte Riunite war von 1933 bis 1935 das schnellste Schiff der Welt.

La Rex nuova fiammante della Italia Flotte Riunite, 51.062 tonnellate di stazza, fu la più veloce nave del mondo dal 1933 al 1935.

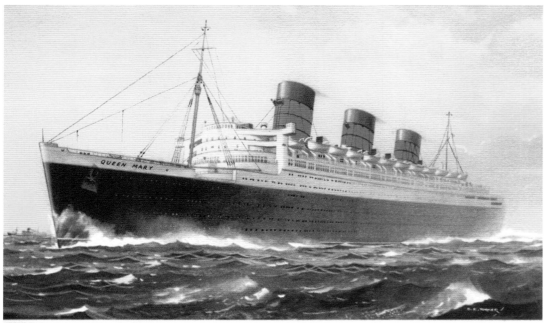

Cunard R.M.S. Queen Mary

Postcard of the Queen Mary.

Postkarte der Queen Mary.

Cartolina della Queen Mary.

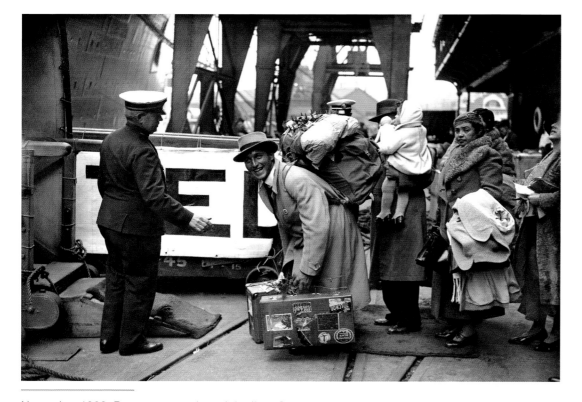

November 1923: Passengers on board the liner Queen Mary.

Passagiere gehen an Bord der Queen Mary, November 1923.

I passeggeri salgono a bordo della Queen Mary nel novembre del 1923.

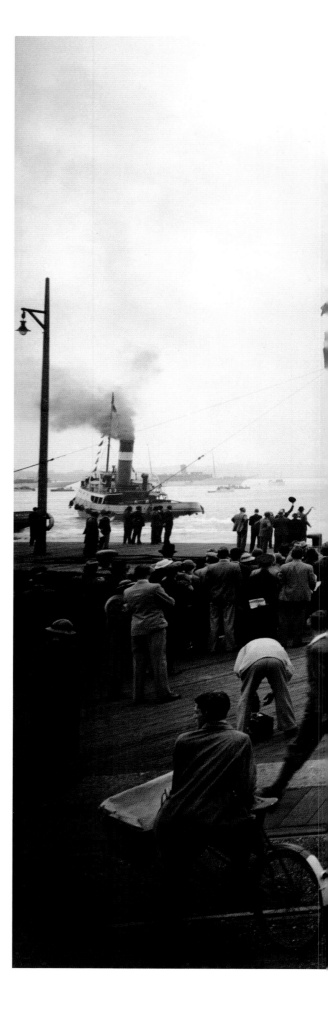

The popular Queen Mary is acclaimed on her maiden voyage, 1936.

Die beliebte Queen Mary wird bei ihrer Jungfernfahrt vom Ufer aus bejubelt, 1936.

L'amatissima Queen Mary viene festeggiata da terra durante il suo viaggio inaugurale nel 1936.

Passengers of cabin class aboard the Queen Mary enjoying their tea on the promenade deck.

Passagiere der Kabinenklasse auf der Queen Mary genießen ihren Tee auf dem Promenadendeck.

I passeggeri della classe cabina sulla Queen Mary sorseggiano il tè sul ponte di passeggiata.

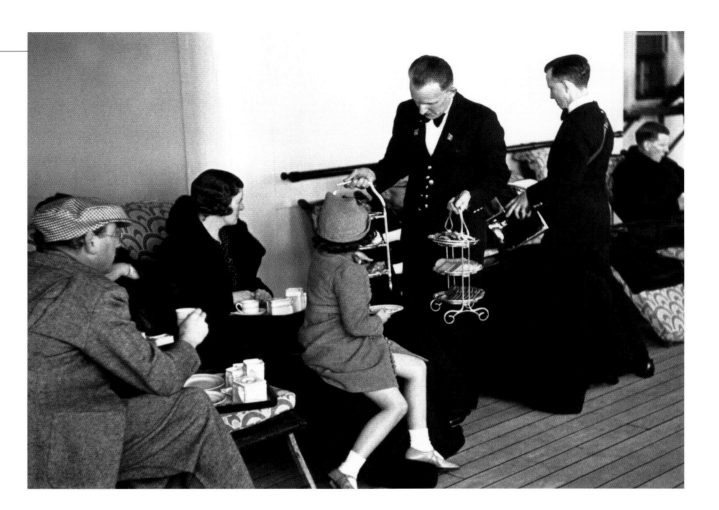

Inspection of the footboys.

Die Pagen werden kritisch begutachtet.

I camerieri vengono esaminati scrupolosamente.

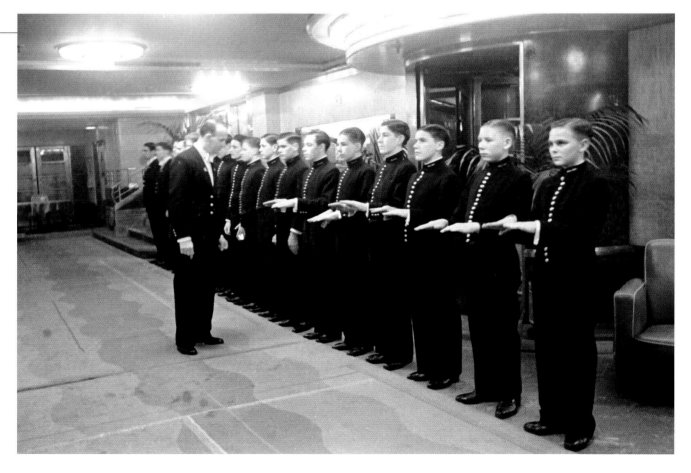

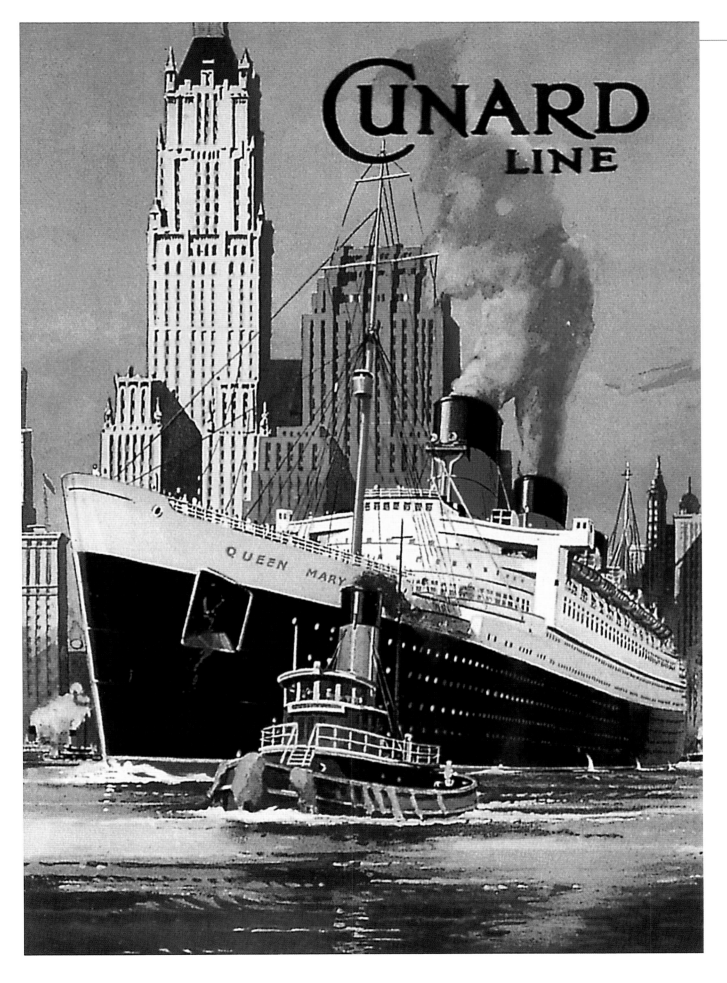

Poster of the Cunard-liner Queen Mary.

Poster der Queen Mary von Cunard.

Manifesto della Queen Mary della Cunard.

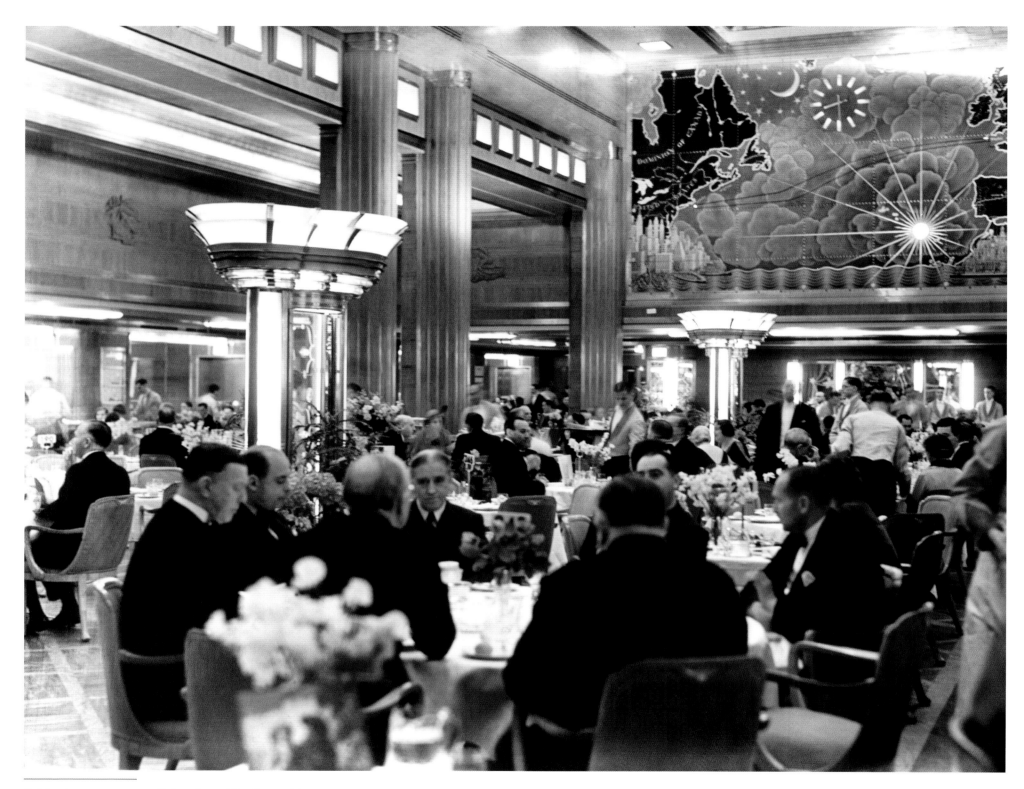

Cabin class passengers dining aboard the Queen Mary.

Fahrgäste der Kabinenklasse beim Diner an Bord der Queen Mary.

Gli ospiti della classe cabina durante il pranzo a bordo della Queen Mary.

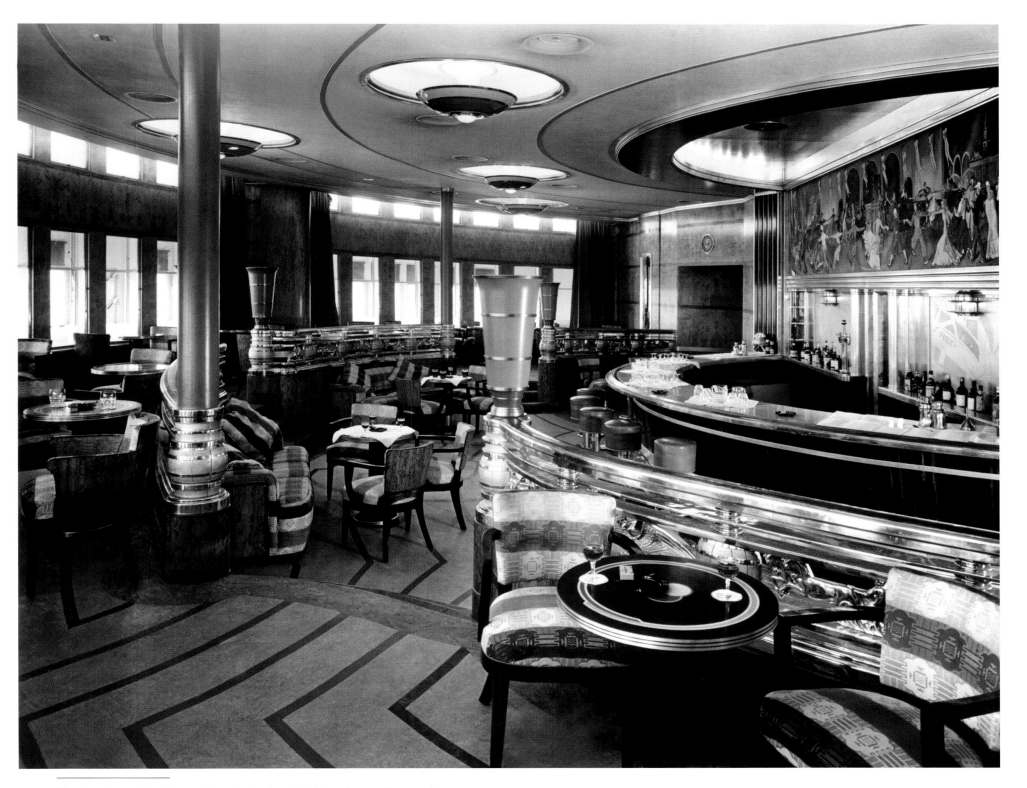

The bar aboard the Queen Mary. Its design is lavish using exotic wood.

Die mit edlen Hölzern aufwendig gestaltete Cocktailbar an Bord der Queen Mary.

Il bar per gli aperitivi della Queen Mary, realizzato con costosi legni pregiati.

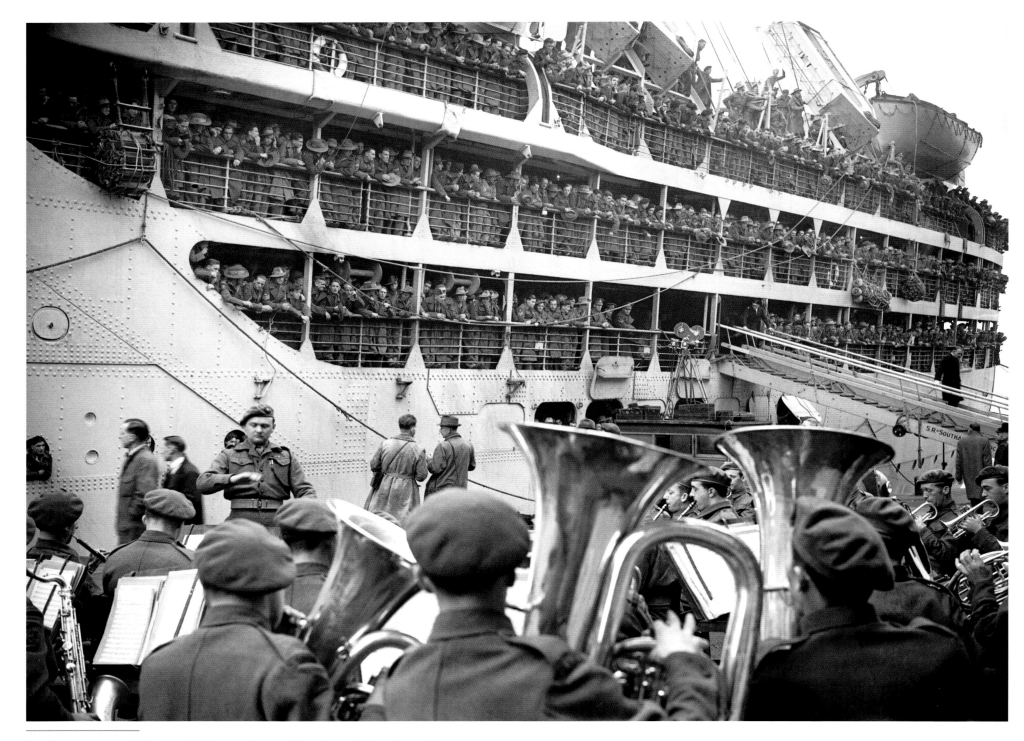

A salutatory serenade for the British repatriates of Southeast Asia on board the Strathmore.

Britische Heimkehrer aus Südostasien an Bord der Strathmore. Zu ihrer Begrüßung spielt eine Kapelle im Hafen auf.

L'orchestra di bordo suona in un porto britannico per festeggiare il ritorno in patria della Strathmore, proveniente dal Sud-est asiatico.

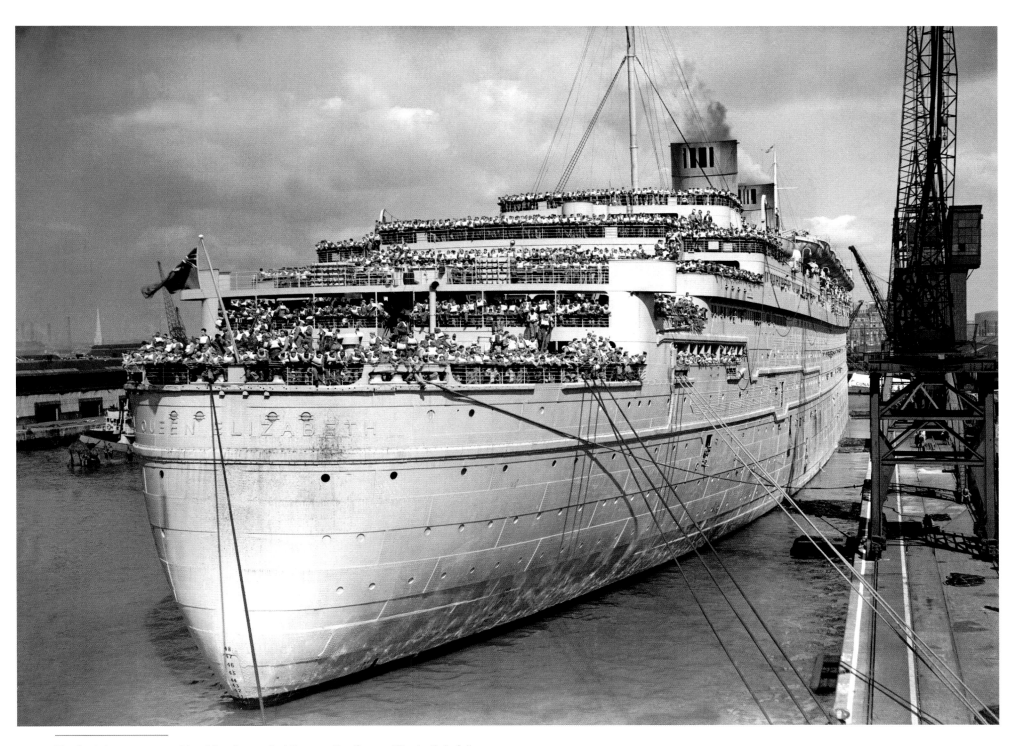

The last days as a warship: After the end of the war the Queen Elizabeth is fully laden with exultant American soldiers, August 1945.

Die letzten Tage als Kriegsschiff: nach Kriegsende im August 1945 ist die Queen Elizabeth voll beladen mit jubelnden amerikanischen Soldaten.

Ultimi giorni come nave militare: finita la guerra, nell'agosto del 1945 la Queen Elizabeth è gremita di soldati americani esultanti.

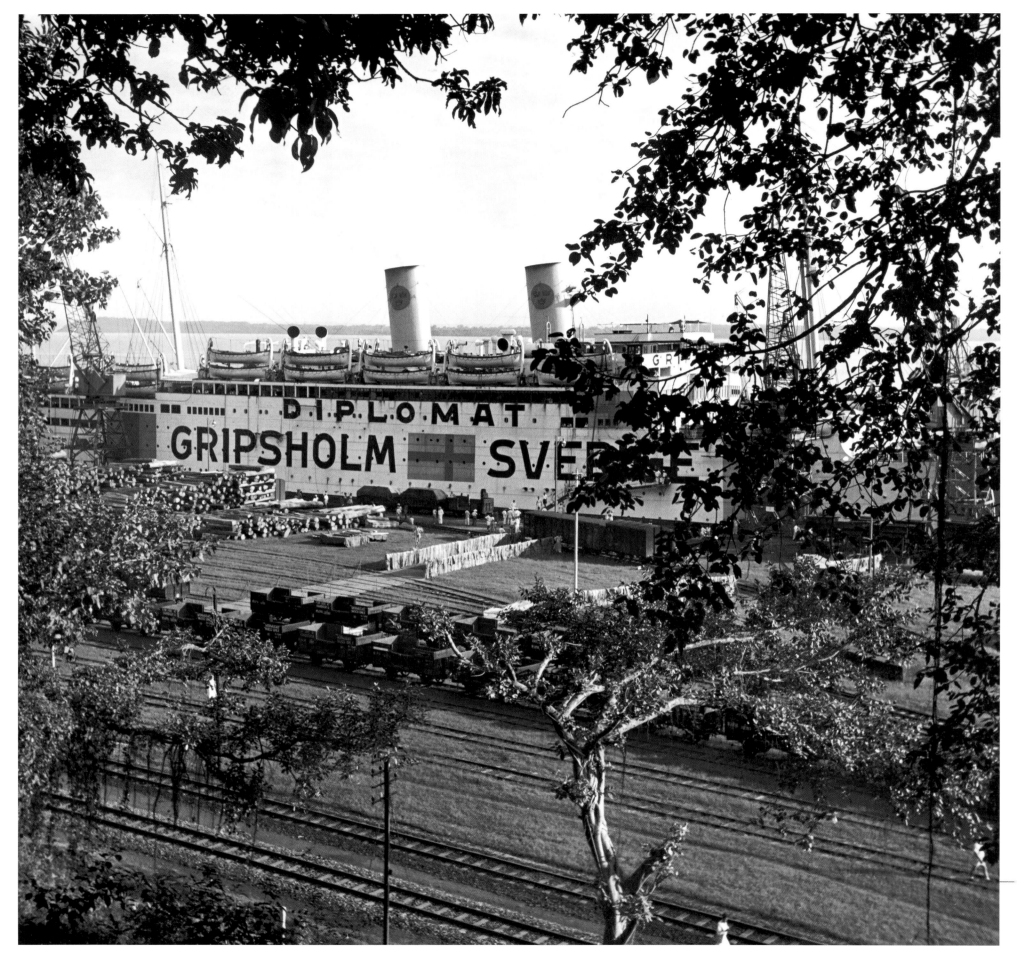

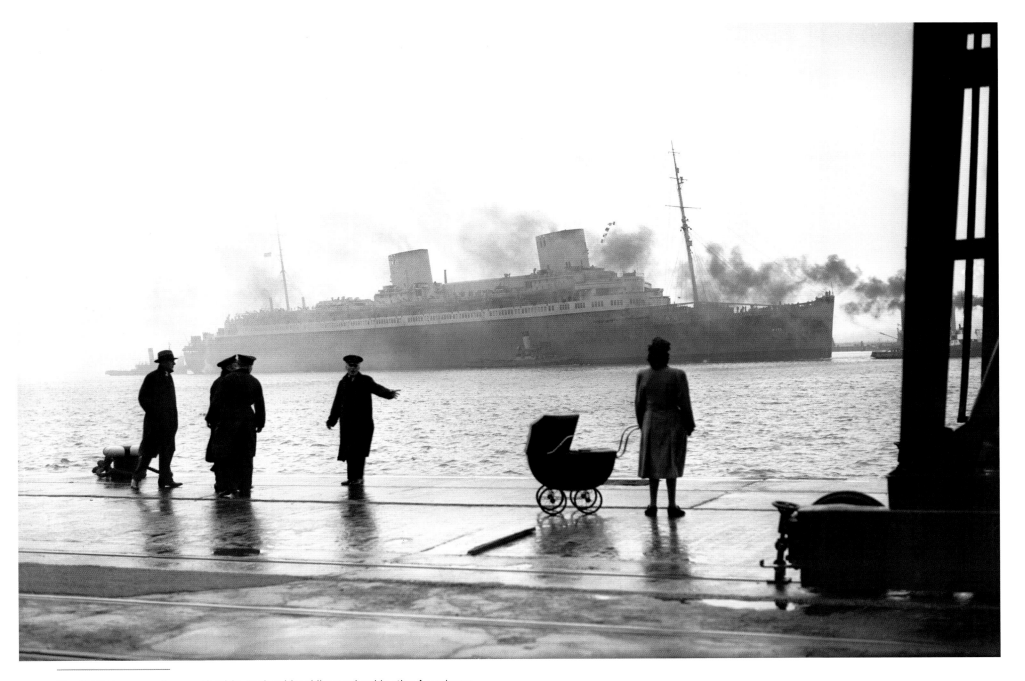

The USS Europa, a former Norddeutscher Lloyd liner seized by the Americans during World War II pulls into Southampton Docks, ready to transport US troops back home, 1946.

Die USS Europa, die ehemals dem Norddeutschen Lloyd gehörte und im Zweiten Weltkrieg von den Amerikanern beschlagnahmt wurde, läuft in den Hafen von Southampton ein, um US-Truppen nach Hause zu befördern, 1946.

La USS Europa, un tempo di proprietà del Norddeutscher Lloyd, ma poi requisita durante la Seconda guerra mondiale dagli americani, arriva nel porto di Southampton per riportare a casa le truppe statunitensi (1946).

View of the Swedish liner Gripsholm, 1943.

Ansicht des schwedischen Liners Gripsholm, 1943.

Vista del transatlantico svedese Gripsholm (1943).

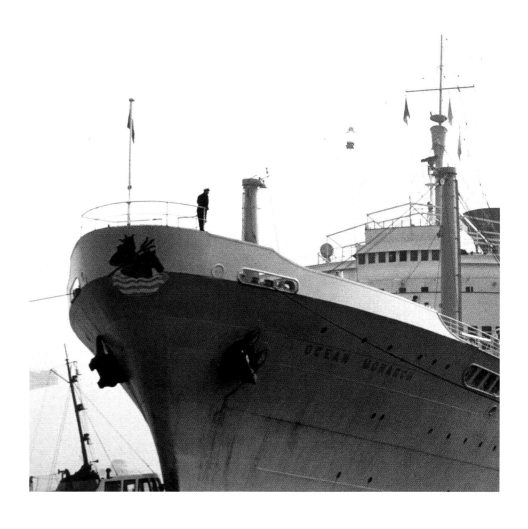

THE END OF AN ERA
FROM CLASSIC OCEAN LINERS TO MODERN CRUISE SHIPS

✦ ✦ ✦ ✦

DAS ENDE EINER ÄRA
VOM OZEANRIESEN ZUM KREUZFAHRTSCHIFF

✦ ✦ ✦ ✦

LA FINE DI UN' ERA
DAL TRANSATLANTICO ALLA NAVE DA CROCIERA

May 2nd 1956: The Ile De France ocean liner sailing between the Statue of Liberty and Governor's Island, New York City.

2. Mai 1956: Die Ile de France passiert bei der Ankunft in New York die Freiheitsstatue und Governor's Island.

2 maggio 1956: a New York la Ile De France avanza tra la Statua della Libertà e la Governor's Island.

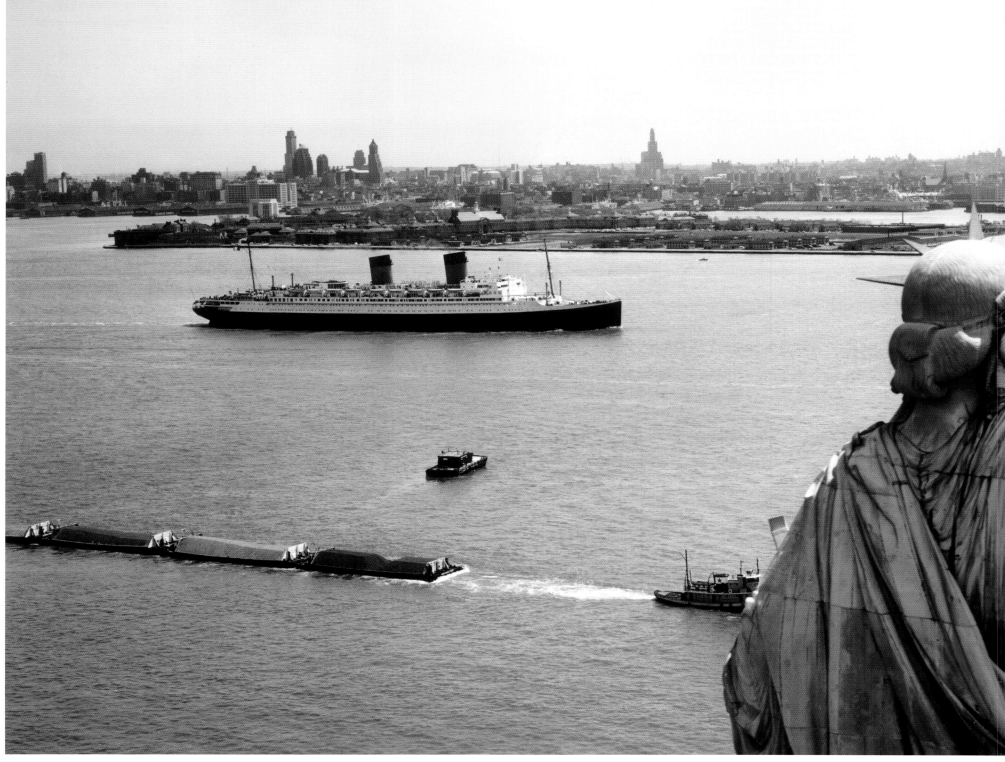

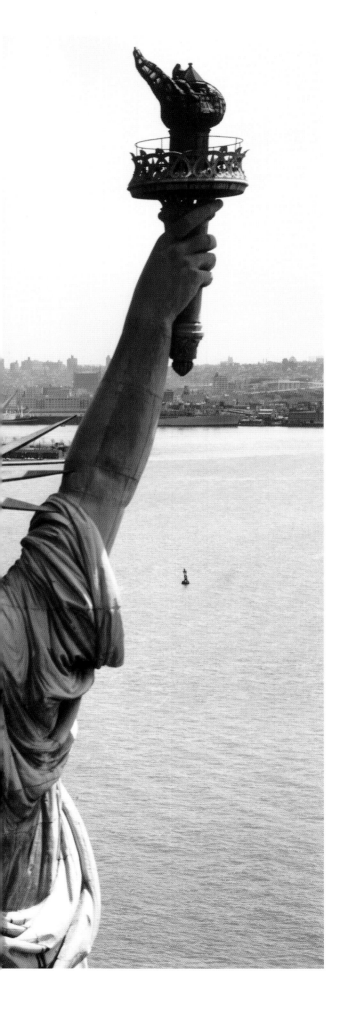

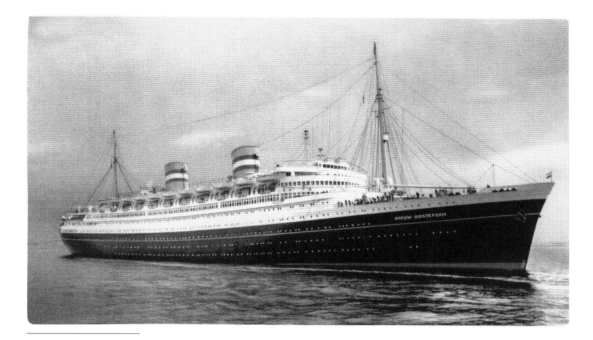

Postcard of the Ile de France.
Postkarte der Ile de France.
Cartolina della Ile de France.

Paquebot "ILE DE FRANCE". — Fumoir des 1res classes. — First class Smoking Room

The first class smoking room on board of the Ile de France.
Rauchzimmer der Ersten Klasse an Bord der Ile de France.
Sala fumatori della prima classe a bordo della Ile de France.

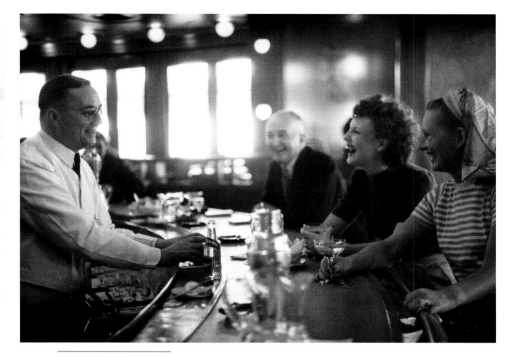

On a hot summer's day the bar on board the Queen Elizabeth is well attended.

Gut besuchte Cocktailbar an einem heißen Sommertag an Bord der Queen Elisabeth.

L'affollato bar degli aperitivi della Queen Elizabeth in un'assolata giornata estiva.

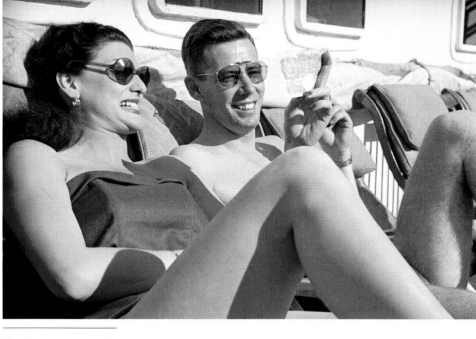

Young passengers in the sun.

Junge Passagiere auf dem Sonnendeck.

Giovani passeggeri al sole.

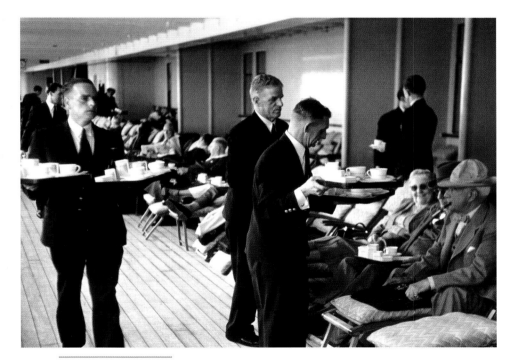

Tea is served on the promenade deck.

Auf dem Promenadendeck wird Tee serviert.

Sul ponte di passeggiata viene servito il tè.

A walk an the promenade deck of the Queen Elizabeth on a hot day in July, 1948.

Spaziergang auf dem Promenadendeck der Queen Elizabeth an einem heißen Julitag, 1948.

Passeggio sul ponte della Queen Elizabeth in una calda giornata di luglio (1948).

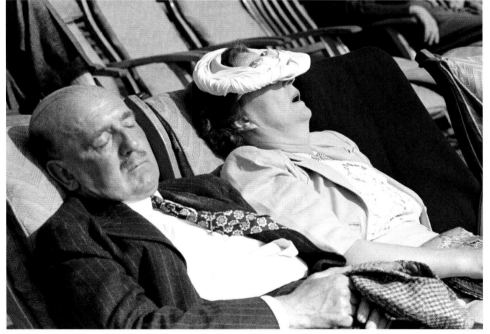

Meanwhile two elder passengers take a nap in deck chairs.

Währenddessen halten zwei ältere Fahrgäste in den Deckstühlen ihr Mittagsschläfchen.

Nel frattempo due ospiti anziani fanno il riposino pomeridiano sulle sedie a sdraio.

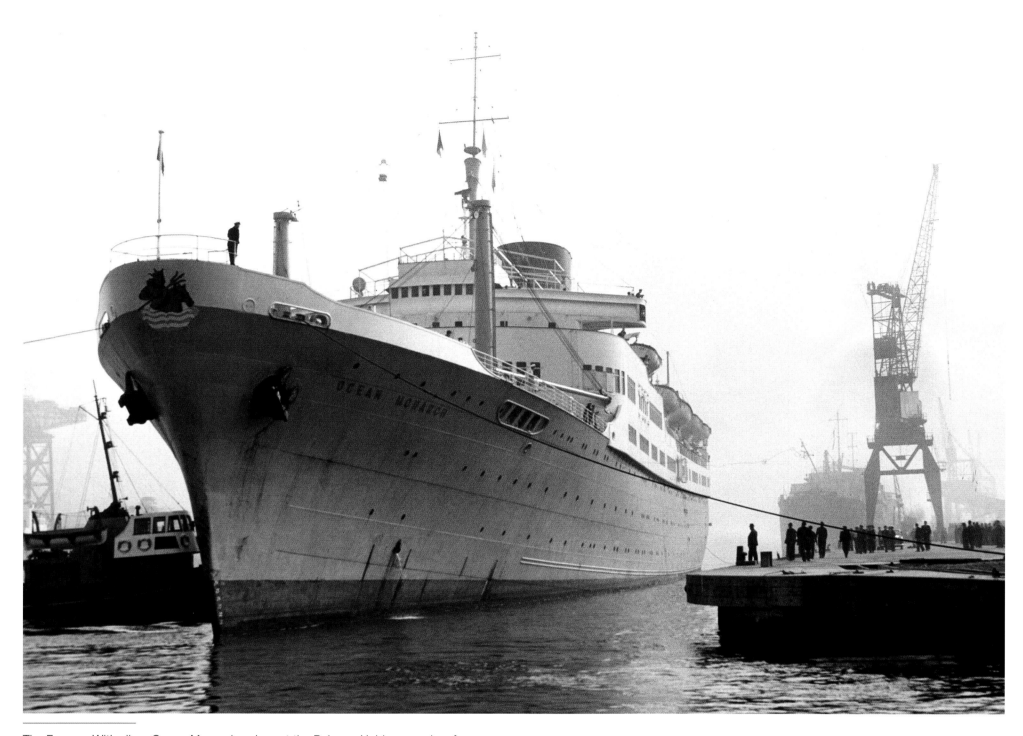

The Furness Withy liner Ocean Monarch arrives at the Palmers Hebburn works of Vickers-Armstrong Ltd for her annual refit. She is the first vessel to test the yard's new deep water berth, 1959.

Die Ocean Monarch der Furness Whity Line erreicht die Palmers Hebburn Werke der Vickers-Armstrong Ltd zur jährlichen Überholung. Als erstes Schiff testet sie den neuen Tiefwasser-Ankerplatz, 1959.

Il transatlantico Ocean Monarch della Furness Withy Line giunge nei cantieri Palmers Hebburn della Vickers Armstrong Ltd per la revisione annuale. È la prima nave a sperimentare il loro nuovo ancoraggio in acque profonde (1959).

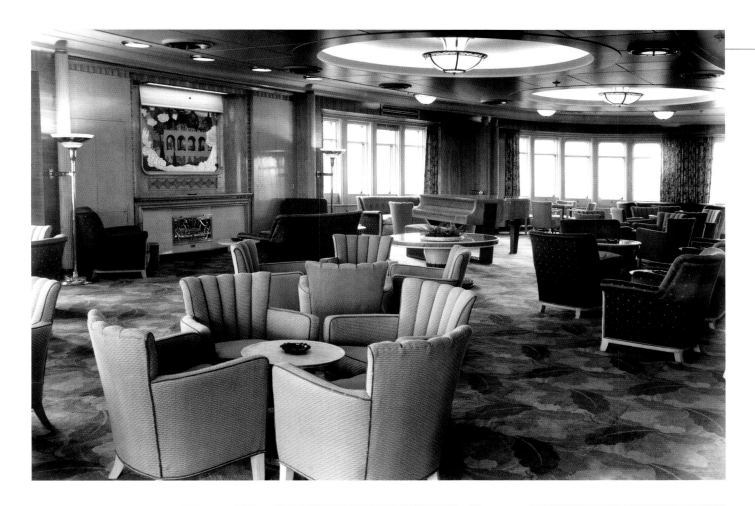

A saloon aboard the Ocean Monarch in a modern design.

Modern gestalteter Salon an Bord der Ocean Monarch.

Il moderno salone a bordo della Ocean Monarch.

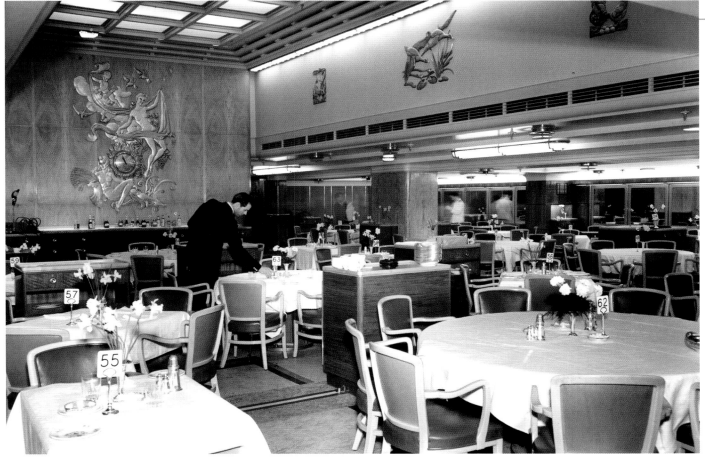

The elegant dining-room.

Der elegante Speisesaal.

L'elegante sala da pranzo.

The United States, the last ocean liner to get the Blue Riband, arrives at Le Havre triumphantly.

Die United States läuft triumphierend in Le Havre ein und erhält als letzter Ocean-Liner das Blaue Band.

La United States fa il suo ingresso trionfale a Le Havre; è l'ultimo transatlantico che riceve il famoso Nastro Azzurro.

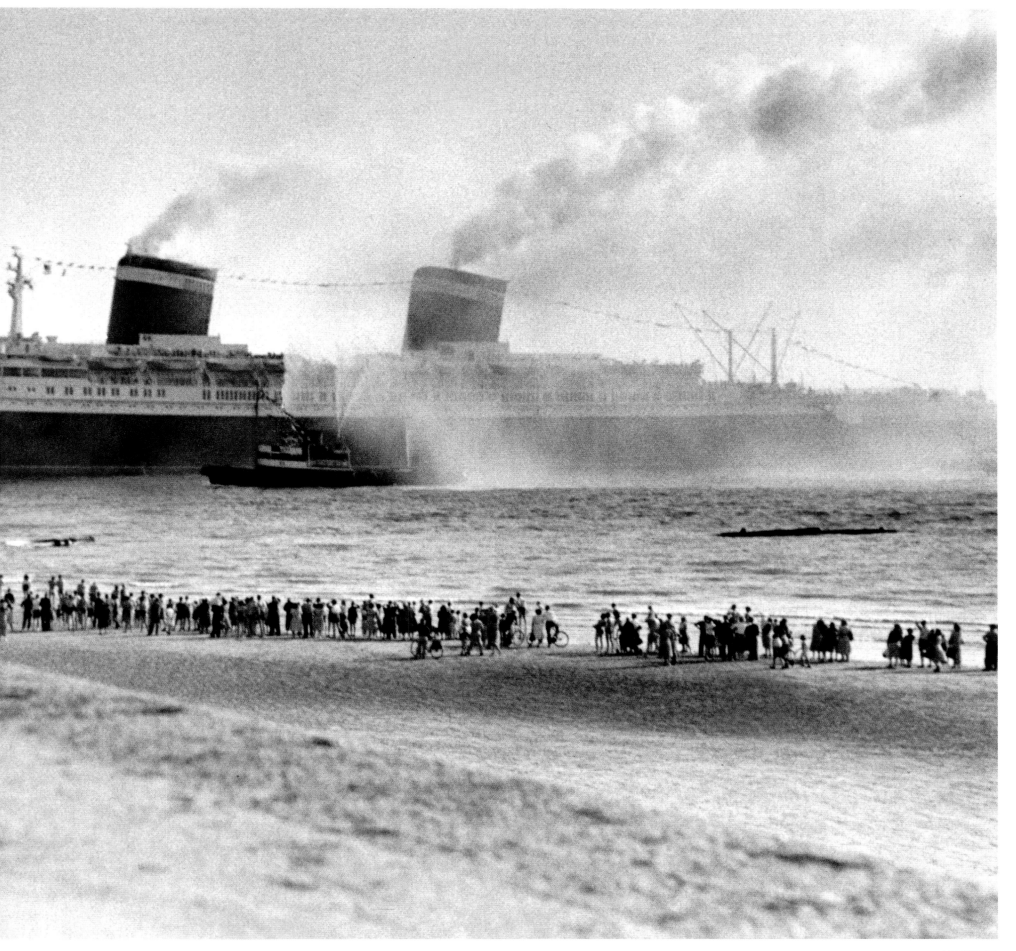

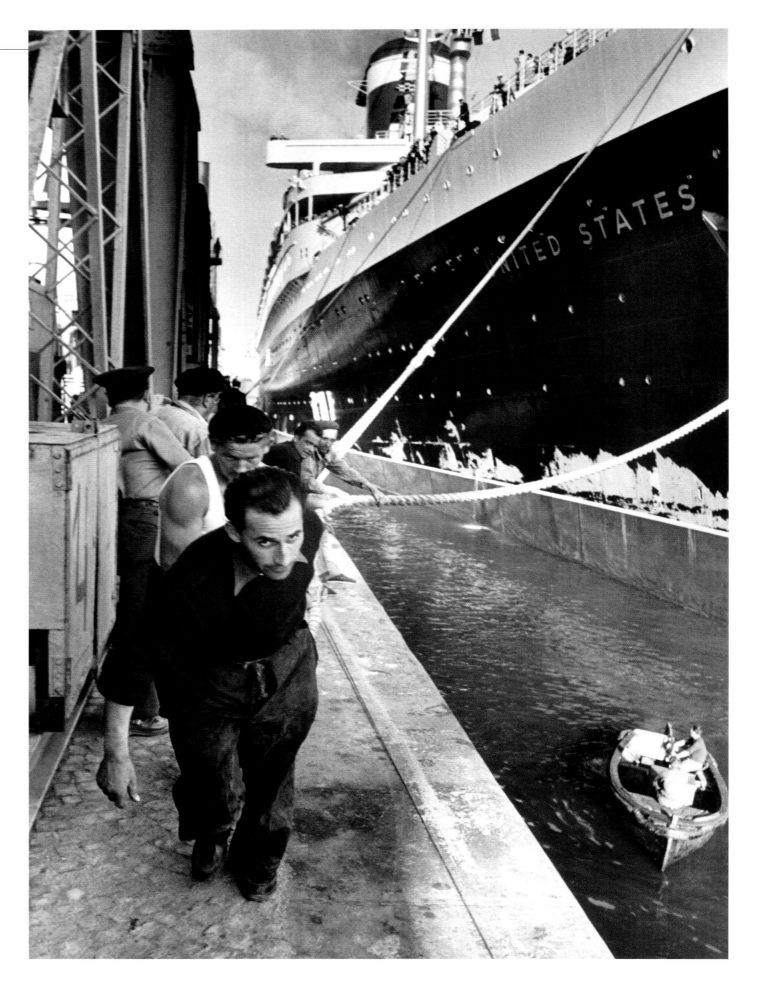

July 1952: The United States at dock in Le Havre.

Die United States im Juli 1952 am Kai in Le Havre.

La United States nel luglio del 1952, attraccata nel porto di Le Havre.

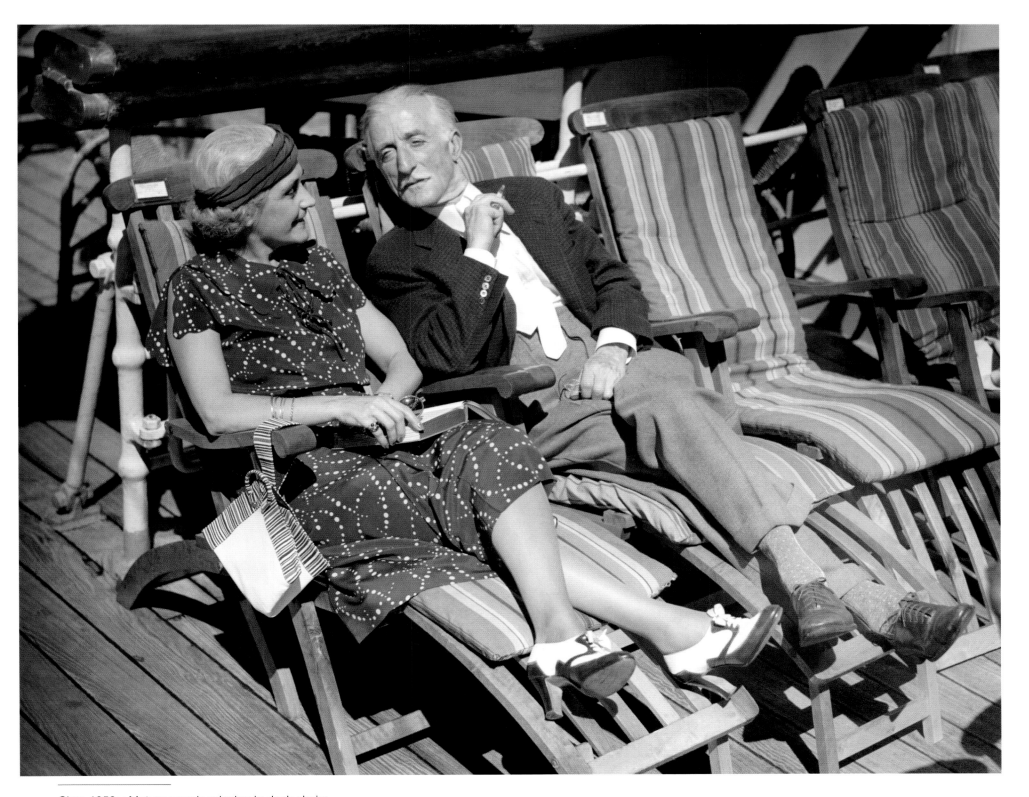

Circa 1950s: Mature couple relaxing in deck chairs.

Ein älteres Paar entspannt sich in den Deckstühlen an Bord der United States, um 1950.

Una coppia si rilassa sulle sedie a sdraio a bordo della United States (1950).

July 1st 1956: Italian liner Andrea Doria sinking in Atlantic after collision with the Swedish ship Stockholm.

1. Juli 1956: Der italienische Liner Andrea Doria versinkt nach einer Kollision mit dem schwedischen Schiff Stockholm im Atlantik.

1° luglio 1956: l'Andrea Doria affonda nell'oceano Atlantico dopo la collisione con la nave svedese Stockholm.

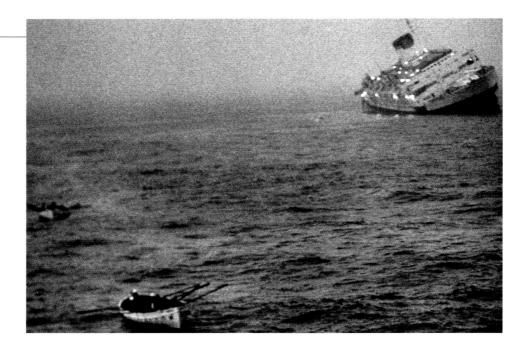

Dizzy Height: Chain cable at the bow of the Andrea Doria.

Schwindelerregende Höhen: die Ankerkette am Bug der Andrea Doria.

Altezza vertiginosa: la catena dell'ancora dell'Andrea Doria.

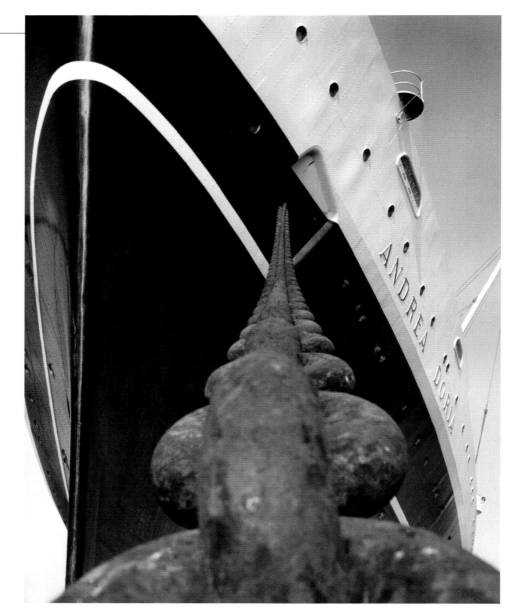

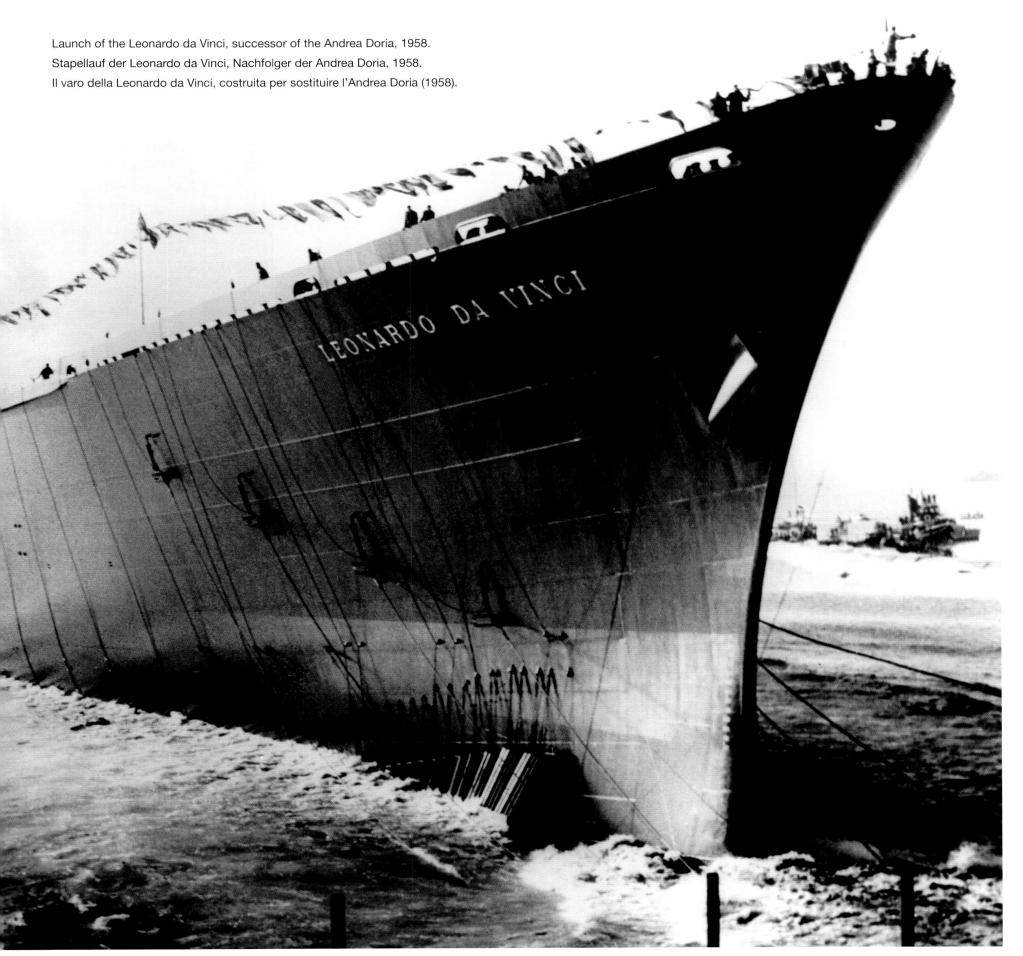

Launch of the Leonardo da Vinci, successor of the Andrea Doria, 1958.

Stapellauf der Leonardo da Vinci, Nachfolger der Andrea Doria, 1958.

Il varo della Leonardo da Vinci, costruita per sostituire l'Andrea Doria (1958).

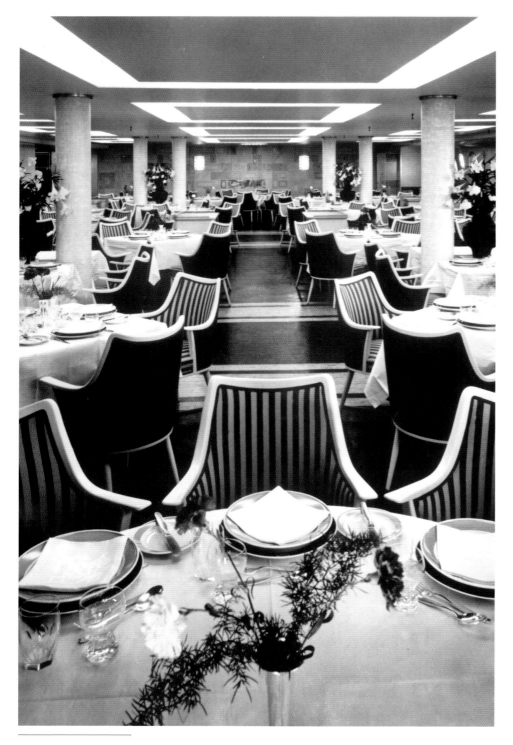

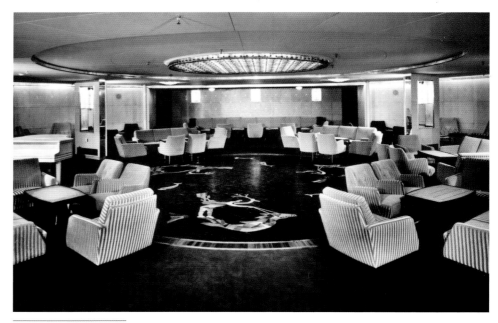

First class saloon

der Salon der Ersten Klasse

il salone della prima classe

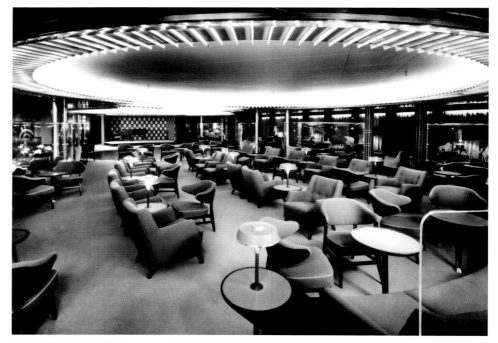

The new Bremen's first class dining-room. She was rebuilt of a French liner named Pasteur.

Die neue Bremen, umgebaut aus einem französischen Schiff namens Pasteur. Hier der Speisesaal der Ersten Klasse,

La nuova Bremen, nata dal restauro di una nave francese chiamata Pasteur. Qui, la sala da pranzo della prima classe,

and tourist class saloon, 1959.

und der Salon der Touristenklasse, 1959.

e quello della classe turistica (1959).

The new Bremen, at dock in Bremerhaven, is ready for her maiden voyage to America, 1959.

Die neue Bremen bereit zur Jungfernfahrt nach Amerika am Kai in Bremerhaven, 1959.

La nuova Bremen nel porto di Bremerhaven, pronta per il suo viaggio inaugurale in America (1959).

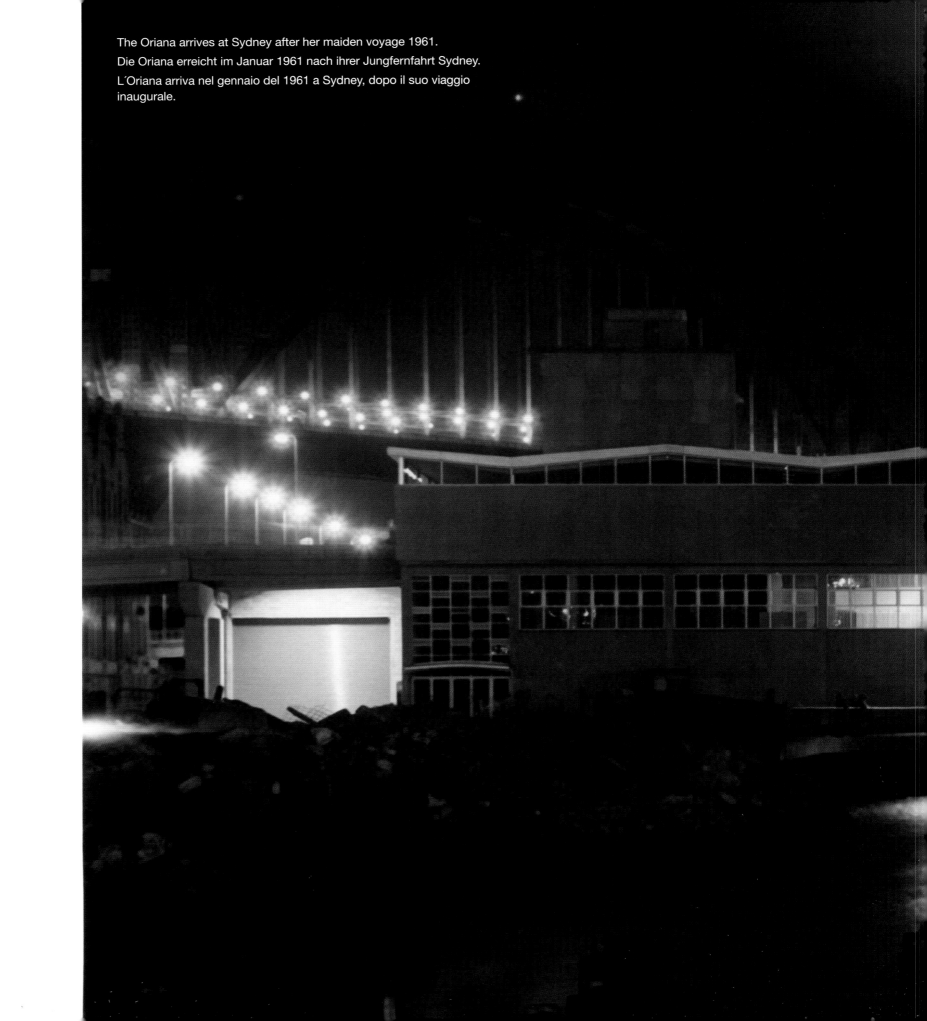

The Oriana arrives at Sydney after her maiden voyage 1961.

Die Oriana erreicht im Januar 1961 nach ihrer Jungfernfahrt Sydney.

L´Oriana arriva nel gennaio del 1961 a Sydney, dopo il suo viaggio inaugurale.

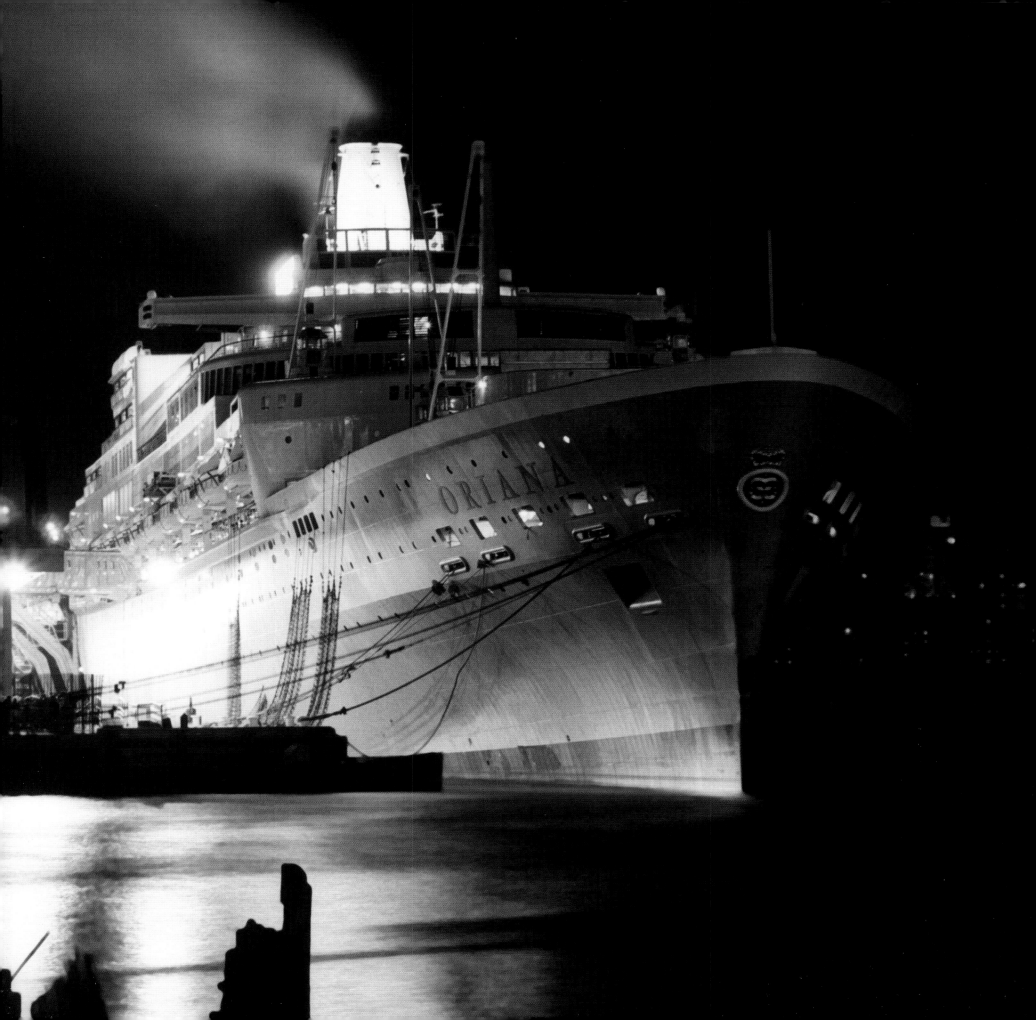

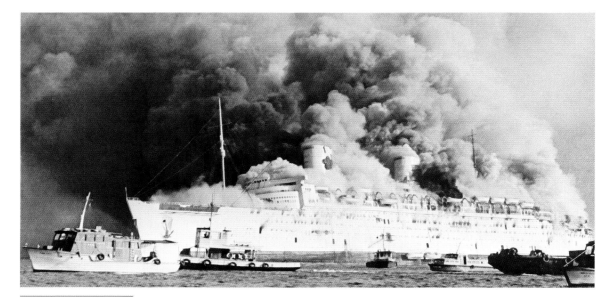

The Queen Elizabeth, which should act as swimming university at Hong Kong, on fire. She capsized and got broken up shortly afterwards, 1972.

Blick auf die brennende Queen Elizabeth, die vor Hongkong als schwimmende Universität dienen sollte. Sie kenterte und wurde abgewrackt, 1972.

L'incendio della Queen Elizabeth; la nave avrebbe dovuto servire come università galleggiante davanti a Hong Kong. Si rovesciò e fu smantellata (1972).

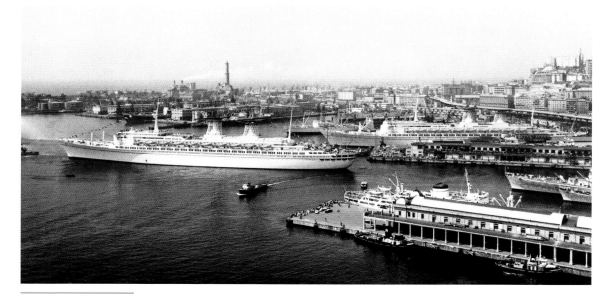

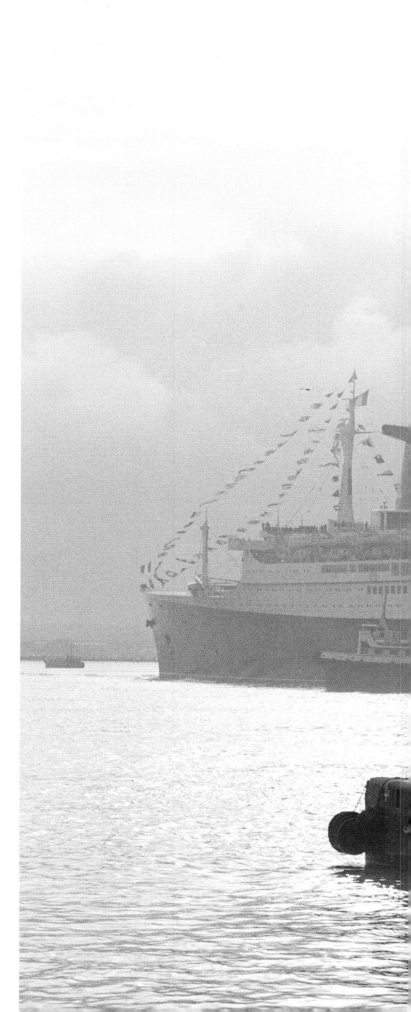

The Raffaello, the newest addition to the Italian Liner fleet and the sister ship to the Michelangelo, leaves Genoa on her maiden voyage to New York, calling at Cannes and Naples, 1965.

Die Raffaelo, neuester Zugang der italienischen Liner-Flotte und Schwesterschiff der Michelangelo verlässt Genua für ihre Jungfernfahrt über Cannes und Neapel nach New York, 1965.

La Raffaello, ultimo acquisto della flotta italiana e sorella della Michelangelo, parte da Genova per il suo viaggio inaugurale: Cannes, Napoli e infine New York (1965).

The new French liner France, later rebuilt as the cruise ship Norway, steams away after completing her docking trials at Southampton, 1962.

Der neue französische Liner France, später umgebaut zum Kreuzfahrtschiff Norway, verlässt Southampton nach seiner Andockübung, 1962.

Il nuovo transatlantico France, poi riadattato a nave da crociera Norway, parte dopo l'esercitazione di attracco a Southampton (1962).

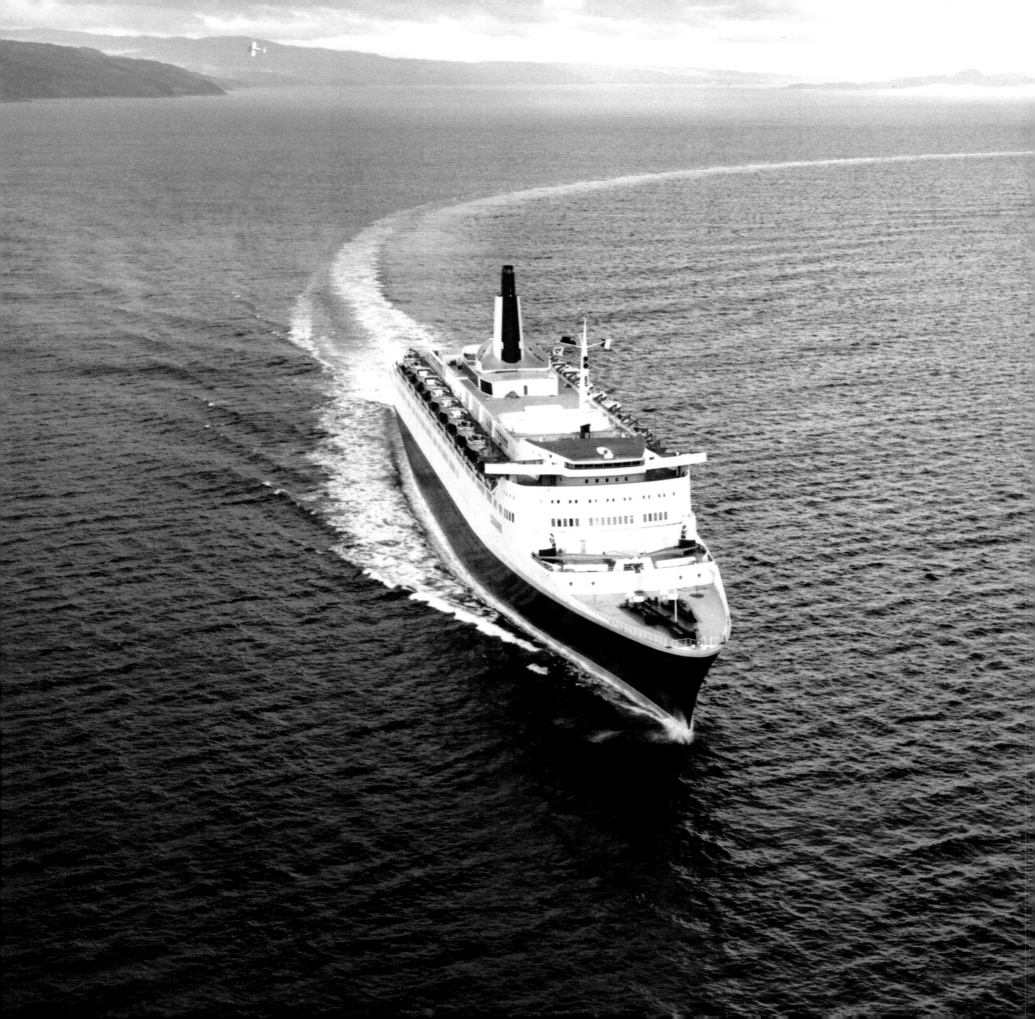

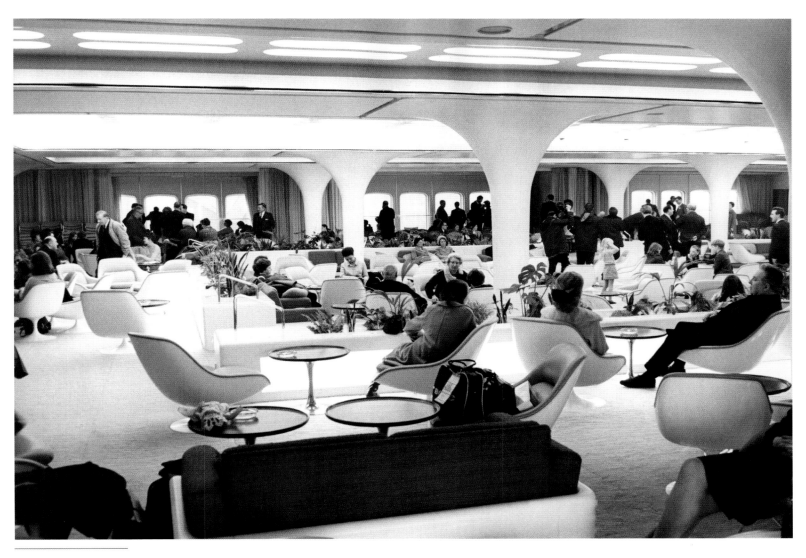

The interior of the 'Queen's Room' on the Queen Elizabeth 2, 1969.

Die Innenausstattung des ‚Queen's Room' 1969 auf der Queen Elizabeth 2, 1969.

L'arredamento della 'Queen's Room' a bordo della Queen Elizabeth 2 (1969).

The Queen Elizabeth 2, which is still on duty today, on her first trial run, November 1968.

Die Queen Elizabeth 2 ist heute noch im Dienst. Hier bei ihrer ersten Probefahrt im November 1968.

La Queen Elizabeth 2 è ancora oggi in servizio. Qui, durante il primo viaggio di prova nel novembre del 1968.

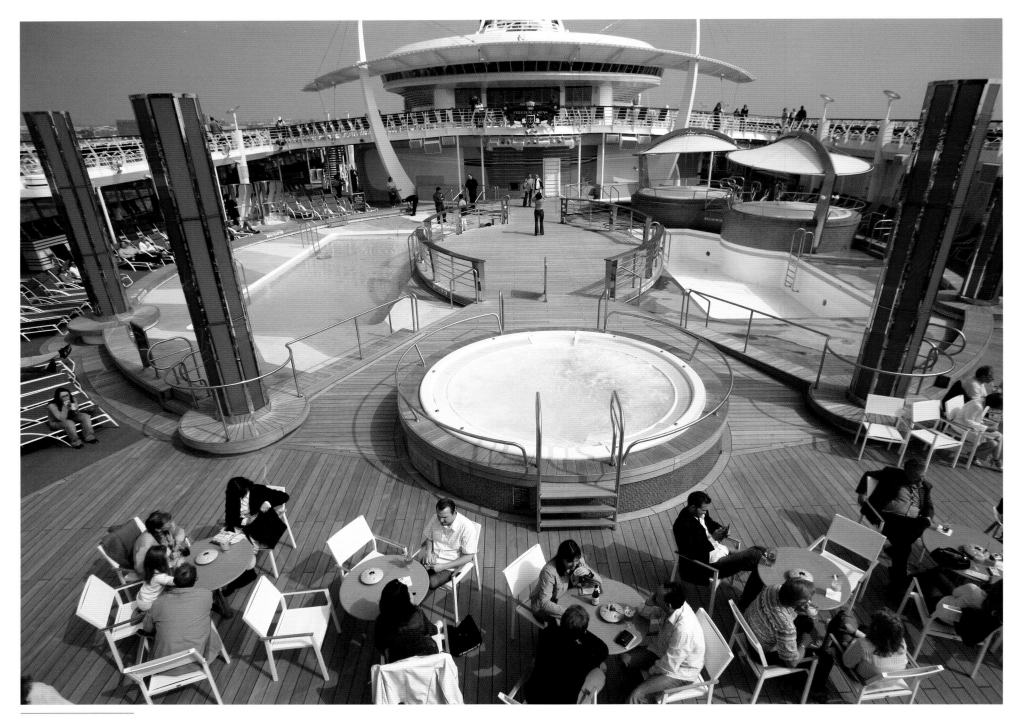

Hamburg, April 2006: The inviting upper deck and magnificent dining room on board of the Freedom of the Seas, the world's largest cruise liner.

Das einladende Oberdeck und der prachtvolle Speisesaal an Bord der Freedom of the Seas, dem größten Kreuzfahrtschiff der Welt, angedockt in Hamburg im April 2006.

L'invitante ponte di coperta e la magnifica sala da pranzo della Freedom of the Seas, la più grande nave da crociera del mondo, attraccata nel porto di Amburgo nell'aprile del 2006.

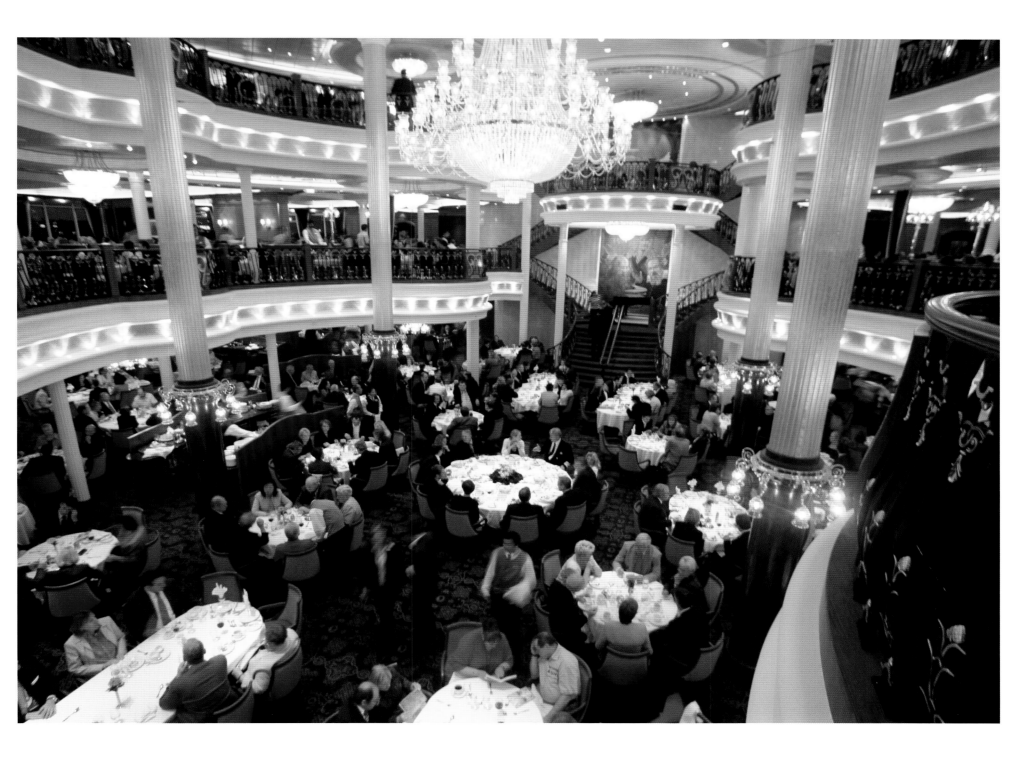

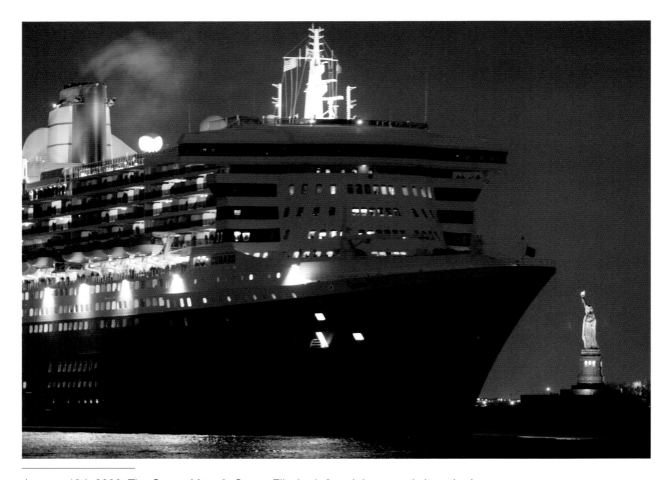

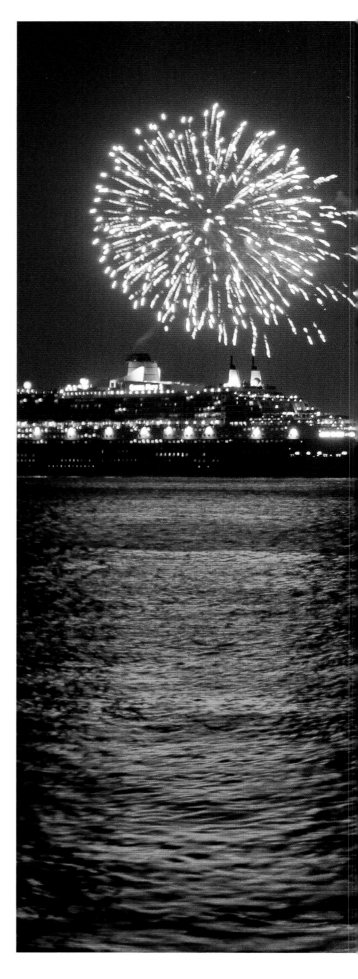

January 13th 2008: The Queen Mary 2, Queen Elizabeth 2 and the recently launched Queen Victoria, three of the world's most famous ocean liners, putting out of New York Port together for the first time in history. Jointly they pass the Statue of Liberty under the cover of darkness while over the heads of the crowd dazzling fireworks illuminate the sky.

13. Januar 2008: Drei der berühmtesten Ocean-Liner der Welt fahren zum ersten Mal aus dem Hafen von New York: Die Queen Mary 2, Queen Elizabeth 2 und die Queen Victoria, die gerade vom Stapel gelaufen ist. Während sie zusammen die Freiheitsstatue passieren, werden sie von einem Feuerwerk begleitet.

13 gennaio 2008: Queen Mary 2, Queen Elizabeth 2 e Queen Victoria, l'ultima a essere stata varata. Per la prima volta nella storia, tre dei più famosi transatlantici del mondo lasciano insieme il porto di New York. Mentre oltrepassano nell'oscurità della notte la Statua della Libertà, fuochi d'artificio colorati illuminano il cielo regalando alla folla uno spettacolo indimenticabile: un evento straordinario per tutti gli appassionati di storia marittima.

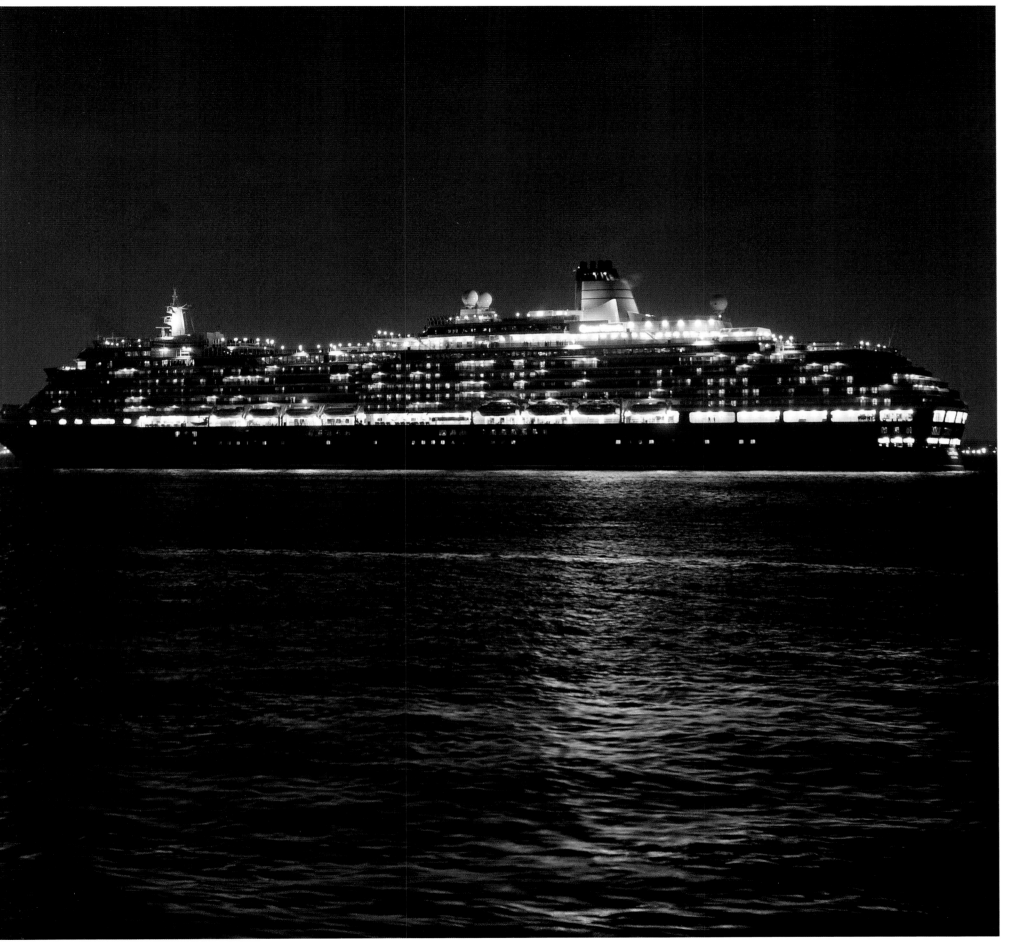

CD 1 ✦ ✦ ✦
Music from the Grand Orchestras Played Aboard

01. Nenita 3:14
(Llossas)
Juan Llossas and his Tango-Orchestra

02. Christopher Columbus 3:42
(Barry/Razaf)
Teddy Stauffer and the Original Teddies

03. Is It True What They Say About Dixie 3:06
(Caesar/Marks)
Teddy Stauffer and the Original Teddies, Vocals: Billy Toffel

04. Die launische Polka 2:47
(Joost)
George Boulanger and his Dance Orchestra

05. Schöne Rosmarin 1:41
(Kreisler)
George Boulanger and his Dance Orchestra

06. Patetico 3:22
(Llossas)
Juan Llossas and his Tango-Orchestra

07. Valse Medley 3:32
(Scherfzinger/Grey/Ayer/Terriss/Robledo)
Teddy Stauffer and the Original Teddies

08. Quand Je Suis Content 2:36
(Boulanger)
George Boulanger and his Dance Orchestra

09. Sing, Sing With A Swing 2:31
(Prima)
Teddy Stauffer and the Original Teddies, Vocals: Billy Toffel

10. Penny Serenade 2:48
(Weersma/Halifax/Schwenn/Schaeffers)
Juan Llossas and his Tango-Orchestra

11. Practice Makes Perfect 2:43
(Roberts/Gold)
Teddy Stauffer and the Original Teddies, Vocals: Billy Toffel

12. Samba Caramba 3:12
(Llossas)
Juan Llossas and his Tango-Orchestra

13. Granada 2:49
(Llossas)
Juan Llossas and his Tango-Orchestra

14. Tango Mio 3:25
(Llossas)
Juan Llossas and his Tango-Orchestra

15. Blonde Claire 3:12
(Llossas/Rotter)
Juan Llossas and his Tango-Orchestra

16. A Sailboat In The Moonlight 3:14
(Lombardo/Loeb)
Teddy Stauffer and the Original Teddies, Vocals: Billy Toffel

17. Ave Maria 2:47
(Bach/Gounod)
George Boulanger and his Dance Orchestra

18. Winke, Winke 2:55
(Wichmann/Boulanger)
George Boulanger and his Dance Orchestra

All tracks licensed from M.A.T. Music Theme Licensing GmbH, Hamburg, Germany

CD 2 ✦ ✦ ✦
Music in the Parlours at High Tea

01. Hora Mare 2:28
(Boulanger)
Prima Carezza

02. Comme-Ci, Comme-Ça 2:29
(Boulanger)
Prima Carezza

03. Tes Yeux Noir, Gypsy 2:53
(Traditional/Arr. Neftel)
Prima Carezza

04. That's Amore 2:42
(Warren/Brooks)
Jürg Kienberger

05. Kleiner Walzer 3:53
(Kistner/Siegel)
Performed by Teresa Carreño April 10th 1905, Welte-Mignon No 371

06. Thais Méditation 4:47
(Massenet)
Trio Frakas

07. Cavatine 5:22
(Raff)
Prima Carezza

08. La Campanella 4:42
(Paganini/Arr. Liszt)
Performed by Ferruccio Busoni, June 1905, Welte-Mignon No 444

09. Czardas 3:51
(Monti/Arr. Neftel)
Prima Carezza

10. Bessarabican Hora 3:19
(Traditional/Arr. Pipczynski)
Prima Carezza

11. Sirba Din Muntenia 2:18
(Dinieu)
Prima Carezza

12. Einmal Ist Keinmal 2:45
(Benatzky)
Prima Carezza

13. Diner-Walzer 3:52
(Grünfeld)
Performed by Alfred Grünfeld, January 20th 1905, Welte-Mignon No 193

14. Love In Portofino 3:57
(Buscaglione)
Jürg Kienberger

All tracks with kind permission from Music Edition Winter & Winter, Munich

CD 3 ✹ ✹ ✹
Ballroom Dancing after the Captain's Dinner

01. Stompin' at the Savoy 3:54
(Sampson/Webb/Goodman/Razaf/Arr. Werner Tauber)
Thilo Wolf Big Band

02. From This Moment On/Too Darn Hot 5:34
(Cole Porter/Arr. Thilo Wolf)
Thilo Wolf Big Band & Strings; Vocal: Clarissa Pöschel

03. Mack The Knife 4:44
(Weill/Brecht/Arr. Thilo Wolf)
Thilo Wolf Big Band & Strings; Vocal: Clarissa Pöschel

04. Porgy and Bess-Medley/Summertime 5:29
(Gershwin/Du Bose Heyward/Arr. Thilo Wolf)
Thilo Wolf Orchestra

05. A Nightingale Sang In Berkley Square 5:21
(Sherwin/Maschwitz/Arr. Thilo Wolf)
Thilo Wolf Orchestra; Vocal: John Marshall

06. Desafinado; The Girl From Ipanema, Meditation 4:34
(Jobim/de Moraes/Gimbel/Mendonca/Arr. Werner Tauber)
Thilo Wolf Orchestra

07. True Love/High Society 4:06
(Porter/Arr. Werner Tauber)
Thilo Wolf Orchestra

**08. Is It True What They Say About Dixie; Ol' Mac Donald;
I Scream, You Scream („Ice Cream") 4:13**
(Caesar/Lerner/Marks/Arr. Werner Tauber)
Thilo Wolf Big Band

09. The Coffee Song 2:37
(Hilliard/Miles/Arr. Thilo Wolf)
Thilo Wolf Big Band; Vocal: John Marshall

10. Pennies From Heaven; Luck Be A Lady 4:02
(Johnston/Burke/Loesser/Arr. Thilo Wolf)
Thilo Wolf Big Band & Strings; Vocal: John Marshall

11. Take The A-Train 3:24
(Strayhorn/Arr. Thilo Wolf)
Thilo Wolf Big Band

12. Autumn in New York 4:40
(Duke/Arr. Werner Tauber)
Thilo Wolf Big Band

All tracks with kind permission of MDL JAZZ Musikproduktion GmbH, Germany
www.mdl-jazz.de www.thilo-wolf.de

CD 4 ✹ ✹ ✹
Nightcap in the Bar after Midnight

01. You Make Me Feel So Young* 4:16
Theo Bleckmann (Vocals)/Fumio Yasuda (Piano)

02. St. Thomas 6:49
Sonny Rollins
(Rollins)

03. Comes Love 4:23**
Michael Kaeshammer
(Brown/Stept/Tobias)

04. We Kiss In A Shadow* 3:34
Theo Bleckmann (Vocals)/Fumio Yasuda (Piano)
(Rodgers/Hammerstein II)

05. Decision 8:06
Sonny Rollins
(Rollins)

06. Cry To Me 4:00**
Michael Kaeshammer
(Landreville)

07. I've Got A Gal In Kalamazoo* 1:34
Theo Bleckmann (Vocals)/Fumio Yasuda (Piano)
(Warren/Gordon)

08. I'm An Old Cowhard 5:41
Sonny Rollins
(Mercer)

09. Button Up Your Overcoat* 3:25
Theo Bleckmann (Voc)/Fumio Yasuda (Pno)/Kammerorchester Basel
(Brown/De Sylva/Henderson)

10. Sleepy Time 3:11**
Michael Kaeshammer
(L.Rene/O.Rene/Muse)

* With kind permission from Music Edition Winter & Winter, Munich
** With kind permission from Alma Records, Toronto

This compilation ℗ 2008 edel entertainment GmbH